THE COMPLETE BOOK OF

TEXTURES

FOR

ARTISTS

Step-by-step instructions for
MASTERING MORE THAN 275 TEXTURES
in graphite, charcoal, colored pencil, acrylic, and oil

Steven Pearce

Denise J. Howard

Mia Tavonatti

Brimming with creative inspiration, how-to projects, and useful information to enrich your everyday life, Quarto Knows is a favorite destination for those pursuing their interests and passions. Visit our site and dig deeper with our books into your area of interest: Quarto Creates, Quarto Cooks, Quarto Homes, Quarto Lives, Quarto Drives, Quarto Explores, Quarto Gifts, or Quarto Kids.

Table of Contents

SECTION II: Colored Pencil with Denise J. Howard....47

SECTION III: Oil & Acrylic with Mia Tavonatti....91

How to Use This Book

This book includes step-by-step instructions for achieving a wide range of textures with graphite, charcoal, colored pencil, oil, and acrylic.

1. Choose Your Medium

Find the section that focuses on your planned medium. Section I features pencil and charcoal; Section II features colored pencil; and Section III features oil and acrylic paint.

2. Review and Gather

At the beginning of each section, you'll find information about materials needed for the featured medium, plus techniques and terminology.

3. Locate

Find your desired subject and texture in the Table of Contents (pages 3–5). Textures are organized into six categories: People, Animals, Fabrics & Textiles, Hard Surfaces, Nature, and Food & Beverage.

4. Follow

Use the step-by-step process outlined to draw or paint your texture.

5. Practice

Recreate the texture as it appears in the book; then integrate the textures into your own works of art!

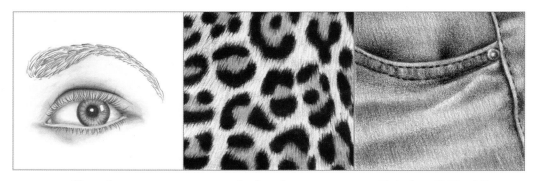

People　　　　　**Animals**　　　　　**Fabrics & Textiles**

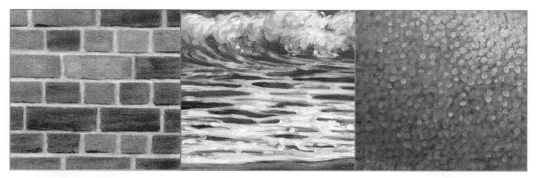

Hard Surfaces　　　　　**Nature**　　　　　**Food & Beverage**

Section I
GRAPHITE
& CHARCOAL

STEVEN PEARCE

Tools & Materials

Paper

Paper has a *tooth*, or texture, that holds graphite and charcoal. Papers with more tooth have a rougher texture and hold more graphite or charcoal, which allows you to create darker values. Rough, textured paper is best when working in charcoal. Smoother paper has less tooth and allows you to create much finer detail when working in graphite. Plan ahead when beginning a new piece, and select paper that lends itself to the textures in your drawing subject.

When you try a paper for the first time, practice and experiment on it. Draw, blend, and erase before starting your final work to see how it will perform. Use high-quality paper and buy acid-free for your finished pieces, which will resist yellowing over time. When working in graphite, it is ideal to use an acid-free Bristol smooth paper or a high-quality 100% cotton rag, hot-pressed watercolor paper. When working in charcoal, toned paper is great, as it allows for dramatic highlights.

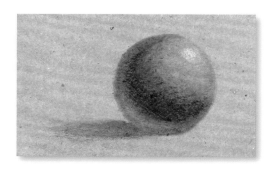

Graphite over rough, toned paper

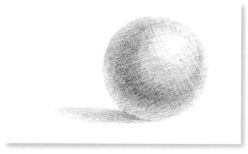

Graphite over smooth drawing paper

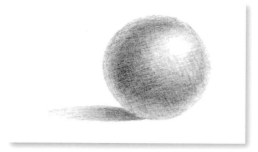

Graphite over medium drawing paper

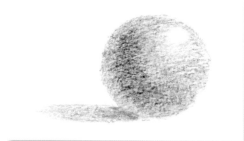

Graphite over rough or cold-pressed paper

Pencils

Graphite drawing pencils come in soft and hard grades. Soft-grade pencils range from B, 2B, 3B, up to 9B and 9XXB—extra soft! Hard-grade pencils range from H, 2H, 3H, up to 9H. The higher the number that accompanies the letter, the softer or harder the lead. Between the two grades is the HB pencil, and between H and HB is the F pencil. Experiment with the different grades to discover which ones you prefer. You will find that you don't need to work with every grade of soft and hard pencil. You will probably narrow down your set to just a small number for most of your work, but keep the others close by in case you need them. Some artists prefer the mechanical drafting (clutch) 2mm pencil rather than traditional wood-encased pencils. A good-quality clutch pencil will last for years and perform very well. The 2mm graphite refill leads come in all the hard and soft grades. When purchasing clutch pencils, make sure you get the sharpener designed for them; it produces a very sharp point for fine-detailed work. You can even save the graphite shavings for later use!

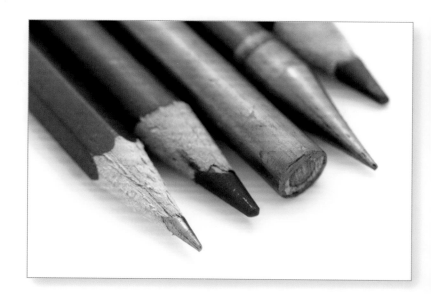

Erasers

There are many different types of erasers available, including the following:

KNEADED This very versatile eraser can be molded into a fine point, a knife-edge, or a larger flat or rounded surface. It removes graphite gently from the paper, but not as well as vinyl or plastic erasers. Use it in a dabbing motion to pull or lift off graphite from the drawing surface. A kneaded eraser works well for final cleanup.

BLOCK ERASER A plastic block eraser is fairly soft, removes graphite well, and is very easy on your paper. Use it to erase large areas or for the final cleanup of a finished drawing.

STICK ERASER Also called "click pencil erasers," these handy tools hold a cylindrical eraser inside. You can use them to erase areas where a larger eraser will not work. Using a utility razor blade, you can trim the tip at an angle or cut a fine point to create thin white lines in graphite. It's like drawing with your eraser! Refills are inexpensive and easy to find.

Blenders

There are many tools available for blending graphite and charcoal. Some you can even find around the house! Never use your finger to blend—it can leave oils on your paper, which will show after applying your medium.

STUMPS These blenders are tightly rolled paper with points on both ends. They come in various sizes and are used to blend large and small areas of graphite, depending on the size of the stump. Keep old, worn stumps for applying light shades of graphite. You can also use stumps dipped in graphite shavings for drawing or shading.

TORTILLONS These tools are rolled more loosely than stumps. They are hollow and have one pointed end. Tortillons also come in various sizes and can be used to blend smaller areas of graphite.

FACIAL TISSUE You can wrap facial tissue around your finger or roll it into a point. Use it when drawing very smooth surfaces or in portraits to achieve soft skin tones. Make sure you use plain facial tissue, without added moisturizer.

CHAMOIS These cloths are great for blending areas into a soft tone. You can use them for large areas or fold them into a point for smaller areas. A good-quality natural leather chamois is best, but a synthetic leather chamois can also yield good results. Cut them into the size that works best for you. When the chamois becomes embedded with graphite, simply throw it into the washer or wash by hand. Keep one with graphite on it to create large areas of light shading. To create darker areas of shading, add graphite shavings to the chamois.

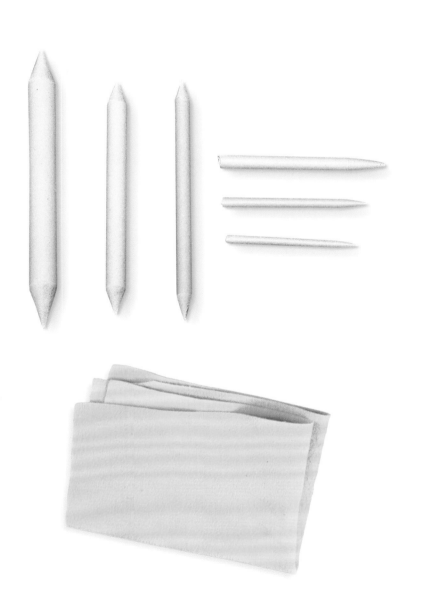

Charcoal

Charcoal is made up of the carbon remains of burnt wood and can produce a rich black with rough, expressive strokes, making it a dramatic alternative to graphite. However, charcoal can also create subtle, velvety blends and fine detail. This medium works best on rougher paper surfaces with plenty of tooth. It also works best with art gum and kneaded erasers. Because charcoal is dusty and dry by nature, it lifts easily and can sometimes be blown off the paper. Use a spray fixative on your finished drawings to ensure that they last.

Charcoal is available in three basic forms, which feel and look very different from one another. It's important to experiment and find the one that suits your personal preferences.

VINE & WILLOW CHARCOAL These lightweight, irregularly shaped rods of charcoal are made of burnt grapevine and willow tree. Vine produces a gray line, whereas willow produces black.

COMPRESSED CHARCOAL STICKS Compressed charcoal is mixed with a binder, such as gum, which makes it adhere more readily to paper and produces creamier strokes than vine or willow charcoal. Compressed charcoal sticks come in a range of hardnesses, including soft, medium, and hard—or they are listed by number and letter, similar to pencil hardness. You can use the broad side of the stick for large areas of tone, or you can use the end (which you can sharpen with a knife) to create more detailed strokes.

CHARCOAL PENCIL These compressed charcoal tools in a pencil format offer maximum control, allowing you to create fine, precise strokes. Some are wood-encased, so you can sharpen them as you do graphite pencils. However, some charcoal pencils have tips wrapped in paper. To expose more charcoal, simply pull the string to unwrap the paper. Hone the tips with a sandpaper pad or knife.

Charcoal pencil sets usually come with a white "charcoal" pencil (which is usually made of chalk and a binder—not actual charcoal). You can use this pencil with your black charcoal pencils to create dramatic highlights on toned paper.

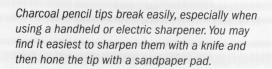

Charcoal pencil tips break easily, especially when using a handheld or electric sharpener. You may find it easiest to sharpen them with a knife and then hone the tip with a sandpaper pad.

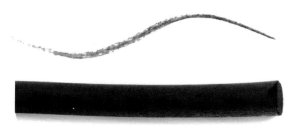

Vine & Willow Charcoal

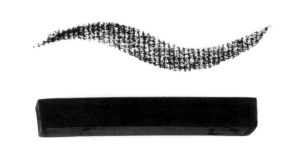

Compressed Charcoal Sticks

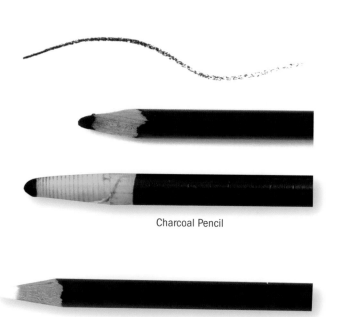

Charcoal Pencil

White Charcoal Pencil

Graphite vs. Charcoal

Compare the canine portrait drawn in graphite (left) with the canine drawing in charcoal and white pencil on toned paper (right). Soft, muted, and peaceful, the graphite drawing has a much different mood than the bolder, richer charcoal portrait.

GRAPHITE	CHARCOAL
Works well on smooth to rough papers	Works best on smooth (not glossy), rough, and textured papers
Produces a wide range of gray tones	Produces rich, dark tones and blends into gray tones
White of the paper serves as the highlights	White charcoal on toned paper serves as the highlights
Capable of producing very detailed, controlled linework	Capable of producing very expressive linework

White charcoal (which is actually chalk) comes in different forms, such as compressed sticks and wood-encased pencils. You can use white charcoal either alone on dark-toned paper or alongside regular charcoal to create beautiful highlights and dramatic contrast. Use different pressures to create different values. Like regular charcoal, you can blend white charcoal for a smoother look if desired.

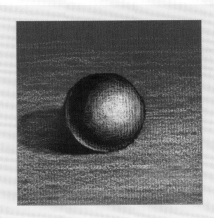

Graphite Techniques

Here are some of the basic graphite techniques you can use to create the drawings in this section. Practicing a new technique first will save you from doing a lot of erasing later! There are many more techniques to discover that apply to other styles of drawing, so keep exploring after you have mastered these techniques.

Applying Graphite with a Blender

Using a chamois is a great way to apply graphite to a large area. Wrap it around your finger and dip it in saved graphite shavings to create a dark tone, or use what may be already on the chamois to apply a lighter tone. Stumps are also great for applying graphite. Use an old stump to apply saved graphite shavings to both large and small areas. You can achieve a range of values depending on the amount of graphite on the stump.

Blending

When you use a blending tool, you move already-applied graphite across the paper, causing the area to appear softer or more solid. Using a circular motion when blending achieves a more even result. Here are two examples of drawing techniques blended with a tortillon. On your practice paper, experiment with the various blending tools mentioned in this book.

Burnishing

When you use a soft pencil, the result may appear grainy depending on the tooth of the paper. In some of your drawings, you may desire this look. However, if the area requires a more solid application, simply use a pencil that is a grade or two harder to push, or "burnish," the initial layer of graphite deeper into the tooth of the paper.

Circular Strokes

Simply move the pencil in a continuous, overlapping, and random circular motion. You can use this technique loosely or tightly, as shown in this example. You can leave the circular pattern as is to produce rough textures, or you can blend to create smoother textures.

Erasing

Stick and kneaded erasers are a must. The marks on the left side of this example were created with a stick or click pencil eraser, which can be used for erasing small areas. If you sharpen it, you can "draw" with it. The kneaded eraser is useful for pulling graphite off the paper in a dabbing motion, as shown on the right side.

Linear Hatching

In linear hatching, use closely drawn parallel lines for tone or shading. You can gradually make the lines darker or lighter to suggest shadow or light. Draw varying lengths of lines very close and blend for a smooth finish. You can also curve your lines to follow the contour of an object, such as a vase.

Negative Drawing

Use your pencil to draw in the *negative space*—the area around the desired shape—to create the object. In this example, graphite is laid down around the vine and leaves, leaving the white of the paper—the *positive space*—as the desired shapes.

Scribbling

You can use random scribbling, either loose or tight, to create a variety of textures such as old leather, rusty metal, rocks, bricks, and more. You can even use it for rendering the rough skin of some animals, like elephants. Lightly blend the scribbling to produce different effects.

Stippling

Tap the paper with the tip of a sharp pencil for tiny dots or a duller tip for larger dots, depending on the size you need. Change the appearance by grouping the dots loosely or tightly. You can also use the sharp tip of a used stump or tortillon to create dots that are lighter in tone.

Charcoal Techniques

The following two pages feature the basic charcoal techniques you can use to create many different textures. Charcoal requires practice to master, so try out each technique before attempting the step-by-step textures in this section.

Charcoal Grades

As discussed on page 10, you can choose from a variety of charcoal forms—from vine charcoal sticks to compressed charcoal pencils. The projects in this section were created with wood-encased charcoal pencils, which are graded according to hardness. Depending on the manufacturer, these pencils may be labeled soft or 4B, medium or 2B, hard or HB, and extra hard or 2H. View the difference in richness between these examples.

4B (soft)

2B (medium)

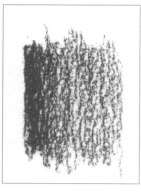
HB (hard)

2H (extra hard)

Paper Textures

A variety of textured papers can be used for charcoal drawings. The heavily textured paper with a laid finish (left) can be used for more expressive charcoal drawing, and the smoother, less textured paper (right) can be used for drawings that require finer detail. The paper should not be too smooth or glossy; these surfaces will not hold the charcoal properly. To avoid smudges, apply workable fixative during various stages of the drawing and upon finishing.

Blending

You can employ a variety of blending tools with charcoal, each yielding its own result as demonstrated in this example. Stumps (A) are made of packed paper and create dark blends because they don't pick up much charcoal from the paper's surface; instead, they simply move the charcoal around the paper. A tortillon (B) yields similar results to a stump; but, because it is made of loosely rolled paper, it can have a sharper tip. A chamois (C) is a soft piece of animal skin that produces soft, light tones, as it absorbs some of the charcoal from the paper. Like the chamois, tissue (D) blends softly and lightens the tone as it picks up some of the charcoal off the paper's surface. You can fold both the chamois and tissue to create a narrow tip for blending small areas.

A
B
C
D

Linear Hatching

To create linear hatching, draw parallel lines to tone the paper. Draw them closely for a darker value, and draw them farther apart for a lighter value. You can use tapered strokes, such as when drawing hair, to create a highlighted effect. You can blend over the lines to smooth and soften the tone, but it's generally a good idea to allow at least some of the lines to show through for texture and interest.

Applying Soft Tones

To apply smooth tone of varying value to your paper, you can use a blender (such as a stump or chamois) with graphite already embedded in its surface. If your blender does not contain enough graphite, dab it into charcoal shavings. A chamois is great for smoothly toning large areas, whereas a stump is best for working in small areas.

Negative Drawing

Also called "charcoal reductive" drawing, negative drawing refers to applying charcoal to a portion of the paper and then "drawing" by removing tone. You can remove tone using a kneaded, block, or stick eraser. Apply varying amounts of pressure to achieve different values.

Scribbling

Scribbling, also called "scumbling," is simply random scribbling applied in either a tight or loose manner. This technique is effective for producing rough textures, such as the look of rusted metal.

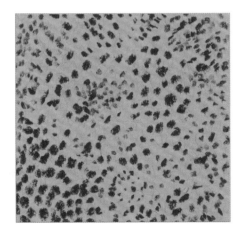

Stippling

To create the dots that make up stippling, simply tap the paper with the tip of a charcoal pencil. Use a sharp point for small dots and a dull tip for larger dots. (You can also draw larger dots, if needed.) You can group the dots loosely or tightly, and you can make them light or dark depending on your desired result. Stippling effectively adds character to rock, brick, and wood, among many other drawn textures.

Value

Values are the lights and darks you see in a drawing or photograph. Essentially, values are all the shades, or tones, from black through various shades of gray to white—the paper itself. By using hard and soft pencils, we attempt to create a wide range of these values in our drawing to give depth and an illusion of three-dimensionality to the forms. We use smooth transitions of value from light to dark on curved or round forms like a ball (or the light bulb shown at right), and we use mostly abrupt changes in value on forms such as a cube or pyramid.

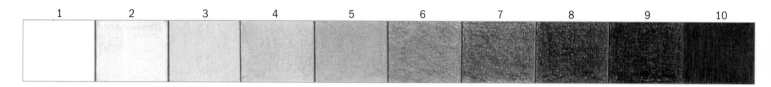

Many artists use a value scale (above) to match the values of a subject to the actual drawing. Using your pencils, make your own value scale, starting with white or the color of the paper. Then add nine other values, ending with the darkest square you can make using the softest pencil that you would normally use in your drawings.

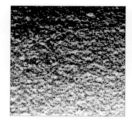 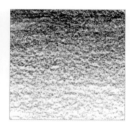

Your pencil's hardness determines the range of values you can produce. Pictured here are gradations of 8B, 4B, HB, and 4H graphite, allowing you to see differences in stroke quality and value.

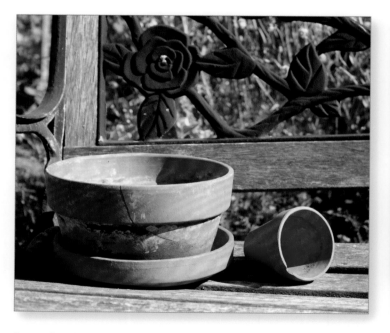 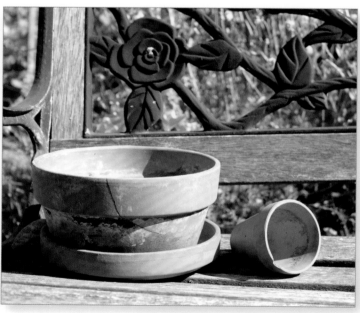

Remember: Drawing is seeing. Plenty of preparation and thorough study of your subject matter should be done long before you make a mark on the paper. Study your subject and really get a sense of its values. Identify where your darkest and lightest values should be. When using a reference photo, it's best to convert it to a grayscale image so you can get a better idea of the values you can use.

Don't be afraid to "push the darks"—or use the darkest values in your drawings. You'll need a good amount of contrast between light and dark. A drawing can be done well but look flat or washed out if it lacks darks or contrast.

Shading

When drawing textures, it's important to understand the basics of what happens when the light source hits your subject matter. You need to identify where the darkest and brightest values are by studying the composition thoroughly before you start drawing. This will help you to be more successful when you transfer what you see onto your drawing paper. Use a wide range of values when you shade objects in your composition; the contrast between lights and darks is what gives your drawing three-dimensionality. Let's look at the light and shadow elements of a basic form.

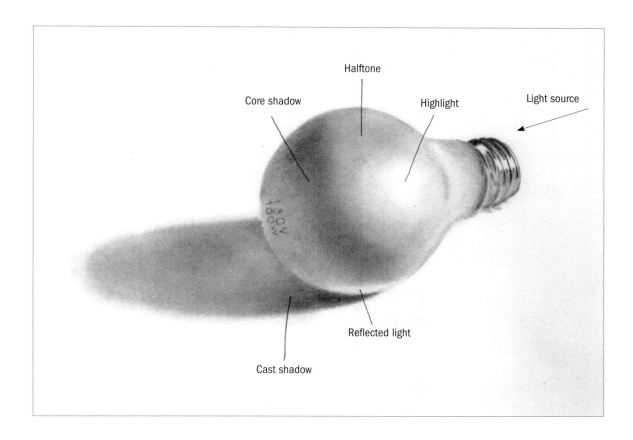

HIGHLIGHT This is the light that shines directly on an object and reflects back into our eyes. This will be the lightest value of the drawing—usually the white of the paper.

CORE SHADOW This the darkest value on the object. It is the part, or side, of the object that separates the light from the shadow areas.

HALFTONE Also referred to as "midtone," this is the area between the highlight and the core shadow. As the shape of the object turns away from the light source, there is a gradation of tones between the highlight and the core shadow.

REFLECTED LIGHT This is light that bounces back onto the shadow area of the object from the surface or other objects in the drawing.

CAST SHADOW This shadow falls from an object onto a nearby surface and away from the light source. Where the object sits or contacts a surface is where the darkest value of the cast shadow is found. As it grows out, the shadow becomes lighter in value.

PEOPLE

1 | Smooth Skin in Graphite

 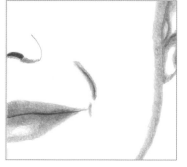 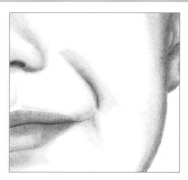

Block in the main areas of the face with light lines. Then establish the darkest values using a 4B for the nostril and crease of the lips, followed by a 2B for the crease of the cheek and folds of the ear.

Using an HB and overlapping circular strokes, create the shaded areas of the nose, crease of the cheek, face, and ear. Using overlapping circular strokes can help you avoid making the skin look too plastic.

Using a 4H and overlapping circular strokes, create the lightly toned areas. Alternatively, you can use graphite shavings and a blending stump to work in a circular motion, also creating smooth skin tones.

Blend all areas of the face with a stump to create smooth transitions. Use the tip of a folded tissue to further blend the graphite where needed.

2 | Aged Skin in Graphite

 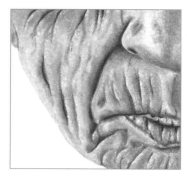

Using a 4H pencil, lightly draw the basic outline of the face, including the wrinkles of the skin. Switch to a 4B and draw the darkest values of the deep wrinkles.

Using a 2B and overlapping circular strokes, work from the darkest areas outward to create a gradation along the deep wrinkle shadows. Use the 2B pencil to develop additional wrinkles.

With HB and 2H pencils, continue overlapping circular strokes to create different values. For a more realistic texture, keep the circular strokes loose.

Lightly blend your strokes to smooth the skin, allowing some of the circular strokes to show through the finished drawing.

3 | Facial Hair in Graphite

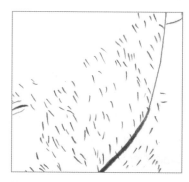 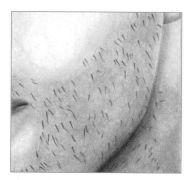 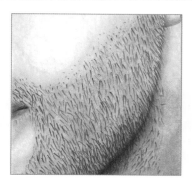 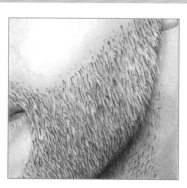

Lightly outline the face. Using a 4B pencil, build the darkest values, such as the corner of the mouth and jaw line. Include some whiskers, but remember that individual whiskers grow in different directions and do not appear perfectly parallel.

With a 2B and overlapping circular strokes, start in the 4B area and move outward to shade along the jaw line. With an HB and overlapping circular strokes, shade the jaw and neck. Use a 2H or a graphite-coated stump for lighter areas. Very lightly blend all areas.

Add more facial hair to the jaw and neck. When drawing each whisker, start by placing the tip of the pencil on the paper; then stroke and lift the pencil at the end for a tapered finish. To suggest shorter whiskers along the beard's edge, use stippling.

With a pencil eraser trimmed at a sharp angle, stroke in some highlighted whiskers for a realistic touch.

4 | Wavy Hair in Graphite

 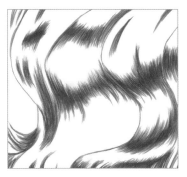 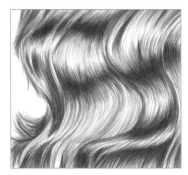 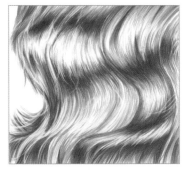

Draw the hair and determine where the darker areas will be. Use a reference photo of the hair you're drawing to help you determine the darks, lights, and general flow.

Using a 4B pencil, begin working the darkest areas. Apply overlapping strokes that follow the basic flow. Use light pressure at the start and lift at the end of each stroke to create tapered lines.

Using 2B and HB pencils, continue applying tapered, overlapping strokes. For the lightest areas, use very few strokes, if any. Notice the contrast in values that occurs within the hair; these differences achieve a realistic, three-dimensional effect.

For more realism, use a click pencil eraser that has a trimmed, sharp edge to create some light strands of hair. Using a tortillon or stump, finish with some light blending, especially in the darker areas.

5 | Wavy Hair in Charcoal

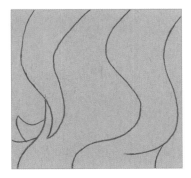 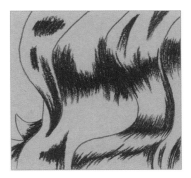 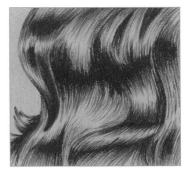 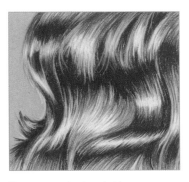

Use gray-toned charcoal paper for this drawing, or select a different midtone color per your preference. With an extra-hard or 2H charcoal pencil and light pressure, create guidelines to indicate the basic flow of the wavy hair.

Using a soft charcoal pencil, such as a 3B, build the darkest areas. Apply overlapping strokes that follow the flow of hair. Use light pressure at the start and lift at the end of each stroke for tapered lines that resemble hair.

Using a 2H or extra-hard charcoal pencil and light lines, continue building tapered, overlapping pencil strokes. Begin each stroke in the darkest areas and lift as you finish to taper the end. For the lightest areas, use few strokes.

To create contrast and shine, use a white charcoal pencil to add highlights with long, tapered strokes. Avoid stroking over the dark charcoal as much as possible.

6 | Curly Hair in Graphite

 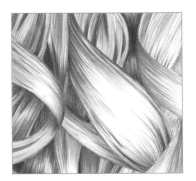 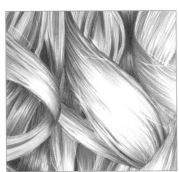

Drawing curly hair can be trickier than wavy or straight hair. The form is similar to a single strand of a curled ribbon. First draw the basic flow of the curly hair, including where the darker areas will be. Use a reference photo to block in the darks, lights, and flow.

Using a soft 4B pencil, identify and build the darkest values first. Use overlapping, tapered strokes that follow the curves of the hair and taper both ends of each stroke. Practice this type of stroke on a separate piece of paper, if necessary.

Using 2B and HB pencils, continue applying tapered, overlapping strokes that follow the flow of the hair. For the lightest areas, use few strokes, if any. Notice the contrast in values within the hair; these differences are needed to achieve a realistic, three-dimensional look.

Use a sharply cut end of a click pencil eraser to "draw" highlighted strands of wayward hair. Lightly blend some areas of hair with a tortillon or stump, particularly the darker areas.

7 | Straight Hair in Graphite

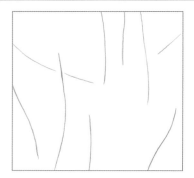 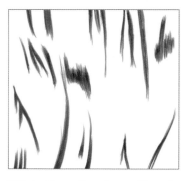 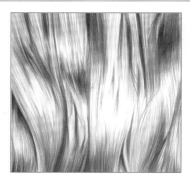 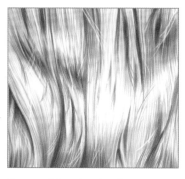

Draw lines showing the basic flow of the straight hair and some of the larger darker areas. (Your lines should be much lighter than the example shown here.) If you're working closely with a reference photo, use lines to block in the main dark areas.

With a soft pencil, such as a 4B, apply some of the darkest values using a series of overlapping strokes that are tapered on both ends. It's a good idea to practice this type of stroke on a separate piece of drawing paper.

Using a 2B for darker values and an HB for lighter values, apply tapered, overlapping strokes that follow the basic flow of hair. Create the darker and lighter values within the hair, which will give it a three-dimensional feel. Remember that it's not necessary to draw every strand of hair. For the highlighted areas, simply leave the white of the paper exposed.

For more interest and realism, you can use a click pencil eraser that has a trimmed, sharpened edge to create some wayward light strands of hair. Using a tortillon or stump, finish with some light blending if needed, especially in the darker areas.

8 | Straight Hair in Charcoal

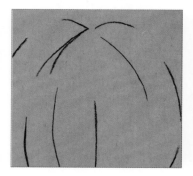 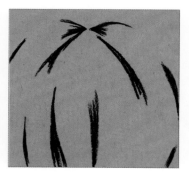 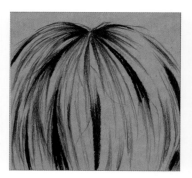

This example uses tan-toned paper, but you can use the paper color of your choice. Toned paper provides a middle value that will help bring out any white charcoal pencil used for lights and highlights. With a soft charcoal pencil, such as a 3B, draw lines to show the flow of the straight hair. The lines shown here indicate where some of the darker areas of value will be.

With the same soft pencil, use tapered strokes and fill in areas to first establish the darkest values of the drawing. Similar to graphite, establishing the darkest values first can help you better see where the other values are needed.

Using a hard-grade charcoal pencil, such as a 2H, use long, tapered strokes to create the strands of hair. Apply more or fewer strokes depending on the darkness, lightness, or thickness of the hair you want to depict.

Using a white charcoal pencil, use tapered strokes to add highlights where needed. Create a few wayward strands of hair using both the 2H charcoal and white charcoal pencils to add more interest. Blend lightly where needed.

To create an accurate sketch of your subject, consider transferring a drawing. Print out a copy of your reference photo, coat the back of the paper with graphite, and place it over a clean sheet of drawing paper. (You can also use graphite transfer paper.) As you trace over the drawing, the lines will transfer to the clean paper below, revealing a light outline.

9 | Eye in Graphite

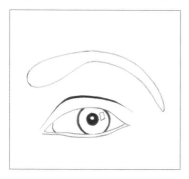

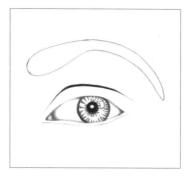

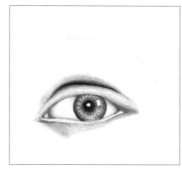

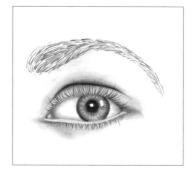

Block in the basic shape of the eye using light lines. Use a 4B pencil to apply the darkest values, such as the eyelid and pupil. Outline white highlights in the pupil and iris, and keep them white as you develop the rest of the eye.

Irises vary from eye to eye. Create a break in the tapered lines between the inner and outer edges. Use HB and 2H pencils to shade the "white" of the eye with small, circular strokes.

With 2B, HB, and 2H pencils, continue using small, circular strokes to add various values around the eye. Notice the gradation of tones. Using the HB and 2H pencils, create different values within the iris.

Lightly blend the skin, "white" of the eye, and iris. Then use tapered strokes to create the eyelashes and eyebrow. The eyelashes and hairs of the eyebrow differ in length and vary somewhat in their direction of growth.

10 | Nose in Graphite

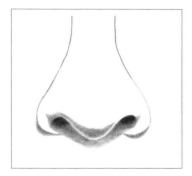

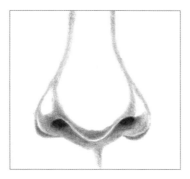

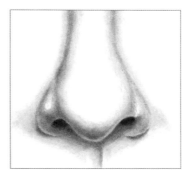

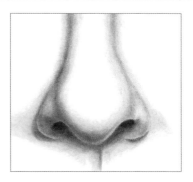

Begin by outlining the nose's basic shape with very light lines. Using a 4B and overlapping circular strokes, fill in the dark nostrils. Then use a 2B pencil to shade the next darkest areas using small, overlapping circular strokes. Lightly blend your strokes.

Continue using the 2B to develop tone on the nose with small, circular strokes. Leave a thin, light edge under the nose to show reflected light. Always look for reflected light on facial features; these subtle changes in value will help create contrast and depth.

Using an HB pencil, start developing the 2B areas with overlapping circular strokes and move outward to create a gradation for the shadows around the nose. Leave the white of the paper to suggest highlighted areas on the sides and tip of the nose.

To finish, apply some light blending, but avoid blending away all the realistic texture. After blending, recover some of the darkest values using 4B or 2B pencils.

11 | Lips in Graphite

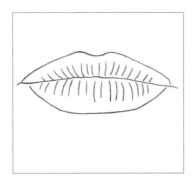

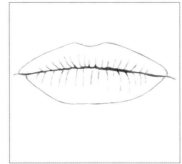

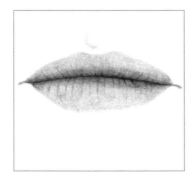

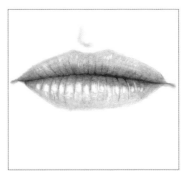

Very lightly draw the basic shape of the lips using a hard-grade pencil, such as a 2H. (The example shown here is drawn darker for demonstration purposes.)

Using a soft-grade pencil, such as a 4B, apply a dark value where the lips come together. Notice how the dark values extend into some of the lines or creases in the upper and lower lips.

Using a 2B and small, overlapping circular strokes, work your way out from the darkest areas to create a gradation, changing to an HB and then a 2H for the lighter areas. Move along the length of the upper and lower lips.

With a click pencil eraser, remove graphite to create highlights on the lower lip and a few subtle highlights on the upper lip. If desired, lightly blend with a stump or tortillon.

ANIMALS

12 | Smooth Canine Fur in Charcoal

This example shows a textured, toned charcoal paper. Using a soft 3B charcoal pencil, establish the darks with short, tapered strokes. A soft charcoal pencil dulls quickly on textured paper; turn the pencil as you work for finer lines.

Using an HB charcoal pencil, begin your strokes in the darkest areas and taper the ends. Vary the direction of some strokes slightly for realism, as fur never grows perfectly parallel.

Continue developing the fur with light, short, and tapered strokes of 2H charcoal pencil.

If desired, you can add tapered strokes of white charcoal pencil to further bring out highlights.

13 | Curly Canine Fur in Graphite

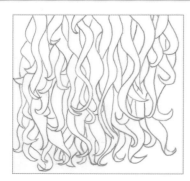 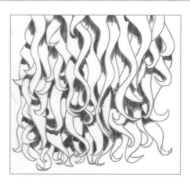 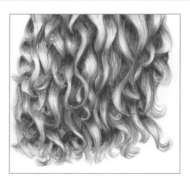 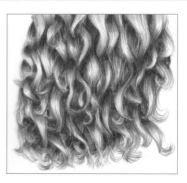

Some dog breeds have curly, human-like hair, so the drawing technique is very similar. This example shows the curly fur of an Irish Water Spaniel. Begin by drawing the basic shapes of the curls using a 4H pencil.

Establish the darkest areas of value using a 4B pencil, stroking in the direction of hair growth.

With 2B and HB pencils, use tapered strokes to create progressively lighter fur. Allow the white of the paper to serve as the highlighted areas of the curls. Remember that you don't need to draw every strand of fur.

To finish, lightly blend your strokes with a tortillon or small stump. With a click pencil eraser trimmed at sharp angle, pull out some wayward fur and enhance highlights as needed.

14 | Coarse Canine Fur in Graphite

 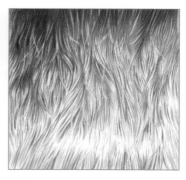

This example shows the coarse fur of a wirehaired dog breed. Use a 4B pencil to boldly build the darkest areas. Leave some white paper exposed to indicate light hairs mixed with dark hairs. Randomly applied strokes will contribute to the wiry texture.

Using a 2B or HB pencil, continue applying the same bold, random strokes as in step one. Within the lighter areas of the coat, allow more of the white paper to come through for realistic highlights. Taper each stroke at the end for a realistic touch.

Switch to a harder, lighter pencil for more highlighted areas as needed. In this example, see how using few strokes (or none at all) allows more of the white of the paper to show through, creating the illusion of highlights.

To finish, use light blending to tone down some of the lighter individual hairs in the darker area. Using a click pencil eraser trimmed at a sharp angle, create additional strands of wayward hairs. You can use a pencil to shade one side of these highlighted hairs for more depth and realism.

15 | Canine Nose in Graphite

 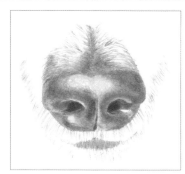 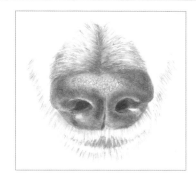

Canine noses have a basic shape, but they can vary depending on the dog breed and size. Also, noses can range from very dark to very light in color. To begin, draw the basic shape of the nose lightly with a 2H or 4H pencil.

Now apply the darkest values of the nose using a 4B pencil. Establishing the darkest values first will help you better judge the remaining values.

Use a 2B and small, overlapping strokes to build outward from the darkest values of the nose, switching to an HB to create a gradation. Use a 4H for the highlighted areas of the nose. To create the fur around the nose and mouth, use HB and 2H pencils.

All canine noses share a distinct, bumpy texture. For this nose, use a 2H pencil to draw an irregular pattern in the highlighted area and blend lightly. Use a stick eraser cut at a sharp angle to create lighter whiskers around the mouth.

16 | Canine Eye in Graphite

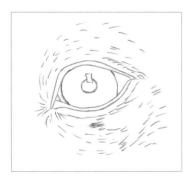 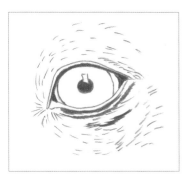 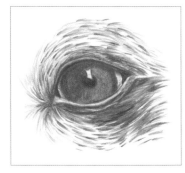 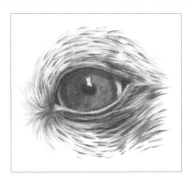

Very lightly draw the outline of the eye and the basic direction of the surrounding fine fur. Delineate the reflection of light so you can keep it free of tone. (Always include a reflection to give the final drawing more depth and realism.) Canine eyes vary depending upon the breed, so it's a good idea to study a high-quality reference photo as you draw.

Establish your darkest values using a 4B or 6B pencil, which will help you set up a drawing with a good amount of contrast.

The iris is darkest along the outer edge and lightest near the pupil. Replicating this will give the eye depth and dimension. Create the edge using small, overlapping circular strokes and a 2B, switching to HB for the lighter areas and using the white of the paper for the reflection. Shade any "white" of the eye that shows with a 2H, as well as the upper and lower lids. Then build the fur with 2H and 2B pencils.

If desired, lightly blend with a small stump or tortillon. Try not to over-blend, which can soften some of the sharper, finer lines that should remain crisp. Use a stick pencil eraser with the tip trimmed at an angle to create any subtle, fine reflective areas in the eye.

The "white" of an eye is never truly white! For a realistic look, always think of it as gradations of tone.

17 | Cat Eye in Graphite

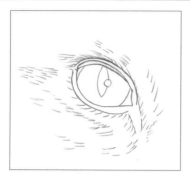 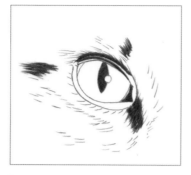 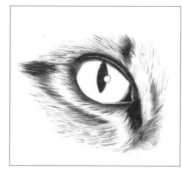 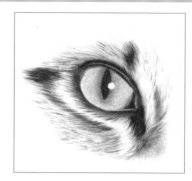

Using very light pressure, outline the structures of the cat eye and sketch in some lines showing the direction of the fur around it. (The lines shown here are dark for demonstration purposes; your lines should be much lighter.)

With a 4B pencil, fill in the darkest areas of value. With the darkest value established and the white of the paper as a guide, you'll have a better sense of where other values belong. Use overlapping, tapered strokes to add fur around the eye.

Now use a 2B and an HB to develop the structures around the eye, creating hairs with tapered strokes. Remember that it's not necessary to draw each strand of hair. Allow the white of the paper to serve as highlights in the fur.

Using 2H and 4H pencils, apply overlapping circular strokes, starting with the darker areas in the iris (2H) and moving to the lighter areas (4H). Lightly blend with a tortillon. Then lightly blend the areas around the eye and fur.

18 | Short Cat Hair in Graphite

 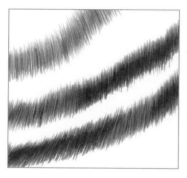 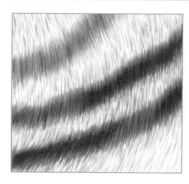

In this example of short cat hair, the stripes can help you understand the techniques of creating both light and dark fur. When drawing an animal with stripes, start by lightly outlining the main values, following the curvature of the animal.

As an example of how the stripes can be of different values, two of the stripes are shown as darker in value and the third (top) as lighter. For the darker stripes, use a 4B pencil; for the lighter stripe, use a 2B. Apply overlapping, tapered strokes.

Continue adding tapered strokes between the stripes with a lighter pencil, such as an HB. Make the strokes dense in dark areas and sparse in light areas. Avoiding drawing each individual strand of fur, and vary the direction of some strokes for a more realistic look.

To finish, add random, dark, and thin strokes to the fur for more depth. Very minimally blend with a stump or tortillon. Use your pencil eraser or a kneaded eraser to enhance or create more highlighted areas for more contrast.

19 | Long Cat Hair in Charcoal

Using a soft charcoal pencil, such as a 3B, draw areas of dark value. Long cat hair can appear tangled, so the strokes should not be perfectly parallel. Most of the tapered strokes form a narrow "V" shape, which indicates the deeper areas of shadow within the fur.

Use a hard-grade charcoal pencil (or lighter pressure) to create long, tapered strokes through the dark areas. Curve the strokes for a wavy flow. Avoid drawing individual strands of fur; suggest the appearance of fur using just a few light and dark strokes.

For more contrast and detail, use a white charcoal pencil to fill in areas between some of the strokes, which will lighten and highlight the fur. Again, use strokes that taper at each end.

To finish, return to darken areas with a soft charcoal pencil for more contrast and depth. Using a stump, lightly blend areas that need a softer look, or darken some areas by pushing the charcoal into the tooth of the paper for more contrast.

20 | Horse Coat in Graphite

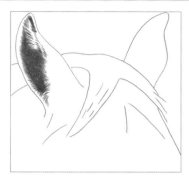 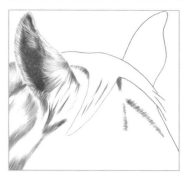 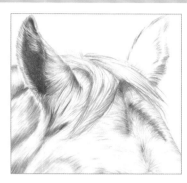 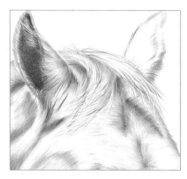

This texture shows a close-up example of a short, smooth horse coat. Start by outlining the basic structures of the horse's head with a 2H or 4H pencil. Use tapered strokes as indications of hair in the ear.

Using a 2B pencil, fill in the light values using short, tapered strokes. As you stroke, be sure to follow the curves of the anatomy and note any other ways that fine hair grows on a horse.

Using an HB pencil, complete the lighter values using the same tapered strokes. Keep the strokes sparse in highlights and lighter areas of the horse's coat.

Using a stump or tortillon, blend your strokes to give the hair a smooth appearance. Then use a click eraser with the tip trimmed at a sharp angle (roughly 45 degrees) to pull out highlights. To finish, darken any areas that lost value when blending.

21 | Horse Mane in Graphite

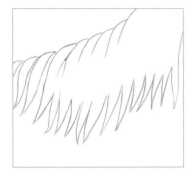 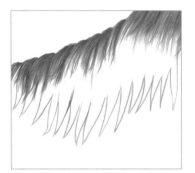 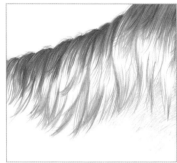 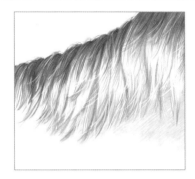

Begin by outlining the horse mane using very light lines. The outline can be a simple, rough indication of the mane's general shape and location. (The lines shown here are dark for demonstration purposes; your lines should be much lighter.)

With a 4B pencil, apply long, tapering strokes close together to build up the areas of darkest values. Notice that not all of the hair is flowing in the same direction; some strands appear slightly windblown for a realistic touch.

Continue with a lighter (harder) pencil, such as an HB, to draw more of the mane. Use long strokes and tapered ends. Remember not to draw every single hair, and always allow some white of the paper to indicate highlights.

Finish with light blending, and use a trimmed pencil eraser to pull out some final highlights.

22 | Horse Mane in Charcoal

 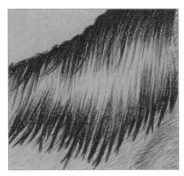 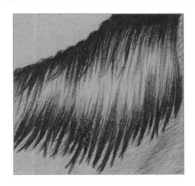 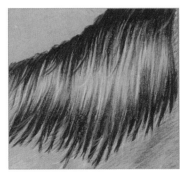

Begin by lightly outlining the general shape of the horse mane. To create a lighter line than shown here (as you would do for a light-colored mane), use a hard-grade charcoal or even a light graphite pencil for this step.

Horse mane hair is similar to human hair. Using a soft charcoal pencil, such as B or HB, establish the darks. Then use a harder charcoal pencil to create the lighter, finer hairs. Begin your strokes in the dark areas, and taper them at the ends. Use short, light strokes for the horse's coat.

The texture of charcoal paper can be rough, which causes some of the paper to show through a stroke. To cover these bits of paper, you can blend with a stump. However, sometimes the textured strokes of charcoal paper produce a desirable effect.

At this point, you can use a white charcoal pencil to bring out even more highlights and lighter individual hairs.

23 | Elephant Skin in Graphite

If you have recently visited the elephants at your local zoo, you may have noticed how wrinkled their skin appears. Drawing their skin is similar to drawing wrinkled human skin. Using a 4B pencil, begin by drawing the wrinkles.

Continue using the 4B pencil for the darkest values of the drawing, working with overlapping, circular strokes. Use tapering strokes for more dimension, but feel free to be loose and irregular, which will add to the sense of realism.

Using a 2B pencil, work outward from the darkest areas to create a subtle gradation. As you stroke, use less pencil pressure to create lighter values. Use overlapping circular strokes, and don't try to be perfect. Then draw additional, lighter wrinkle lines.

Now lightly blend your strokes. Some of the darkest areas may need another layer of graphite after blending to recover the darkest values for good contrast. To finish, use a kneaded eraser to bring out more highlights.

24 | Zebra Coat in Charcoal

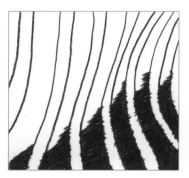

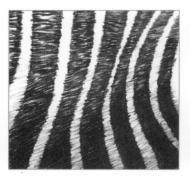

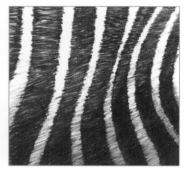

The zebra's very short coat has a striped pattern that is unique to each individual. As with other animals with short coats, the pattern follows the form of the body. Begin by outlining the pattern of stripes using a 2H charcoal pencil.

Then use a 3B charcoal pencil to establish the darkest values, using hatch marks to indicate the individual hairs. Having the darks and lights (the white of the paper) in place will help you effectively determine any remaining values.

Use progressively lighter charcoal pencils, such as B to 2H, to gradually lighten the stripes by stroking from the shadow into the highlights. Leave more space between the hatch marks as you move toward the highlights. For more depth, further darken the whites in shadow by lightly hatching hairs.

To finish, lightly blend the stripes, particularly within the areas of shadow.

25 | Leopard Coat in Charcoal

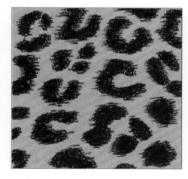

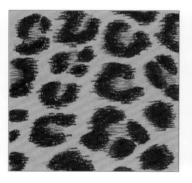

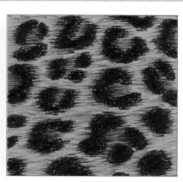

This charcoal example features tan-toned charcoal paper. Begin by lightly outlining the leopard's spots using a 2H or an extra-hard charcoal pencil. You'll notice that some of the spots are actually various shapes, with some resembling the letters "C" and "U."

Using a soft 3B charcoal pencil, fill in the spots using strokes that indicate the direction of fur growth. Charcoal paper is generally a rough surface with plenty of "tooth," so some of the paper will show through the strokes for a broken (but desirable) appearance.

With an HB charcoal pencil, fill in the centers of the spots with tapered strokes so they appear darker than the surrounding fur. With an extra-hard charcoal pencil, create light, tapered strokes to show fur around the spots. You don't need many strokes; you'll want plenty of paper to show through.

Next, lightly blend the spots and add some highlights using a white charcoal pencil and tapered strokes. For a realistic look, remember to vary the strokes of fur rather than make them perfectly parallel.

26 | Burlap in Graphite

 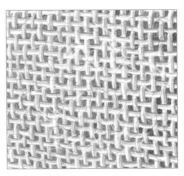

Using a hard-grade pencil, such as a 2B, lightly draw a basket weave pattern. The individual threads of the weave vary in thickness, so there is no need to be perfect.

You can leave the background as the white of the paper if desired. In this example, however, a 2B pencil over the background provides more contrast.

With an HB pencil, apply simple hatch marks to just one side of each horizontal and vertical thread. This gives the appearance of light hitting it from one direction, creating depth.

If desired, lightly blend the threads with a small, fine-tipped tortillon, but avoid blending away the individual hatch marks. For fine details, use an HB pencil to create darker fibers and a stick pencil eraser with a sharply trimmed point to create lighter fibers.

27 | Tweed in Graphite

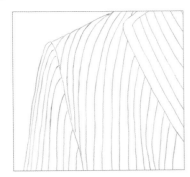 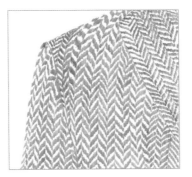 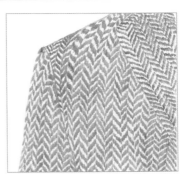

Tweed is a thick, woven fabric used primarily in suits and coats. This sturdy material is also available in a variety of patterns. This example features a "V" or herringbone pattern. Outline the basic flow of the pattern using light lines.

Using a 2B or 4B pencil, roughly draw the individual "V" pattern to represent the thick, darker woven threads of the fabric. Apply this pattern following the basic curves of the coat.

With a lighter 2H pencil, draw a few lines in between the thicker, darker strokes to indicate lighter threads of fabric.

Using a 4B pencil, create the dark areas of shadow around the coat, lapel, and arm. Lightly blend the shadowed areas and the coat's pattern.

28 | Denim in Graphite

This example shows a fairly simple method for drawing denim fabric with a basic seam. Begin by drawing a light outline of your subject. (The lines shown here are much darker for demonstration purposes.)

Use a 4B to lay in long, tapered strokes following the curve of the seam. Allow white of the paper to show through between strokes, especially in the lightest areas. For the seam, create high (light) and low (dark) spots that occur as a result of the stitching.

There are two ways to create cross-stitching on the denim fabric. You can use perpendicular strokes with a 4B pencil over existing strokes, or (shown here) you can use perpendicular strokes using a click eraser cut at a sharp angle to create thin, light lines that resemble light threads.

To finish, use a small stump or tortillon to blend along the sides of the seam and stitching, along with the darker areas between the stitching. Use the white of the paper to represent the lightest areas of the seam and fold.

29 | Leather in Graphite

 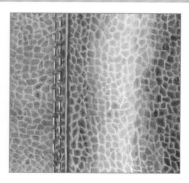

Leather comes in a variety of textures, from smooth to rough. This example of rough leather includes a seam and stitches. Begin by creating an outline with light strokes. (The lines shown here are darker for demonstration purposes.)

Using different hardnesses of pencil (4B, 2B, and 2H), create small, irregular shapes that resemble puzzle pieces placed closely together. For highlights, use light pressure and a 2H. Use small, overlapping, circular strokes and scribbling for a rough texture.

Use a 4H pencil and light, vertical strokes to coat the drawing, avoiding the stitches and areas of highlight. This will add tone overall and darken the areas between the shapes. Add shadows along the stitches and seam for depth and detail.

Using a stump, lightly blend around the seam and over the leather to even out the tone and smooth out pencil strokes where needed. Also, lightly blend both sides of the highlighted area (down the center) to give it more of a gradual tone.

30 | Leather in Charcoal

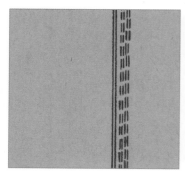 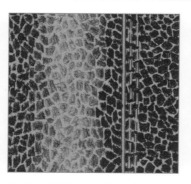 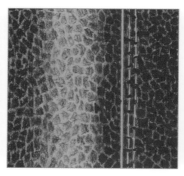 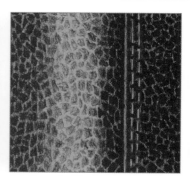

For this example of rough leather in charcoal, begin with a gray- or brown-toned paper. Use light strokes to outline the seam and stitches. (The lines shown here are darker for demonstration purposes.)

Use B and HB charcoal pencils for the darks, plus an extra-hard charcoal pencil to define the irregular shapes within the highlight down the center. The irregular shapes should resemble puzzle pieces separated by small gaps. Stroke loosely and allow the tooth of the paper show through.

To tone down the spaces between the irregular shapes, use an extra-hard charcoal pencil. Coat the leather with vertical, closely placed strokes, working around the seam, stitches, and highlighted areas.

To finish, use the extra-hard charcoal pencil to shadow the ends of each stitch, and use it to tone the seam. Lightly blend areas with a stump to deepen tone where desired, pushing the charcoal deeper into the tooth of the paper.

31 | Silk in Graphite

 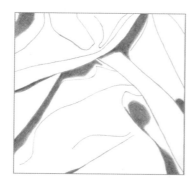 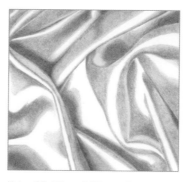 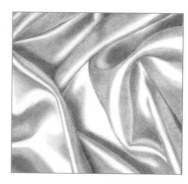

Silk has a very smooth texture that reflects light, which makes it important to pay careful attention to highlights and areas of reflected light. Outline the basic shape of the fabric with light lines (much lighter than shown in this example). You can add more guidelines as the drawing progresses.

Now add the darkest values using 6B or 4B pencils. Apply small, light, circular strokes, covering as much of the paper as you can. To soften some of the hard edges, lighten your pencil pressure as you move away.

Using 2B, HB, and 2H pencils, develop folds of silk using values of light and dark, working in small, overlapping, circular strokes. Use the white of the paper to represent highlights on this reflective fabric. For light values, use a harder pencil. Consider testing values on a separate sheet of drawing paper.

Use a small stump to blend along the reflected light of the folds and a larger stump to blend the shadows. As you move outward, create light shadows using the graphite-coated stump. Create more contrast by touching up with graphite where needed. Use a 4H pencil to create a dark, even tone.

32 | Knitted Yarn in Graphite

 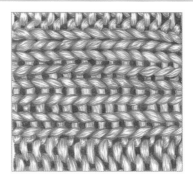 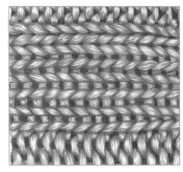

This example of a knitting design shows one of many possible techniques. Begin by outlining the pattern with light strokes; you can always darken the lines as the drawing progresses, if needed.

Using a 4B pencil, fill in the darkest values of the drawing to create a sense of contrast. Use the darks as a gauge for determining subsequent values.

To indicate the fibers of the yarn, use a 2B pencil and short, tapered strokes that follow the curves of the strands. Maintain a sharp pencil point as you apply the strokes, and work around the highlights on each strand.

With a small stump or tortillion, lightly blend throughout to give the knitted design a little bit of a smoother look.

33 | Chunky Wool in Graphite

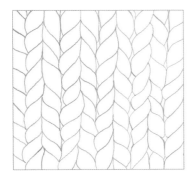 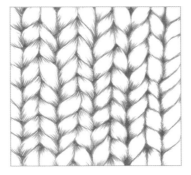 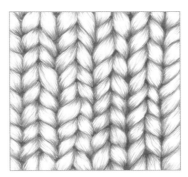

Begin drawing this thick wool by lightly indicating the pattern of your knitted object. (The lines shown here are dark for demonstration purposes; your lines should be much lighter.)

Using a 4B pencil, fill in the areas of shadow. Switch to a 2B pencil and draw outward from the shadows, creating dark, tapered strands of wool. Follow the curves in the yarn, but avoid being too perfect; chunky wool yard often looks loose and tangled up close.

Using a 2H pencil, create lighter strands in the yarn. Again, start your strokes in the darker areas and work outward, leaving the ends of the shorter strokes tapered. Avoid drawing too many strands in the highlights. Let the white of the paper come through to give depth to the drawing.

Lightly blend with a stump or tortillon, working mainly in the darkest areas to smooth transitions from shadow to light. Use the graphite on the stump or tortillon to add soft, light tone to other areas as needed.

34 | Lace in Graphite

 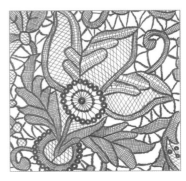

Because this black lace requires a dark tone, use a 4B pencil throughout the drawing. Work out the basic outline on a separate sheet of paper; then transfer it to your drawing paper. For notes on transferring a drawing, see page 20.

If you look at lace closely, you'll notice the basic outline is made up of tiny threads woven together. Continuing with the 4B pencil, use very small, circular, overlapping strokes to thicken the lines for a woven look.

To create fine webbing, use a sharp, fine point to apply criss-crossing strokes over areas of the design. In some areas, follow the curves of the design with your strokes. Leave the flower petals free of the criss-crossing pattern for interest. Fill in the dots and small "donuts" of the design.

For more contrast and variety, use a larger criss-cross design in some areas. Keep your strokes clean and avoid blending as you create this fine, delicate subject.

FABRICS & TEXTILES

35 | Straw Hat in Charcoal

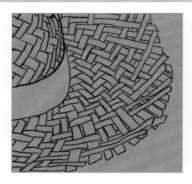

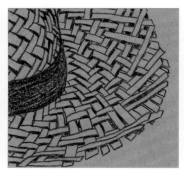

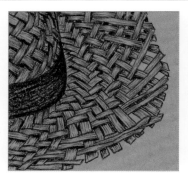

Tan charcoal paper is an ideal choice for this subject. As you begin, note that straw hats are similar in structure to woven baskets (see below). Lightly sketch the outlines with pencil, followed by a hard charcoal pencil, such as a 2H, to create thin, light lines.

Switch to a softer charcoal pencil, such as a 3B, to fill in the shadows around the weaves. Next, with the same pencil, use long strokes to follow the curvature of the hat's band.

Return to the 2H charcoal pencil to create the grain of the weaves with thin lines. Between each stroke, rotate the tip of the pencil so you are always working with a sharp end.

To finish, add some highlights to the drawing by applying strokes of a white charcoal pencil over the raised parts of the weaves and along the band.

36 | Woven Basket in Graphite

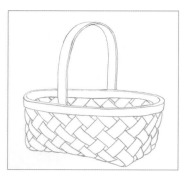

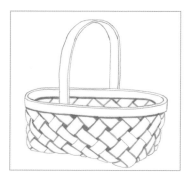

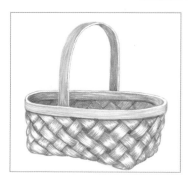

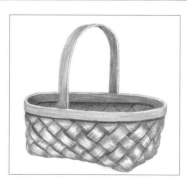

To begin this woven texture, draw the outline of the basket using light strokes. (The lines shown here are darker for demonstration purposes.)

With a 4B pencil, fill in the areas between the weaves. Use a 2B to thicken any lines where the weaves cross over one other, suggesting slight shadows. Also, still using the 2B, draw a thin shadow below the top rim of the basket.

For the basket's exterior, use an HB pencil to draw tapered strokes coming out from both sides of the weaves, avoiding highlights. For the interior, use a 2B and closely placed hatch marks to push it into shadow. For the rim and handle, apply long strokes that follow the form and simulate the grain.

Use a small stump to blend your strokes, focusing on the areas in shadow such as the handle, rim, basket interior, and areas where the weaves intersect. To finish, maintain contrast in the drawing by darkening any areas that have lightened during the blending process.

37 | Cork in Graphite

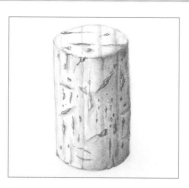

This example features cork from a wine bottle. Begin by drawing a basic cylinder, making sure the ellipse is symmetrical to represent the cork top viewed from an angle.

Use an HB pencil and overlapping circular strokes to create a shadow along the right side. This will serve as the basis for its three-dimensional appearance.

Some corks are fairly smooth and some have character, such as this one. To create imperfections across the surface, use sharp pencils of various hardnesses to create nicks and cracks. Some of the imperfections may be deep, creating shadows and highlights.

Using graphite already embedded in a small stump, smooth out some areas of the cork and create subtly darker areas across the surface.

38 | Beveled Glass in Graphite

Use a ruler to draw square angles and an oval template (or simply work freehand) to create the center shape. Use very light lines to develop the beveled areas of glass, but switch to a 4B to thicken the lines representing the window's lead strips.

With a 2B pencil, create the darkest reflections in the window. This will provide a gauge for adding later values. Use overlapping, circular strokes for an even tone. For a realistic look, leave a slightly lighter edge between the glass and lead strips.

Using HB and 2H pencils, create the lightest values within the reflection. Leave some of the paper white to suggest the lightest reflections.

Use a small blending stump to blend as evenly as possible. You may need to reapply graphite to recover any darks that have lightened during blending. You can also create areas of lighter reflections by removing tone with a click pencil eraser.

39 | Clear Glass in Graphite

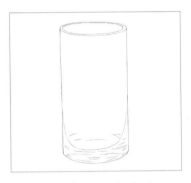 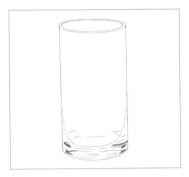 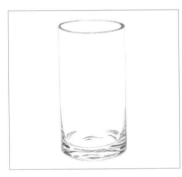 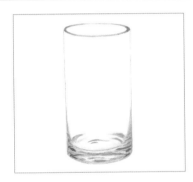

This example features a basic clear drinking glass in simple lighting. Begin by outlining the subject with light strokes, including the various distorted reflections that show through at the base of the glass for a realistic touch.

With a 4B pencil, lay in the darkest values found in the distorted reflections at the base of the glass.

Using HB and 2H pencils, fill in subtle variations of tone around the base and rim of the glass.

Using a small, sharp-tipped blending stump, blend the base and rim so they appear smooth. In cases where the 2H pencil may be too dark, you can use the tip of the stump to place light tone on the drawing paper.

40 | Porcelain in Graphite

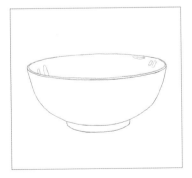 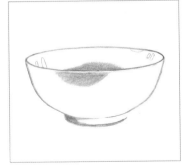 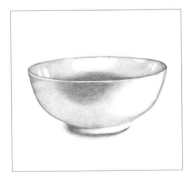 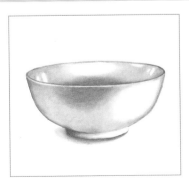

Porcelain is a delicate ceramic baked at a high temperature. This bowl has a smooth, white finish. Start with a light outline. Include outlines of the small reflections with very light, erasable lines, which will later serve as highlights. (The lines shown here are darker than yours should be.)

With an HB pencil and overlapping circular strokes, create a thin line of tone around the rim of the bowl for depth. Also, still using the HB pencil and overlapping circular strokes, create areas of darker shadow on the inside of the bowl, on the outside of the bowl, and on the base of the bowl.

With a 2H pencil and overlapping strokes, work around the small and large highlights on the bowl as you add a middle value. Then create a cast shadow and add some lighter shadows around the base.

Finish by using a stump to smooth and blend all areas of the bowl. A larger stump with a well-used blunt end works well to create a smooth finish for this subject. Alternatively, you can create ultra-soft blends with the tip of a folded tissue.

41 | Polished Silver in Graphite

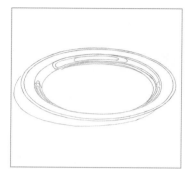

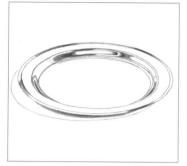

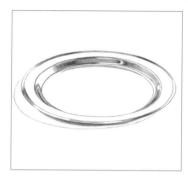

A reflective subject like this involves complex shapes with plenty of changes in value. When creating the initial sketch, use very light lines. (The lines shown here are darker for demonstration purposes.)

Using a 4B pencil, apply the darkest values with overlapping circular strokes. Switch to a 2B and apply a lighter value. Again, use overlapping circular strokes, beginning in the 4B areas and working outward to create a gradation.

Now use an HB pencil and overlapping circular strokes to add another lighter value, again working outward from the areas of 2B.

With a hard 2H pencil, finish the reflective areas using overlapping circular strokes. Then add the plate's cast shadow. For this subject, blend with a tortillon everywhere except the plate's center. For the center, blend with a large stump that is already coated in graphite; then blend with tissue.

42 | Clay Pottery in Graphite

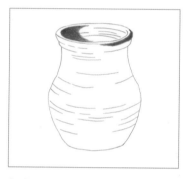

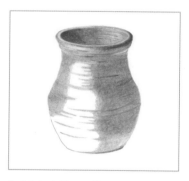

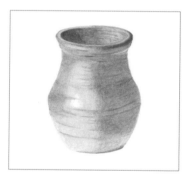

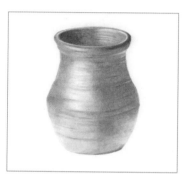

Outline the pottery's main shapes. The exterior should not be perfectly smooth; reflect this in the outline as you follow the pottery's curves. Apply the darkest values, which will provide a gauge for applying subsequent values. For this step, use a 4B pencil with overlapping circular strokes.

Switch to a 2B pencil and use overlapping circular strokes to add slightly lighter values, blending out from the areas of 4B to avoid a visible transition. Then darken the lines over the pottery. Working in overlapping circular strokes will help you retain the rough texture of pottery.

Now switch to an HB to build lighter values, working outward from the areas of 2B for a smooth gradation. Use the HB to thicken the pottery's lines so they show through subsequent values. Using a 2H and overlapping circular strokes, fill in the light areas, gradating as you move away from the darks.

Lightly blend using a large stump, being careful to allow the lines and some texture to show through. Use a kneaded eraser to pull out more highlights for depth, contrast, and a three-dimensional appearance. To bring out highlights around the lip of the pot, use a click pencil eraser.

43 | Rusted Steel in Graphite

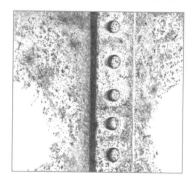

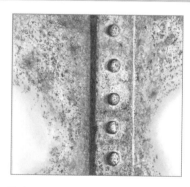

Drawing realistic rusted steel is simple, requiring a combination of stippling and scribbling strokes. To begin, draw the outline of your subject with light lines. This example of rusted steel could be part of an old, abandoned ship door held together with rivets.

To establish contrast, use a 4B pencil to create the darkest shadows. Use a thin crescent moon shape to suggest the domed form of each rivet.

To suggest pitting and rust, apply stippling (small dots) and overlap it with small, scribbling strokes. Vary the concentration of your stippling to make some areas lighter and some darker, and vary the lightness and darkness of your patches of scribbling as well for interest and realism.

To finish, blend random areas while leaving some as they are for variation and interest. You may need to revisit some areas to create more texture or contrast after blending, as the blending process can lighten the overall tone.

44 | Stucco in Graphite

Stucco is a type of cement that is applied to the exteriors of some houses and buildings. This example features just one style (or finish) of stucco. Begin by drawing different sizes of random forms. Use very light, easily erasable lines.

Choose the side from which the light will shine. Then, with an HB pencil, draw a very thin shadow line on each shape, opposite the side of the incoming light.

Continuing with the HB pencil, stipple in the areas between the main shapes. Make the stippling somewhat random.

Use a sharp-tipped tortillon or stump to lightly blend the thin areas of shadow. To finish, use an older stump or tortillon to "draw" across the stucco, leaving wide, light lines to indicate trowel marks for realism and interest.

45 | Brick in Charcoal

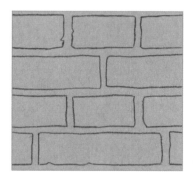 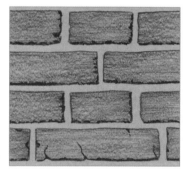 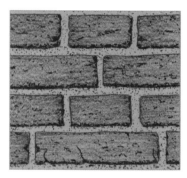 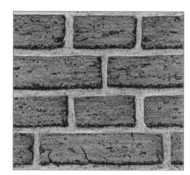

Working on charcoal paper, draw the outlines of your bricks using light pencil or a 2H charcoal pencil.

Using the side of a piece of 2H charcoal or the side of the tip of a 2H charcoal pencil, cover the face of each brick. The "tooth" of the paper will give the bricks texture. Using softer charcoal, apply a thin, rough shadow on each side of the brick. Add random cracks in the bricks.

With the 3B charcoal pencil, add some stippling to both the mortar and the faces of the bricks.

Depending upon the tone of your paper, you may want to add light strokes of white charcoal pencil over the mortar for more contrast.

46 | Weathered Brick in Graphite

 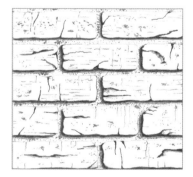 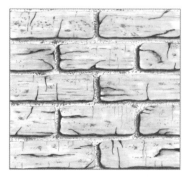

Start with a lightly drawn outline of a brick wall. (The lines shown here are darker for demonstration purposes.) Because these are old bricks, they have rounded corners that show wear.

Old bricks feature cracks and imperfections. Use a 4B pencil to indicate the shadows of cracks. Still using the 4B, apply the dark shadows of the bricks. Note: The lines indicating the edges of brick not in shadow should be light, increasing contrast and depth in the finished drawing.

With an HB pencil, create more light cracks in a random fashion. Then add pitting and stippling on the faces of the bricks and within the mortar. Use the HB pencil to draw a light, thin edge of shadow coming out of the deeper cracks and along the dark shadows on the brick edges, suggesting depth.

With a small stump, lightly blend the shadows around the brick edges. With an older stump already coated with graphite, lightly blend the face of each brick to smooth the texture and add tone. For a darker value, add graphite powder (saved from pencil shavings) to the end of the stump.

47 | Cobblestone in Graphite

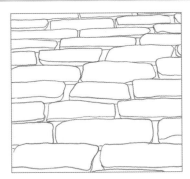 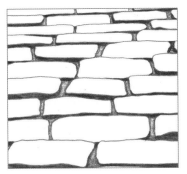 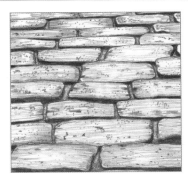 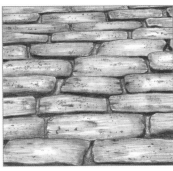

Some cobblestone pathways can appear very old and weathered, full of cracks and rounded corners. To begin, outline the pathway in perspective as it relates to the viewer. Also, think about where the shadows will fall.

Fill in the darkest areas of shadow with a 4B pencil. In the areas between the bricks, suggest mortar and dirt by lightly scribbling with an HB pencil.

With a 2B pencil, create some small cracks, lines, and stippling on the surface of the bricks. Use an HB pencil and long, light, tapered strokes across the surface of the bricks to give them contrast. Leave the centers of some bricks free of tone to suggest depth.

To finish, very lightly blend the bricks. Allow some of the pencil strokes to show through to give the bricks a little surface texture.

48 | Rock Wall in Graphite

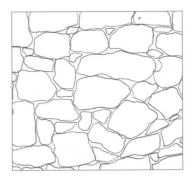 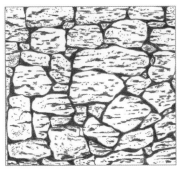 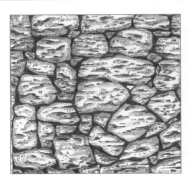

To begin, outline the basic shapes of the rock wall. In drawings like this, you can use a reference photo or rely on your imagination. Note: It's a good idea to carry a camera often and collect photos of various textures, which you can use as future references.

Using a 4B pencil, fill in the darkest areas of shadow between the individual rocks. Switch to a 2B pencil and create random crack shadows and crevices on the faces of the rocks. Further texture them with some stippling.

With an HB pencil, add lighter shadows to the cracks and crevices, and create shadows around the edges of each rock to suggest depth.

With a small stump, lightly blend the shadows added with the 2B and HB pencils.

49 | Wrought Iron in Graphite

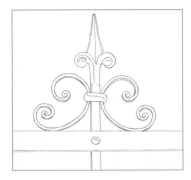 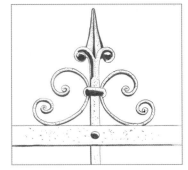 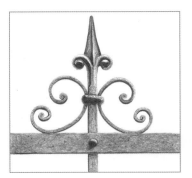

Wrought iron, which is often used in fences and gates, generally comes in black or brown. This example features a simple design in black wrought iron. Begin with a light outline; the lines shown here are darker for demonstration purposes.

Using a 4B, fill in the darkest values first. Add some stippling to suggest small defects and occasional rough areas for interest. For especially weathered and rusty wrought iron, add more imperfections.

Use loose, overlapping strokes (or scribbling) to fill in the wrought iron's surface. Switch between 2B and HB pencils for varying values. To show the direction of light and suggest depth, allow the white of the paper to serve as the highlight on a few areas.

To finish, use a medium to small stump or tortillon to blend and smooth your strokes. Use less blending to suggest rougher wrought iron. To create more areas of highlight throughout the design, lift graphite with a kneaded eraser, always keeping in mind the direction of light.

50 | Smooth Wood in Graphite

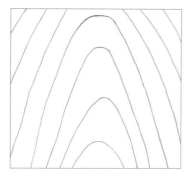 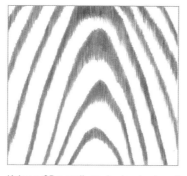 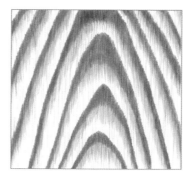

When cut and sanded, wood can produce a variety of beautiful patterns and textures. To re-create this basic wood texture, begin by outlining the rings with very light lines. (The lines shown here are darker for demonstration purposes.)

Using a 2B pencil, apply closely placed short, vertical strokes that follow the arch of the rings. Notice how the thickness of each arch varies from the sides to the top.

Using an HB pencil, apply more vertical strokes downward from the initial lines created in step two. Vary your stroke length, applying both long and short strokes to create the appearance of a subtle gradation of tone from the top of the each arch.

Finally, blend with a tissue folded to a narrow triangle. Some of the pencil strokes should still show through after blending to retain the realistic look of wood grain.

51 | Aged Wood in Graphite

 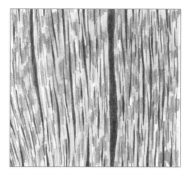

Begin by drawing the large and small cracks on the surface. Use a soft 4B pencil for this step, as these lines will later be in shadow. Continuing with the 4B pencil, widen some of your lines and fill in the cracks. Leave tapered ends on each crack to indicate the splitting of the wood.

With a 2H pencil, apply long strokes to indicate light wood grain. Note: When creating long strokes, it's best to keep your wrist steady and move your arm at the elbow.

Using an HB pencil, apply tone to suggest patches of discoloration. When drawing wide strokes such as these, hold the pencil at a steep angle to the paper, working with the side of the graphite rather than the sharp tip.

To finish, lightly blend the patches and some areas of the wood grain.

52 | Aged Wood in Charcoal

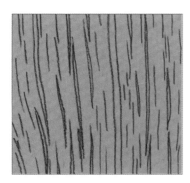 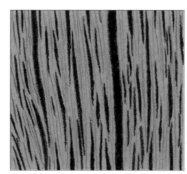 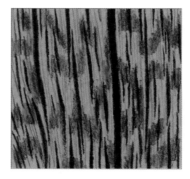

Draw the large and small cracks on the surface using an HB charcoal pencil. Continuing with the HB, widen your lines and fill in the cracks. Leave tapered ends to suggest the realistic splitting of old wood.

Switching to a harder 2H charcoal pencil, apply long, thin strokes to create the grain of the wood. Note: Charcoal pencil can dull quickly. Instead of continually sharpening the pencil, simply rotate the pencil between each stroke.

Again utilizing the HB charcoal pencil, use a light touch to create scattered patches of tone on the wood. Very lightly blend the dark patches, leaving the cracks and light wood grain untouched.

For more interest and contrast, use a white charcoal pencil to highlight select areas of the wood. Avoid stroking over the cracks or dark patches as much as possible.

HARD SURFACES

53 | Driftwood in Charcoal

For cool driftwood tones, work on gray paper. Using a B charcoal pencil, create wood grain in a wavy pattern to suggest the warped, uneven surface. Use an HB to thicken some lines and fill in the cracks, leaving the ends tapered to show splitting.

Switch to a 2H pencil to create light strokes that follow the grain. Suggest areas of discoloration by applying loose, uneven tone.

Use a stump to lightly blend the discolored areas, which will give it a smoother appearance.

Create highlights and areas of lighter tone using a white charcoal pencil. This will create more contrast and strengthen the sense of light falling on the wood.

54 | Wood Knot in Graphite

When drawing wood, including a wood knot or two can add interest to the finished work. To begin, outline the shape of the knot along with a few small cracks. Also, outline the wood grain around the knot. Use light lines for this step; the lines shown here are darker for demonstration purposes.

The knot in the wood is often a bit darker than the wood surrounding it. In this case, use an HB pencil with small, overlapping circular strokes. Switch to a 2B when working in the very center. Darken the cracks with a 4B pencil, keeping them tapered at the ends.

With an HB, draw closely placed vertical strokes to represent wood grain around the knot. With a very sharp 2B pencil, create tiny growth rings in the knot itself.

To finish, use a small stump or tortillon to blend around the outside of the knot, softening its edge. Also, blend the grain of the wood around the knot, allowing most of the lines to show through for texture.

55 | Wooden Barrel in Graphite

 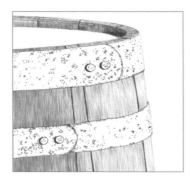 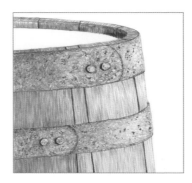 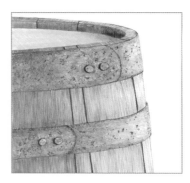

To begin, use light lines to outline the top of the barrel, which must be drawn accurately and symmetrically to suggest realistic perspective. Use a 4B to create the darkest shadows, including on top of the barrel, the lines between the wooden slats, and the rivet shadows.

Use a 2B pencil and short, overlapping hatch strokes to create the grain in the oak slats. Because the light is coming from the right, use fewer hatch strokes on the right side to allow more white paper to show through. You can switch to an HB to create lighter strokes on the lit side of the barrel.

For interest, the metal bands on the barrel can show some rust. To begin, stipple irregularly over the bands with a 4B pencil. Then apply scribbling strokes over the bands. Use lighter coverage on the right side of the bands. Use a 2B for the darker part of the bands and an HB for the lighter side.

On the top lid of the barrel, apply light, long parallel strokes with a 2H to suggest a hint of wood grain. To finish, use a stump to very lightly blend the wood grain of the barrel and lid. Use heavier blending for the metal, but make sure to allow the stippling and scribbling to show through.

56 | Smooth Bark in Graphite

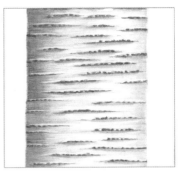

Begin by drawing two vertical lines for the trunk and a series of horizontal lines to indicate imperfections in the bark. Use light lines for this step; the lines shown here are darker for demonstration purposes.

Using a 2B pencil, thicken and taper the horizontal lines and stipple to represent holes in the lines of the bark.

With an HB pencil and slightly curved horizontal strokes, create the shadowed side of the tree (left). Then, using a 2H pencil, add curved, horizontal strokes for a smooth transition from the HB strokes. Apply strokes along the right edge with a 2H.

To finish, use a stump to blend all areas of the bark, including the imperfections. Then use a click eraser with the tip cut at an angle to pull out some thin highlights above the imperfections, making them appear slightly raised.

57 | Rough Bark in Graphite

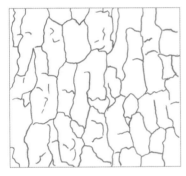

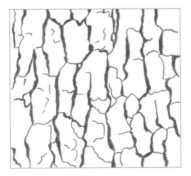

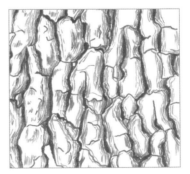

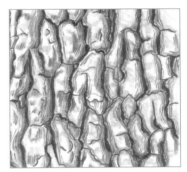

To begin, use a 2B pencil to outline the rough bark. In this example, you can use dark outlines because they will serve as shadows in the final drawing.

With a 4B pencil, establish the darkest values of the drawing within the deep, shadowed cracks of the rough bark.

With an HB pencil and rough hatch marks, create lines around the raised areas of bark to suggest layers. This will give the bark a raised appearance.

Use a stump to lightly blend all areas of the bark, leaving the layered lines visible. Then create some darker patches on the bark surface by smudging tone with the graphite already on the stump.

58 | Rough Bark in Charcoal

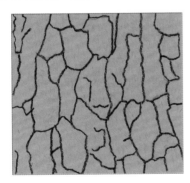

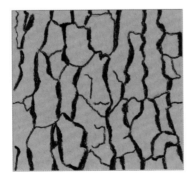

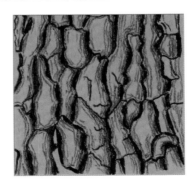

Use a B charcoal pencil to outline the rough bark. In this example, you can use dark outlines because they will serve as shadows in the final drawing.

With a 3B charcoal pencil, fill in the areas of shadow in the cracks of the bark to establish the darkest value of the drawing. Keep these dark areas irregular in shape.

With a sharp 2H charcoal pencil, use light, rough hatch marks around the raised areas of the bark for a layered appearance.

With a stump, blend lightly to allow the layers to show through. Finish by applying white charcoal pencil to highlight areas of the flat, uppermost surfaces.

59 | Pine Needles in Graphite

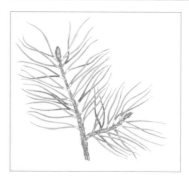

Begin by creating an outline, with both branches ending in a terminal bud.

Using a sharp 2H pencil, draw thin needles coming out of the branch. There is a thin, paper-like wrapping at the base where two or more needles sprout outward. Some of the needles are drawn to look as though they are behind some of the others.

The small branches and terminal buds of a real pine tree appear a bit scaly. To capture this, simply use small groupings of very short hatch marks using a 2B pencil. Now fill in the needles, using HB for distant ones and 2H for closer sunlit ones.

To finish, use a small tortillon with a sharp tip to very lightly blend all areas of the drawing. Too much blending can diminish the much-needed textures of the branches and buds.

60 | Pine Cone in Graphite

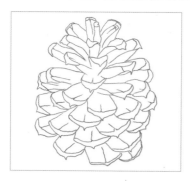

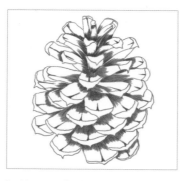

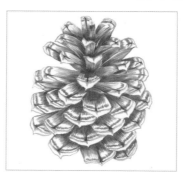

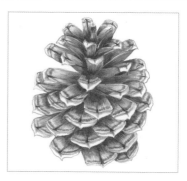

A pine cone is a complex drawing subject, so a good reference photo is important. Use very light strokes to create the outline; the lines shown here are darker for demonstration purposes.

In this example, the darkest shadows will be nearest the core of the pine cone. Use a 4B pencil to stroke outward from the center of the pine cone.

Continue working outward from the 4B areas using an HB pencil. Then use very short strokes to create a line across the end of each pine cone scale. Leave the tips mostly white, toning some areas subtly with a 2H pencil.

Now apply some light blending throughout to smooth the texture, allowing some of the pencil strokes to show through.

61 | Palm Frond in Graphite

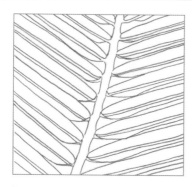

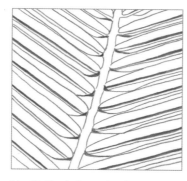

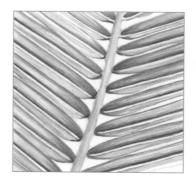

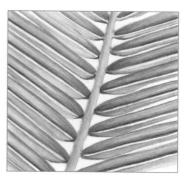

Begin by drawing an outline of the palm frond. Use lines that are much lighter than shown here, which will prevent any hard lines from showing through in the finished drawing.

Identify the darkest value first, which includes the most shadowed areas of the plant. Use a 4B to fill in these areas on each leaf of the frond.

Use an HB for the next darkest value, followed by a 2H for the lightest values on the leaves and stem. Use long, parallel strokes on the leaves to represent the veins.

To finish, lightly blend the leaves and stem with a stump or tortillon for a smoother finish.

62 | Fern in Graphite

 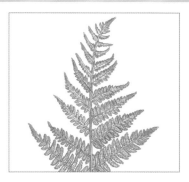

Begin by drawing the basic outline of the fern. Use light strokes for this step; the lines shown here are darker for demonstration purposes.

With a sharp-tipped HB pencil, draw the veins in the small, individual fern leaves, as well as a line representing the main stem. On this type of fern, the main stem is concave and runs down the length of it, which you can represent with a thick line down the center.

With a 2H pencil, fill in around the very edges of the individual leaves, avoiding the previously drawn veins. Fill in the leaves toward the tips of each branch.

To finish, use a fine- or sharp-tipped tortillon or stump to blend around the edges of the leaves (where you applied the 2H). Leave some of the veins and leaf centers light. To finish, lightly blend the stems.

63 | Grass in Graphite

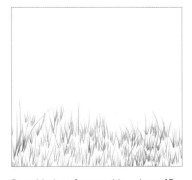 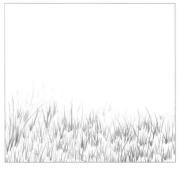 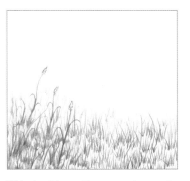 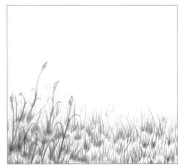

Draw blades of grass with a sharp 4B pencil, stroking upward and tapering the tips. Place clumps of grass randomly, and avoid placing them in a straight line. Curve each blade as you stroke, allow some to cross over each other, and vary the lengths of your strokes.

To give the grass contrast and depth, use sharp HB and 2H pencils to thicken the grass with more tapered strokes throughout. Add light blades above your original strokes to suggest grass that fades into the distance.

With the 4B pencil, create a few seed-tipped stalks of grass and add random longer, darker blades where needed. To create the seed tips, apply very short strokes that angle slightly outward.

To finish, use a small tortillon to lightly blend the bottom of most of the clumps, giving the drawing even more contrast and depth.

64 | Seashell in Graphite

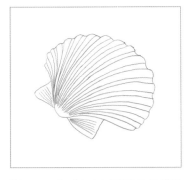 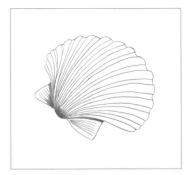 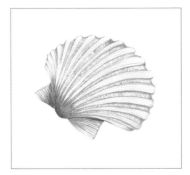 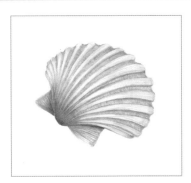

This example shows a common scallop seashell. Begin by creating a light outline of the shell; the lines shown here are darker for demonstration purposes.

Use a 2B pencil to establish the darkest values within the scene.

Switch to a 2H pencil to tone the raised ribbed areas using long strokes that follow their natural curves. Between the ribs, draw small, curved lines using an HB pencil, which suggests the concave nature of the structure.

To finish, blend very lightly and be sure to retain some of the lines from step three.

65 | Smooth Rock in Graphite

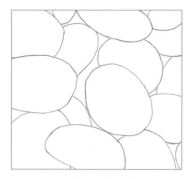

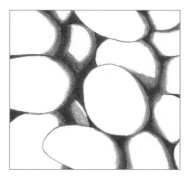

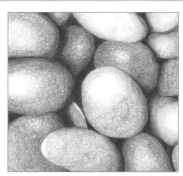

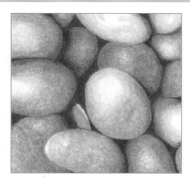

Drawing smooth rock is a simple process. Begin by drawing a light outline using various oval shapes; the lines shown here are darker for demonstration purposes.

Use a 4B pencil to establish the darkest value first, which is in the deepest areas between the rocks. Then use a 2B and overlapping circular strokes to draw outward from the 4B areas, creating a smooth gradation for a three-dimensional appearance.

With an HB and looser, overlapping circular strokes, create the next darkest values of the rocks. Then switch to use a 2H to build the lightest areas. These loose, circular strokes will create a realistic texture.

To finish, lightly blend with a stump, allowing some of the strokes to show through for a realistic touch.

66 | Mountain Rock in Graphite

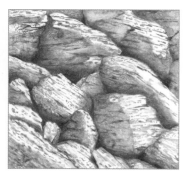

Draw the basic outline of the jagged mountain rock, including the larger shadowed areas. Use light lines for this step; the lines shown here are darker for demonstration purposes.

Use a 4B pencil to fill in the darkest values, which are the small areas of deep shadow between the rocks.

Use 2B and HB pencils to create linear cracks and stippling on the surface of the rocks, including areas in light shadow. With the HB pencil and loose, overlapping circular strokes, create the lightest shadows.

To finish, lightly blend all the areas of shadow. Allow some of the circular strokes to show through to maintain the rough texture. To lighten areas if needed, simply dab away tone with the kneaded eraser.

67 | Mountain Rock in Charcoal

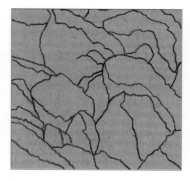

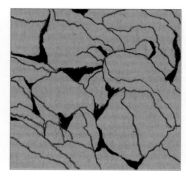

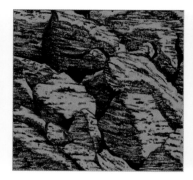

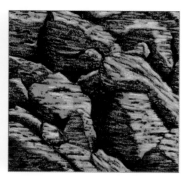

To begin, draw an outline of a hillside of mountain rock using very light lines over toned paper. (The lines shown here are darker for demonstration purposes.) Use a 2H charcoal pencil with light pressure. If needed, outline some areas of light and shadow.

Using a 3B charcoal pencil, create some of the darkest shadows in between the deepest areas of the individual rocks.

Use long strokes and an HB charcoal pencil to create lighter areas of shadow. When applied over charcoal paper, the surface texture adds to the rough look. Add lines and stippling on the highlighted areas of the rocks for more detail.

Lightly blend the areas of shadow. To finish, use a white charcoal pencil to add highlights for depth and contrast.

68 | Running Water in Graphite

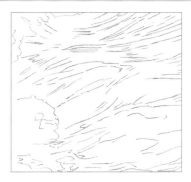 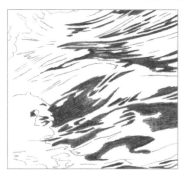 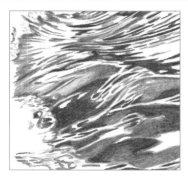

Running water can be difficult to draw due to the variety of shapes and values involved. Simplify your reference photo by converting it to grayscale, removing the distraction of color. Begin by outlining the various shapes that make up the water's surface.

Use a 4B pencil to add the darkest values first. Like most graphite drawings in this chapter, this example uses 4B, 2B, HB, and 2H pencils. Each pencil grade can yield several different values, depending on the amount of pressure applied.

For the remainder of the drawing, use 2B, HB, and 2H pencils to build the various values throughout. Leave some areas of the paper white to represent the lightest reflections.

To finish, lightly blend all areas with a tortillon, except for the white of the paper that remains. Add lighter values throughout for more depth and variety by applying tone with the tortillon as you work.

69 | Raindrops on Water in Graphite

 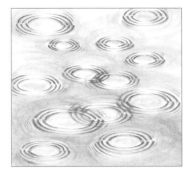

When viewed from above, raindrops on water create circles; when viewed from any other angle (such as from the shore), they look elliptical. To begin this subject, draw different sizes of ellipses.

When raindrops hit the water, they create waves that move out from the center. To re-create this example, draw two small ripples around each original ellipse.

Use a 2B pencil to draw tapered shadows around the waves for depth. The shadows closest to the viewer appear on the outside of the wave, and the shadows farthest away are on the inside. Add smaller waves on the sides of each raindrop.

To finish, use a worn stump with a dull tip to apply tone around and inside each raindrop, creating subtle waves and lightly toning the water's surface. To reload the stump with graphite, simply dip the tip into graphite powder and stroke over a separate sheet of paper until you reach the desired value.

70 | Clouds in Graphite

In this method, you will simply use a stump, graphite powder (saved from pencil shavings), tissue, and a click pencil eraser. Begin by dipping a folded tissue into graphite powder and rubbing over the paper. Create a smooth sky on top and darker clouds below.

Using the click pencil eraser, create a sharp outline of the edge of the clouds. As you erase, use a circular motion to produce a bumpy appearance.

Next use an old, blunt stump to apply graphite over the cloud shadows. As the shadows lighten, apply increasingly less pressure. Then use the click pencil eraser again to create sharp edges.

Use the stump to reapply graphite to create darker areas of the clouds. Then use the sharply cut tip of a pencil eraser to work around the bright edges, giving the clouds a wispy appearance. Use this eraser to create linear clouds and small puffs.

71 | Citrus Fruit in Graphite

 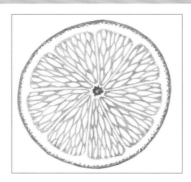 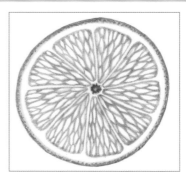

This can serve as an example of any citrus fruit, such as orange, lemon, or grapefruit. (However, tweak as necessary; for example, the rind of a lime is often thinner.) To begin, draw the outline of the cut citrus fruit using light lines.

Using an HB pencil, thicken the outer edge and add some stippling along the cut rind. Darken the very center to show that it's in shadow.

Still using the HB, create pointed, tapered shapes to represent the pulp. Fill in the space around the shapes (called "negative drawing"; see page 13).

To finish, blend lightly around the edge of the cut rind using a small stump. Around the tapered shapes in the fruit, use a small, sharp-pointed tortillon to blend within the smallest areas.

72 | Apple in Graphite

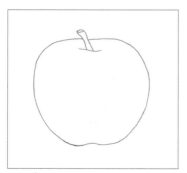 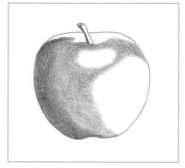 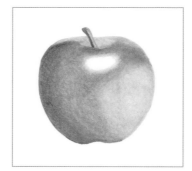 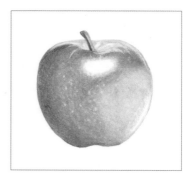

Begin by creating a basic outline with a 2H pencil. You can begin with a simple circle and then refine the sketch to include the bumps and bulges of an apple.

In this drawing, the light is coming from the right. Create the shadowed left side (the darkest value) using a 2B pencil and overlapping circular strokes. Continue using an HB pencil to apply a slightly lighter value to the apple, leaving the oval highlight free of tone.

With a lighter 2H pencil and overlapping circular strokes, coat the rest of the apple, still leaving the oval highlighted area free of tone. Using a stump, blend all areas of the apple to a fairly smooth finish.

Using a small-tipped click pencil eraser, create lighter spots and lines around the stem and top of the apple. Also, create some light stippled spots on the skin. Finally, suggest reflected light by removing a thin band of tone along the bottom right edge.

73 | Pear in Graphite

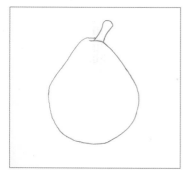 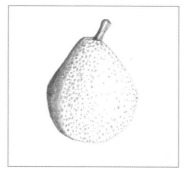 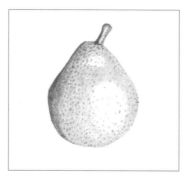 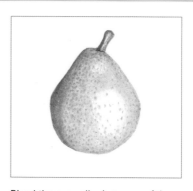

Begin by drawing a light outline of the pear with a 2H pencil. You can begin with a simple circle and then sketch the top of the pear. (Note that the lines shown here are darker for demonstration purposes.)

In this drawing, the light is coming from the right. Begin with the darkest value—a shadow on the left side of the pear and stem. Use loose, overlapping circular strokes that allow a bit of the white paper to show through. Then, using an HB pencil, stipple over the skin for texture.

Switch to a 2H pencil and apply loose, overlapping circular strokes over the pear skin, leaving two areas of highlights: one on the upper portion, and one on the bottom portion.

Blend the pear, allowing some of the pencil strokes to show through. Leave the highlighted areas free of tone, including the thin highlight on the stem.

74 | Grapes in Graphite

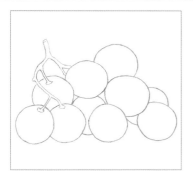 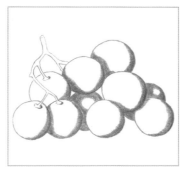 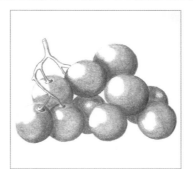 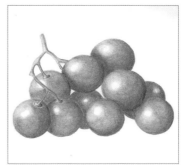

Using simple circles, create a basic outline of the grapes and stems. Use light strokes; the lines shown here are darker for demonstration purposes.

Create the shadows with a 2B pencil. The light is coming from the upper left, so the darkest values will be the shadows at right. Apply tone with small, overlapping circular strokes, which you will later blend to a smooth finish.

Apply a slightly lighter value of the grapes with an HB pencil, again using small, overlapping circular strokes. Still using the HB pencil, create the shadowed areas on the grape stems.

Switch to a 2H and apply small, overlapping strokes, leaving highlights free of tone. Then use the 2H and long hatch marks for the stems. Finish by blending the grapes to a smooth finish with a stump or tortillon. Then lightly blend the stems.

75 | Cherries in Graphite

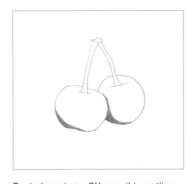 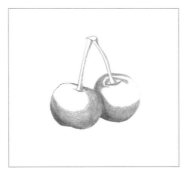 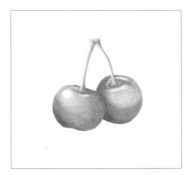 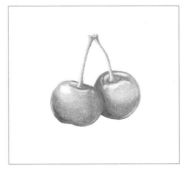

Begin by using a 2H pencil to outline the cherry shapes and stems with very light lines. The darkest value of the drawing (2B) will be the shadows on the lower parts of the cherries. Work in small, overlapping circular strokes, which you will later blend.

Switch to an HB pencil and apply a lighter value to the cherries using small, overlapping circular strokes. Then tone the stems, working along the sides opposite the light source.

For the lightest values, use a 2H pencil to develop tone. Using a stump or tortillon, blend the cherries and stems to a smooth finish. Allow the highlights to remain the white of the paper.

Using a small click pencil eraser, add tiny highlights for more interest and to further suggest the reflective nature of the cherries. Also, use the pencil eraser to create tiny light speckles on the skin.

76 | Strawberry in Graphite

 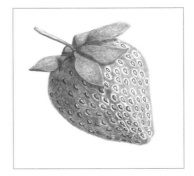 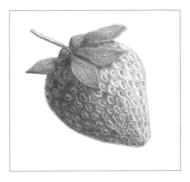

Begin by drawing the simple outline of a strawberry, stem, and sepal with light lines (the lines shown here are darker for demonstration purposes). Then use a 2B pencil with a sharp tip to create teardrop-shaped seeds. Note how the tip of each seed points toward the tip of the strawberry.

Next, using a 2B pencil, create areas of shadow on the leaves, stem, and sides of each seed on the part of the strawberry in shadow. (In this case, the light is coming from the right, putting the left side in shadow.)

Using a 2B and small, tight, circular strokes, add tone to the dark side of the strawberry (left), leaving a small amount of white around the seeds closest to the center. Switch to an HB and fill in the rest of the berry, leaving highlights around the seeds. Then use the HB to coat the leaves and stem.

To finish, use a tortillon or small stump to blend all areas of the strawberry, allowing the white of the paper to serve as the highlights. Then use a sharp HB pencil to create veins on the sepals for a realistic touch.

77 | Peanut Shell in Charcoal

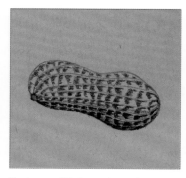

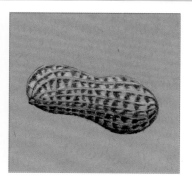

In this example, a tan-colored charcoal paper is a good match for drawing a peanut shell. Begin by drawing a basic outline using a 2H graphite pencil or using a 2H hard charcoal pencil with a light touch. Notice the mixture of recessed square and triangular shapes that make up the surface of the shell.

The darkest values will be the shadows along the bottom of the shell. Use a B charcoal pencil to develop the shadows within the small recesses.

Next use a 2H charcoal pencil to apply the next darkest value near the bottom of the peanut shell. Use this same pencil to apply light shadows to the remaining recessed areas. Notice how the veins along the peanut shell are left as the color of the paper for now.

Finish by simply using a white charcoal pencil to create highlights along the veins and within some of the recessed areas near the light source.

78 | Walnut Shell in Charcoal

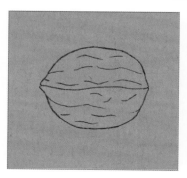

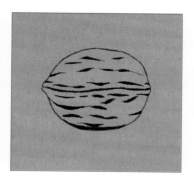

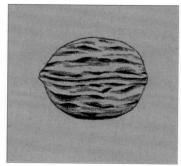

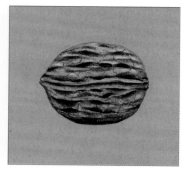

A tan-colored charcoal paper is a good match for drawing a walnut shell in charcoal. Begin by drawing the basic shape of the walnut, indicating the line through the middle and the creases on the shell's surface.

Establish the darkest value of the drawing with a 3B charcoal pencil, filling in the shadows and creases of the walnut shell.

With a harder 2H charcoal pencil, create light shadows moving out from the darker ones to create a gradation, and suggest a few shallow creases on the shell.

To finish, lightly blend the darker and lighter shadowed creases. Then use a sharp 2H charcoal pencil to create thin veins on the shell's surface. Use a white charcoal pencil to add highlights along the top of the shell.

A soft charcoal pencil dulls quickly on textured paper; instead of constantly sharpening the pencil, turn the pencil slightly as you work to yield finer lines. (You can use this technique with graphite tips as well.)

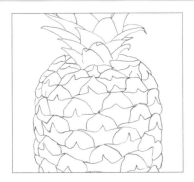

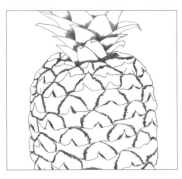

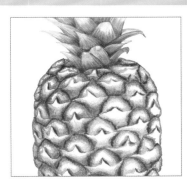

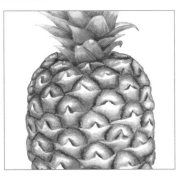

Using light lines, draw the outline of the pineapple, including the crown and the individual hexagonal shapes on the exterior. (The lines shown here are darker for demonstration purposes.)

Use a 4B to establish the darkest values of the drawing. Work in jagged strokes around the hexagonal shapes, and use hatch strokes on the leaves of the crown.

With a 2B pencil, use overlapping circular strokes as you work outward from the jagged strokes to create a slightly lighter value. Also use the 2B and hatch strokes to build tone on the leaves. Switch to a 2H and stroke in the rest of the leaves as you move toward the tips. Then use the 2H and overlapping circular strokes to establish the lighter areas of the hexagonal shapes, leaving some highlights.

To finish, use a stump to lightly blend all areas of the pineapple.

80 | **Corn** in Graphite

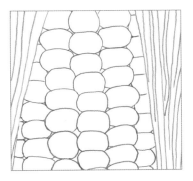

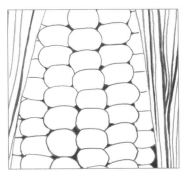

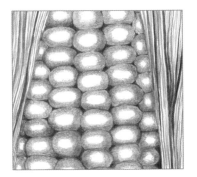

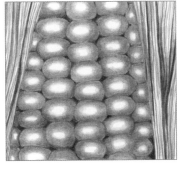

Begin by drawing a basic outline of the ear of corn, which includes the husk for more interest. Use a 2H pencil for this step; the lines shown here are darker for demonstration purposes.

To make sure the finished drawing features adequate contrast, use a 4B to develop the shadows. Apply dark tone between the kernels and along the husk in long strokes.

Using an HB pencil, create more lines along the husk. Then apply tight, overlapping circular strokes around the edges of the kernels, leaving the center of each free of tone to represent highlights.

To finish, lightly blend the lines on the husk with a stump. Then smoothly blend the strokes in each kernel, leaving the white of the paper to serve as a highlight in the center.

Don't be shy about using dark values, as they will allow your drawing to "pop" more than moderate values. In most cases, the less contrast used, the flatter and less compelling your drawing will be.

81 | Coconut in Graphite

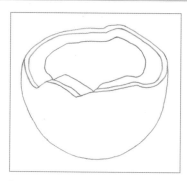

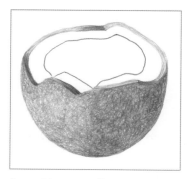

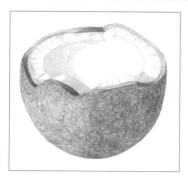

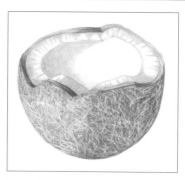

Draw the basic outline of the coconut, which has been broken in half to reveal what's inside. Use a 2H pencil for a light outline; the lines shown here are darker for demonstration purposes.

Coconut has a very fibrous exterior. To represent this texture, work in scribbling strokes using a 2B (for the darker right side) and an HB (for the lighter left side). Apply long strokes of the 2B and HB pencils along the cracked edge of the coconut, following the curve of the rim.

With a 2H pencil, create a bit of texture and light shadows on the interior and rim.

Lightly blend the interior, exterior, and cracked rim of the coconut. Then use a click pencil eraser to suggest some thin, random fibers on the surface.

82 | Tomato in Graphite

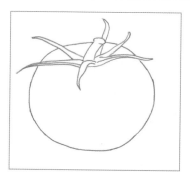

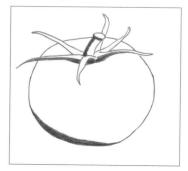

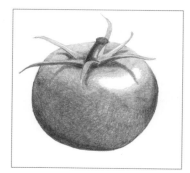

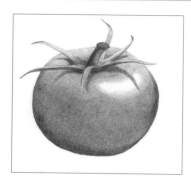

Begin with an outline of the tomato, stem, and sepals. Use light lines for this step; the lines shown here are darker for demonstration purposes.

With a 4B pencil, create the darkest values of the drawing. These areas include the shadowed bottom of the tomato, side of the stem, and undersides of the sepal.

With 2B and HB pencils and overlapping circular strokes, create the next darkest values of the tomato. Work around the highlight. Use the 2B to develop shadows cast by the sepal. Use the HB pencil on the surface of the sepal and on the stem, leaving a small, thin highlight.

Use a stump to evenly blend the body of the tomato, and switch to a small tortillon for the stem and sepal.

Section II
COLORED PENCIL

DENISE J. HOWARD

Tools & Materials

Paper

The *tooth*, or texture, of a paper grabs and holds onto pigment. The toothier the paper, the rougher it is and the more pigment it will hold, but that also makes it more difficult to achieve a smooth, blended look with no speckles of paper peeking through. Very smooth paper makes it easier to create fine, smooth details, but it will not accept as much pigment, making it more difficult to achieve rich, complex color. Examples of toothy paper are cold-pressed watercolor paper and papers made for use with pastels. Examples of very smooth paper are smooth and plate Bristol. In between are papers such as hot-pressed watercolor paper, vellum Bristol, and printmaking paper, such as Stonehenge.

Choose good-quality, acid-free paper that has the right characteristics for the textures you plan to depict, and practice on it first to familiarize yourself before launching into a full project. Acid-free, 100-percent cotton rag, archival paper is preferred. White Stonehenge paper was used for all the examples in this section because of its consistent, fine tooth; durability; and availability in many art-supply stores—in both pads and large single sheets.

EXTRA PAPER Always keep a disposable sheet of paper under your drawing hand as you work to protect the drawing from the oils of your hand and prevent smudging. Glassine is excellent for this—it looks like wax paper but is more slippery. Plain printer paper will also do.

Pencils

GRAPHITE For planning basic outlines, a graphite pencil of grade HB or H works well. It is a little harder than a standard 2B, so it deposits less graphite on the paper. Use it lightly so that it doesn't dent the paper.

COLORED Whatever the brand, colored pencils fall into two main types: wax-based and oil-based. This refers to the composition of the binder that holds the pigment together to form the pencil core. Wax-based pencils are softer and creamier, while oil-based pencils are harder and drier. They can be used together, and neither is better than the other—they're just different.

Depending on the brand, full sets range from 72 to 150 colors. Although purchasing the largest possible set of a brand is always tempting, it's not necessary to make beautiful drawings. A smaller set of 24 or 36 colors can produce a broad spectrum once you learn a little color theory and how to layer them. Many stores also sell individual "open stock" pencils, so you can add the colors you need to your collection as you need them. Avoid cheap "student-grade" or children's pencils. They don't blend well and the colors will change or fade over time.

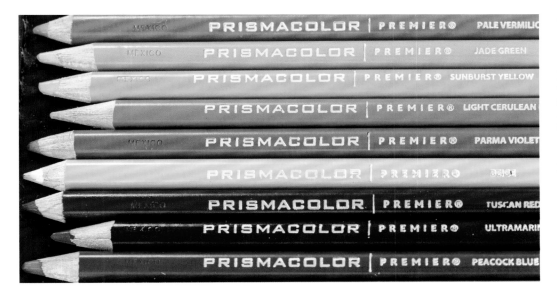

Prismacolor® Premier® colored pencils were used for all the examples in this section. These wax-based pencils are readily available from any store that carries art supplies and are reasonably priced. You may prefer a different brand. Experiment to find the pencils that suit you best.

Erasers

KNEADED RUBBER Applying a light color over a graphite outline is a recipe for disappointment—at best, the graphite will become more noticeable; at worst, it will smear. To avoid this, a kneaded rubber eraser is a must-have. Throughout this section, when preparing to draw with light colors, dab away as much of the graphite outline as you can ahead of any colors. Never scrub with the eraser—scrubbing damages the surface of the paper.

POSTER PUTTY Colored pencil is not easy to erase and almost never erases completely. Lifting it off paper reasonably well requires something with more tackiness than kneaded rubber: poster putty. This is the same stuff that students use to hang posters on walls! Depending on the brand, it might be white, blue, or green; the color doesn't matter. Like kneaded rubber, it can be pinched and rolled into a fine point or a line. It works best by gently dabbing at the paper surface. Again, never scrub the paper. It's a must-have for corrections, lifting the inevitable little blobs of pigment, and cleaning up edges.

OTHER Some artists find great value in electric erasers, or those that come in a holder that clicks like a mechanical pencil (called "stick" or "click" erasers). Either of these can be sharpened to a fine point to make crisp edges.

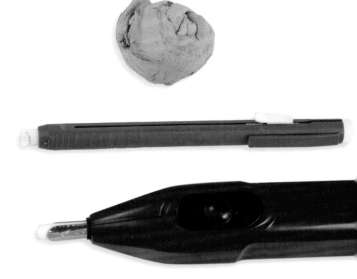

When working with wax-based pencils, occasional blobs of pigment inevitably appear. Even tiny ones can be quite noticeable. When this happens, don't try to keep drawing over them—they will only grow by grabbing more pigment. Instead, pinch your poster putty down to a tiny point and gently dab right away.

Blenders & Solvents

Whether you choose to use blenders and solvents is a personal choice—some artists prefer their work to look like a drawing, even if they depict a very smooth texture, while others prefer their work to look like a painting, even if they depict a very rough texture. In this section, a colorless blender or solvent is often used to demonstrate what a big difference it can make.

COLORLESS BLENDER A colorless blender is a colored pencil with no color—just binder and waxes or oils. Most colored pencil manufacturers make a colorless blender designed to work well with their pencils, sold separately from their sets.

SOLVENT The binder that holds colored pencil pigment together is easily dissolved with a little solvent, either alcohol or odorless mineral spirits. Both evaporate quickly, leaving no residue. Solvent does not turn the pencil into a watercolor effect of liquid color that you can pull around with a brush; it drops the pigment in place into the tooth of the paper, eliminating speckles of paper peeking through and producing a more even, intense color. This is useful when you want to smoothly blend two to three layers of pigment but preserve the tooth of the paper so you can continue with more layers on top.

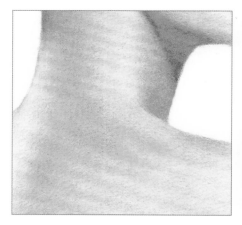 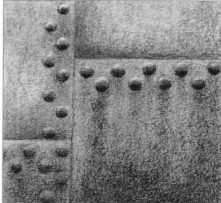

Whenever using odorless mineral spirits, you can also substitute alcohol. Odorless mineral spirits were used for several textures in this section, such as Smooth Skin (#83), Rusted Steel (#132), and Still Lake (#158).

Sharpener

There are hand-held, hand-cranked, and electric sharpeners. There is no "best" sharpener, but an electric one will save time, as you will be sharpening often. When working with colored pencils, it's crucial to get a very sharp point, and sometimes you may need to sharpen every 90 seconds! For an electric or hand-cranked sharpener, choose one with a helical mechanism, as it will last longer and be gentler on the pencils. Occasionally sharpen a graphite pencil in the sharpener to clean the blades of waxy buildup.

Stylus

A stylus is a pen-shaped instrument with a tiny steel ball tip, used for impressing lines into paper without damaging it. An empty extra-fine ballpoint pen will do in a pinch, but manufactured styluses are available with much smaller tips. Do not use a sewing pin or a wire, such as a straightened paper clip—the sharp end will cut your paper.

Frequently rotate your pencil a quarter turn during use between sharpening so that the sharpest part of the point is always on the paper. Sharpen often!

Swatch Chart

The biggest time-saver for working with colored pencil is a swatch chart. For every set of pencils you own, arrange them in color sequence. Then make swatches of color in that sequence on a large piece of paper, and label each swatch with its name. Keep your pencils arranged in that order, and keep your swatch chart next to you while you work. Whenever you need a certain color, you need only to find it on your swatch chart and go right to it in your set, without wasting time making test scribbles to see what color comes close.

067		43	ROYAL BLUE	130		64	TURQUOISE GREEN
085		44	VIOLET	120		65	LIGHT GREEN
075		45	INDIGO BLUE	139		66	JADE GREEN
089		46	PRUSSIAN BLUE	159		67	GREYISH GREEN
080		47	ULTRAMARINE	140		68	VERONESE GREEN
280		48	NIGHT BLUE	149		69	PEACOCK GREEN
270		49	SAPPHIRE BLUE	150		70	EMPIRE GREEN
081		50	BLUE	260		71	BLUISH GREEN
082		51	MARINE BLUE	169		72	DARK GREEN
071		52	BLUISH GREY	145		73	SPRUCE GREEN
051		53	GENTIAN BLUE	370		74	EMERALD GREEN

Several swatch charts are available to download at www.denisejhowardart.com/downloads-media.html.

Fixatives

Fixative is a liquid spray that creates a barrier. There are two main types: workable fixative and final fixative. Workable fixative allows you to continue drawing more layers on top without affecting or blending into the layers underneath. Final fixative completely seals the surface of the drawing to protect it from smudging and is only used upon completion.

For wax-based pencils, final fixative is especially important to prevent wax bloom. Over time, the wax from the binder can migrate to the surface of a drawing, causing a blotchy, cloudy look, known as wax bloom. Bloom is more likely with heavy layers of pigment and more noticeable on dark colors. It's easy to fix by gently wiping the paper's surface with a very soft cloth or cotton swab, but it's better to prevent it by using final fixative. Follow the directions on the can.

Drafting Brush

Crumbs of pigment inevitably appear, along with dust particles and fibers. Resist the urge to sweep them away with your hand, which could embed them into the paper or smudge your drawing. Instead, use a drafting brush; this is exactly its purpose.

Techniques

As an art medium, colored pencil is similar to watercolor: you work from light to dark, reserving bare paper for the lightest highlights; once an area is dark, it's impossible to make it fully light again. This is important to keep in mind if you're familiar with media that work differently, such as pastels, where you work from dark to light and add the highlights last. Unlike paint, you cannot wipe out or paint over errors and start again. But since colored pencil drawings develop slowly, errors do too, so you have time to notice and correct them before they become irreparable. The following information includes tips and techniques. Practice them several times on scrap paper before using them in a project, since colored pencil is not easy to erase!

Holding the Pencil

The position of the pencil relative to the surface of the paper is important for colored pencil drawing, because it affects how evenly and thoroughly the pigment is laid down.

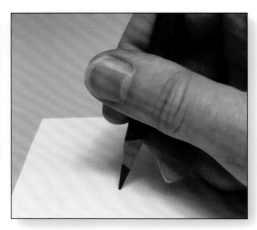

FLAT Holding the pencil so that the side of the point is flat against the paper and stroking with it deposits pigment unevenly and creates a very coarse look. This is useful for drawing textures like rough bark, sand, and rock.

NORMAL Holding the pencil as if you are writing with it, but at a slightly more vertical angle, is the normal position for colored pencil. This ensures that a good amount of pigment gets into the tooth of the paper with each stroke.

VERTICAL Holding the pencil perpendicular to the paper and using a circular/scumbling stroke ensures that the pigment gets fully down into and around the tooth of the paper to create very smooth, complete coverage.

Color Mixing

Regardless of the size of your pencil collection, you probably won't have exactly the right color for every situation. Even if you did, it would look better and richer with another color added. Learning how to "see" the individual colors in your reference, and knowing what colors to combine to achieve that color, takes observation and practice—and it starts with a basic knowledge of color theory.

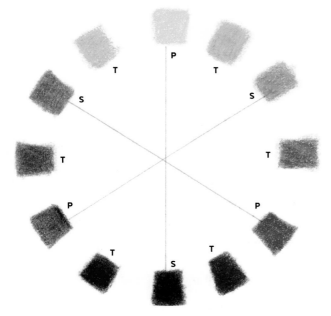

When working with pigments, there are three primary colors, which cannot be mixed from any other colors: red, yellow, and blue. The three secondary colors—orange, green, and purple—can be mixed from other colors. Tertiary colors, which can also be mixed, are combinations of primary and secondary colors (such as red-orange or blue-green). The color wheel (shown at left) is a helpful diagram for seeing how all of these colors relate to one another.

The color wheel can also help you use certain color combinations for dramatic impact in your artwork. Complementary colors lie opposite each other on the color wheel; when placed next to each other, they appear brighter. They can also be used to tone down or neutralize each other for effective shadows. For example, it is a good idea to first apply a green layer (or "underpainting") before applying the red of an apple to create convincing areas of shadow.

P = Primary color, S = Secondary color, T = Tertiary color. The color opposite a given color on the wheel is its direct complement. In this diagram, each primary is connected to its direct complement.

Sharpness & Pressure

Throughout the tutorials in this chapter, some steps describes the sharpness of the pencil and the amount of pressure to use, which will help you achieve your desired results. For example, drawing a very smooth texture, like satin, requires a very sharp point and light pressure, while drawing a very rough texture, like rough bark, is most successful with a dull point and medium pressure.

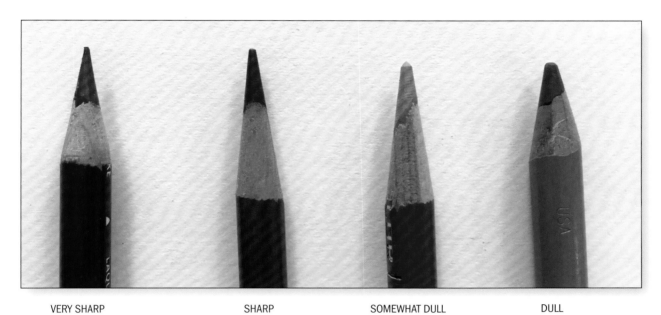

VERY SHARP SHARP SOMEWHAT DULL DULL

SHARPNESS SCALE	
VERY SHARP	A needle-like point
SHARP	Fresh out of the sharpener
SOMEWHAT DULL	After the pencil has been used for a few minutes
DULL	A very rounded point

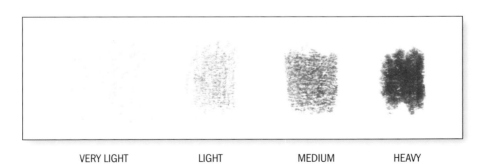

VERY LIGHT LIGHT MEDIUM HEAVY

PRESSURE SCALE	
VERY LIGHT	Barely touching the paper
LIGHT	Gently touching the paper
MEDIUM	Normal, as for handwriting
HEAVY	Pressing so hard that the tooth of the paper is flattened

Strokes

HATCHING Hatching entails drawing parallel lines close together with a smooth back-and-forth motion. By keeping the pressure constant as you move across an area, you can create an even area of color. By keeping the pressure constant and staying in an area, you can build up more pigment coverage without prematurely flattening the tooth of the paper.

CROSSHATCHING Crosshatching is hatching in more than one direction, so that the strokes cross, to reduce the linear appearance. Sometimes this is taught as crossing strokes at a perpendicular; however, when working with colored pencils, this can result in a weave or waffle appearance, which only worsens as you try to fill the gaps. Try crossing strokes at a shallow angle, 30 degrees or less.

TAPERED A tapered stroke begins with a certain amount of pressure and, as you move the pencil, you apply less pressure until it is lifted away from the surface. This is useful for drawing things like eyelashes, clumps of grass, and short fur.

CIRCULAR/SCUMBLING By holding a very sharp pencil nearly vertical and moving the point in tiny, overlapping circles or ovals, the pigment can get fully down into and around the tooth of the paper to create very smooth, complete coverage that reveals no stroke direction. You can visualize this as how water fills all the spaces around rocks and pebbles in a shallow pool.

BLUR A soft blur is easy to achieve if you remember that $1 + 1 = 2$ and $\frac{1}{2} + \frac{1}{2} = 1$. If you partly overlap two full-strength areas of color, the area of overlap will be obvious because it has twice as much pigment, and it won't be soft. But if you fade out color A by half and color B by half, so that the area of overlap is the half-strength of each, you'll achieve a soft blur.

Effects

IMPRESSED LINES Impressing lines into your paper with a stylus before you begin drawing puts the indentations out of reach of pencil points. As you draw over them, they remain white. This is useful for depicting whiskers, single-hair highlights, distant twigs, and more.

WASH A wash is a thin, smooth layer of color. When working with colored pencil, the first step is often to draw a wash with white or another very light color. This provides a base color, as well as a waxy base for smoother blending of the darker colors to follow. A wash can also be a thin layer of color applied on top of another color to create a new color from the combination.

BLENDING Each strip is identical layers of crimson lake and indanthrone blue, applied more heavily at the left and transitioning to a thin wash at the right. Note the increase in color saturation when either a colorless blender or solvent is used, but also note that they can't work as well when the pigment is thin.

OPTICAL Gently drawing one layer of colored pencil on top of another produces an "optical blend." To the unaided eye, it appears to be a blend of the two colors, but viewing it through a magnifying glass reveals individual particles of each color and speckles of bare paper. It can also be considered a transparent blend. This is the most common way to blend colored pencil colors. Many people prefer this result because it looks "like a drawing."

COLORLESS BLENDER When used as the last step of the drawing process, a colorless blender intensifies the colors and creates a smoother appearance. How smooth depends on how much pigment is on the paper and how hard you press. It works best with at least a couple of light layers of pigment. Pressing very hard with it is called "burnishing." This obliterates the tooth of the paper, making the drawing a bit shiny and further adjustments difficult to impossible.

SOLVENT You need at least a couple of layers of pigment on your paper in order for there to be enough wax binder to dissolve for the solvent to effectively create smooth color. An eyedropper-full of alcohol or odorless mineral spirits applied with a ¼" flat brush is enough for a 3" x 3" square. Moisten only the tip of the brush or blot excess on a tissue, and then touch it to your drawing. Gently stroke the pigment just enough to see it dissolve, and move on. Allow at least 15 minutes for it to fully evaporate before drawing more on top. Solvent can be reapplied after every couple of layers.

Clean the tip of your colorless blender between colors to avoid accidental streaks in your artwork.

83 | Smooth Skin

The keys to achieving smooth skin are very sharp pencils, light pressure, adding several layers of color in light washes, and patience. For this example of golden, tan skin, start with a light outline and a wash of jasmine.

Apply a wash of rosy beige over the jasmine, working lightly over the highlights. Then add a wash of peach over the rosy beige, paying attention to the subtle changes in value across the form.

Add a wash of goldenrod over the peach followed by burnt ochre in the warmest areas of skin. Add the shadow under the jaw and on the neck with burnt ochre and sienna brown, using light pressure. Use cream or a colorless blender to smooth any roughness in the darker tones.

This step is optional. Moisten a brush or cotton swab with odorless mineral spirits and apply it overall to dissolve the wax away. If any blotchiness results, even it out with very light touches of the predominant color of that location.

84 | Aged Skin

 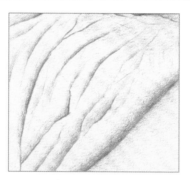 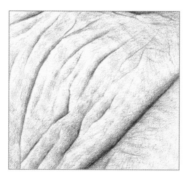 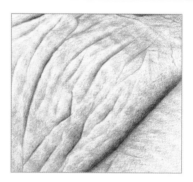

Aged, wrinkled skin is surprisingly easy to draw, because it tends to have an uneven texture and color. Begin with a light outline of the major wrinkles and an overall medium layer of cream.

With a sharp point and light pressure, apply an overall layer of beige. Then use very sharp sienna brown and medium pressure to define the major wrinkles. Use the sienna brown with light pressure to draw the shadow edge of these wrinkles, stroking in the same direction as the wrinkle lines.

With very sharp dark umber and medium pressure, enhance the depth of the most pronounced wrinkles. Use sharp terra-cotta and light pressure to further form the shadow edge of the major wrinkles and to create minor wrinkles by drawing their shadow edges.

Continue adding smaller and smaller wrinkles, as in the previous step, with sharp terra-cotta and very light pressure. Add some uneven color between wrinkles with terra-cotta and sharp rosy beige, using very light pressure. Finish by lightly enhancing or extending some of the existing creases.

85 | Facial Hair

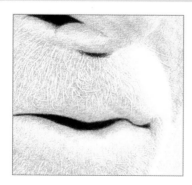 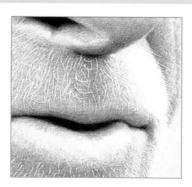 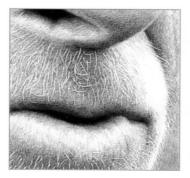 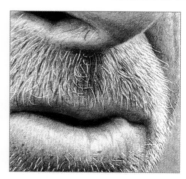

Start with a basic outline, and then impress short whiskers into the paper with a stylus. Apply a light wash of jasmine over the skin, except the highlights, followed by rosy beige. Use black for the nostril, mouth gap, and nose shadow. Lightly apply sky blue light in the background.

Use sharp sienna brown and light pressure on top of the rosy beige, with more coverage under the nose, the underside of the top lip, under the bottom lip, and on the cheek crease. Note that the white whiskers are becoming visible.

Use sharp Tuscan red and light pressure over sienna brown, working in the same manner as the previous step. Use very light pressure to add creases in the lower lip. This man's coarse, ruddy complexion does not call for smooth blending. Add a medium layer of slate gray to the background.

Use dark umber to increase contrast on and under the nose, under the lower lip, and along the cheek crease. Then use it to subtly suggest other whiskers. With very sharp black and medium pressure, apply short, individual strokes to give the whiskers a salt-and-pepper look.

86 | Straight Hair

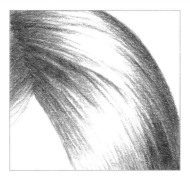 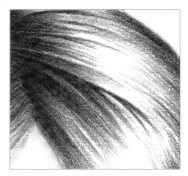 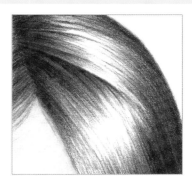 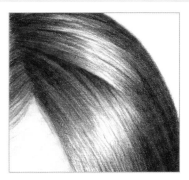

Straight hair is easy to draw because the strokes follow the direction of the hair growth. Begin this brown hair with sharp chocolate, stroking outward from the part or upward from the bottom. Vary the stroke lengths and create darker sections to represent strands. Use bare paper for highlights.

Repeat the previous step with dark umber, allowing some of the chocolate to remain exposed. Remember to lighten the pressure of your stroke as you approach areas of highlight.

Repeat the first step again with light umber. Bring some strokes farther into the highlights.

Use sharp black with light-to-medium pressure to darken some of the gaps, and with very light pressure to suggest individual hairs in the highlights. To finish, touch up any strands or gaps where you'd like to have more color or contrast.

87 | Curly Hair

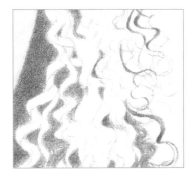 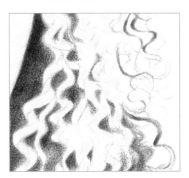 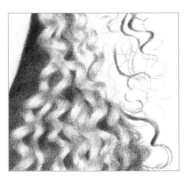 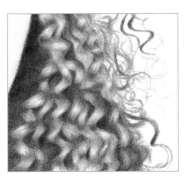

Curly hair is intimidating because each strand is a complex spiral, and many strands together form a tangle of overlapping spirals. Work from major to minor shapes. Use chocolate to outline the most prominent spirals, filling in the largest dark areas behind them and adding flyaways.

The highlights on the major curl strands are where the light hits most directly. Use cream to place these highlights. Further push the darks with dark umber; allow it to be uneven since there is hair in these areas too. Use dark umber to lightly emphasize some flyaways.

Apply very sharp burnt ochre with light pressure between the highlights on the major curl strands, where the light hits indirectly. Stroke in the same direction as the hairs as you move into the cream. Use very light pressure to give color to some of the flyaways and heavy pressure in the dark areas.

Use goldenrod over the burnt ochre on the strands, stroking in the direction of the hairs. Then use light umber where the light hits the strands indirectly. Use goldenrod and light umber for more flyaways. Finish by sharpening the boundaries of the major strands with raw umber. Blend if desired.

88 | Wavy Hair

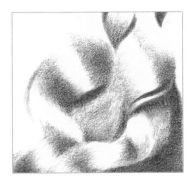 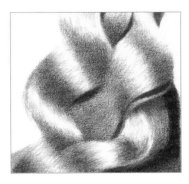 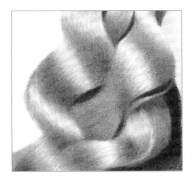 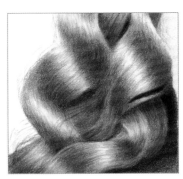

Wavy hair requires all strokes to curve in the direction of the hair. For this auburn example, begin with a light outline and a layer of cream for the highlights. Use sharp chocolate to define the gaps behind the strands and to block in areas between highlights. Overlap the cream a bit.

Use sharp terra-cotta and light pressure on top of the chocolate on the strands, with more coverage where the light is the most indirect. Allow it to overlap the cream a bit farther than the chocolate. Add a layer of dark brown on top of the chocolate in the gaps.

This is a rare instance where adding light over dark works well. Apply sharp beige over all the hair, except the brightest highlights, to blend the previous layers. If you wanted to depict blonde hair, this would be a good stopping point after drawing some individual hairs in the strands.

Use sharp terra-cotta and light pressure to add redness to the waves and suggest individual hairs. Use sharp dark brown and light pressure to add contrast to the darkest parts of the waves. Finish by adding a few flyaway hairs with sharp chocolate. Sharpen the boundaries of the waves as needed.

57

89 | Eye

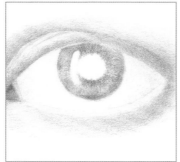
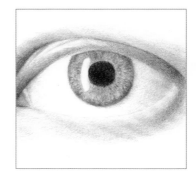
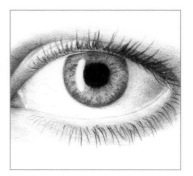

When drawing an eye, remember that the iris and pupil are perfectly circular, the pupil is centered within the iris, and reflections curve with the surface of the lens. Begin with an outline and a light layer of cream on the flesh, iris, and inner corner. Add a layer of white on the eyeball.

Apply light peach over the flesh, and then lightly model the eyelids and inner corner with nectar. Apply even color to the iris with jade green, followed by uneven burnt ochre radiating from the pupil. Use warm gray 10% to shadow the eyeball and corners. Add carmine red to the innermost corner.

Use henna to model the crease and eyelids, followed by peach and some blending. Add dark umber over the crease. In the iris, build color with jasmine and indigo. Fill the pupil with dark umber and use warm gray 30% to further model the eyeball and corners.

Use terra-cotta to finish the eyelids. Use burnt umber and touches of indigo around and within the iris. Fill the pupil with black. Finish shading the outer corner of the eyeball with warm gray 70%. Finish the eyelashes with dark umber, and soften the border of the iris with white.

90 | Nose

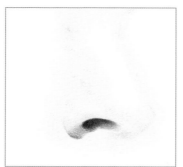
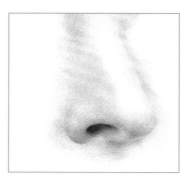
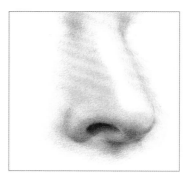

Each nose is a little different in shape and size, which is reflected in the highlights, midtones, and shadows. Build skin tones that depict convincing shapes. Begin with a light outline of the nose edge, the tip, and the nostril. Reserving bare paper for the brightest highlight, add a light wash of cream.

Draw the darkest recess of the nostril with dark umber and the darkest area under it with sharp henna and light pressure. Add a second layer everywhere else, again reserving the highlight, with sharp peach and very light pressure.

Use nectar and very light pressure to build the shape of the nose, with more coverage under the tip and where the curl meets the cheek. Lightly darken the area under the tip and the curl with henna. Note that the edge of the nose is indistinct at this angle and the highlight is not at the edge.

Despite warm light, some areas have cooler, pinker tones. Lightly apply rosy beige to hint at these tones along the edge, around the tip and nostril, and next to the eyes. Lightly darken around the nostril and under the tip with dark umber. Finish by using cream to blend away any roughness.

91 | Lips

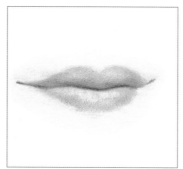
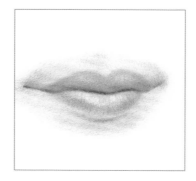
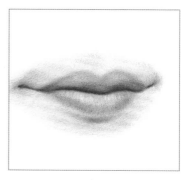

Natural, unpainted lips have soft boundaries and many subtleties of color. Begin with a very light outline and a light wash of cream to provide a waxy base for a smooth blend of the colors to come, reserving bare paper for the brightest highlight.

Draw the line where the lips meet with dark umber (darker at the corners). Add a second layer around the mouth with peach and light pressure. Lightly wash the lips with pink rose and pink. Use carmine red along the bottom of the upper lip, and add a few touches on the fullest part of the lower lip.

The area around the mouth helps shape the lips. Lightly apply nectar and as a third layer, with more coverage at the corners, under the center of the bottom lip, and above the center of the top lip. Use very light pressure to continue forming the lips; this will also help unify the colors.

Use henna and terra-cotta to lightly deepen the color on the lips, along the bottom and near the upper boundary of the upper lip, and in the fullest part and under the lower lip's center. Use dark umber to lightly sharpen the line of the mouth. Finish with pink rose and for the natural creases in the lower lip.

ANIMALS

92 | Smooth Canine Fur

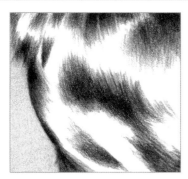 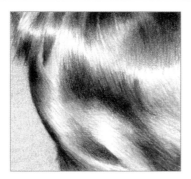 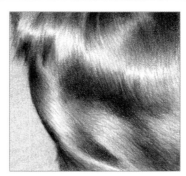 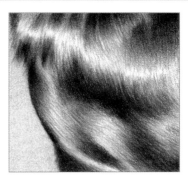

Always stroke in the direction of the hair growth, toward the highlights. For this black Labrador Retriever, begin by blocking in the darkest areas with sharp black, applying medium pressure at the beginning of strokes and light pressure at the end.

Add a silvery sheen to the coat by making strokes with very sharp cool gray 30% and light pressure in the highlights, overlapping the black a little.

Sometimes there are hints of color in the highlights of black fur. In this case, add a few light strokes with very sharp dark cherry throughout the highlights. Make strokes with very sharp cool gray 70% and medium pressure as a transition between light and dark areas.

Increase the contrast by adding more black with medium pressure in the darkest areas. To finish, use very sharp black and light pressure to draw some individual hairs in the highlights.

93 | Curly Canine Fur

Curly dog fur may seem daunting because of the overlapping tangled spirals. Start with the major curls and add detail as you go. For this blonde Cocker Spaniel, begin with a light outline and a light wash of cream. Then use jasmine to lightly block in the areas between the major curls.

Use sharp dark brown and medium pressure to block in the darkest areas, which are behind multiple layers of curls.

Use sharp light umber and medium-to-light pressure to expand out from the dark umber spots, creating midtones between the major curls. Note that your curls don't have to exactly match your reference to look like curly fur.

Add warmth to the midtones with burnt umber. Use it to lightly develop background curls. Add more jasmine over the burnt ochre to complete the major curls. Finish by sharpening the major curl boundaries and adding light strokes of light umber and dark brown to suggest individual hairs.

94 | Coarse Canine Fur

Coarse dog fur has no sheen and clumps in tufts, so it doesn't require a base layer or smooth blend. Stroke with very sharp pencils and light pressure in the direction of the tufts of fur. First draw the tuft's base and/or the shadow under its tip with raw umber.

Use peach beige to give a hint of color to the tips of the tufts. Then use French gray 20% to suggest a few hairs in the middle of some tufts.

Use both French gray 30% and French gray 70% to suggest more hairs in the tufts. Also use French gray 70% to further darken the bases of some tufts.

Finish with dark brown to accentuate the bases and shadows of some tufts even more, and add a few hairs—or rather, the shadows of hairs.

95 | Long Cat Hair

For this ginger cat, begin with a light layer of yellow ochre, planning the location of the strands with more coverage. Rather than drawing strands directly, draw the areas where other strands go under them.

Use burnt ochre and light-to-medium pressure to begin defining the dark areas under the strands. Suggest some individual hairs with light pressure.

Add mineral orange with light-to-medium pressure on top of the burnt ochre, and suggest more individual hairs with light pressure.

Use sienna brown with light pressure to suggest a few individual hairs, with medium pressure to increase the contrast around minor strands and heavy pressure for the darkest areas behind the layers of hair. Finish with touches of goldenrod and light pressure to yield the final ginger color, and use a colorless blender to smooth any roughness as desired.

96 | Short Cat Hair

 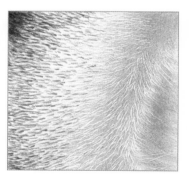 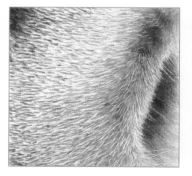 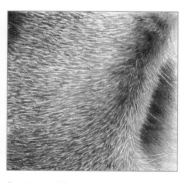

The keys to drawing short cat hair are to always keep your pencils very sharp and make all strokes very short and in the direction of the hair growth. An Abyssinian's "ticked" coat (in which hairs have bands of color) calls for allover short flecks of color. Begin by impressing very short lines in the paper with a stylus—these will become the highlight hairs as color is added. Use sand with light pressure to create a smooth base layer.

Use mineral orange with light pressure as a second smooth layer where the contour curves. Use dark umber to begin evenly adding dark hairs with medium pressure and very short strokes.

Continue adding very short strokes of dark umber. Draw longer, smooth strokes in the deep fold where the hairs are not ticked, and add a few strokes on the contour to suggest gaps. Use very short strokes of burnt ochre with medium pressure as a third layer on the contour, and use longer, smoother strokes in the deep fold.

Continue adding very short strokes all over with previous colors, as well as with chocolate and light umber. Aim to create a gradual transition with the marks, from cooler and browner at the left edge to warmer and redder at the contour. Finish with more mineral orange at the edge of the contour.

The keys to drawing long, soft cat hair are to always keep your pencils very sharp and make all strokes in the direction of the hair growth.

97 | Canine Eye

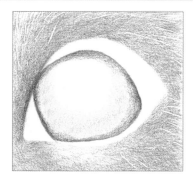 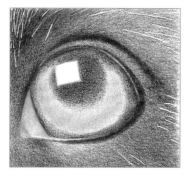 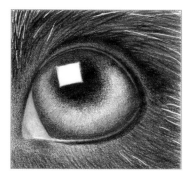 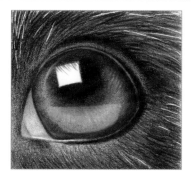

At first glance, most dogs' eyes seem simply brown, but they actually contain several colors, just like humans' brown eyes. For this example, start with a basic outline, and impress a few hair lines with a stylus so that they'll remain white as colors are added. Apply a light layer of sharp yellow ochre to the iris, a light layer of sharp powder blue to the inside corner, and a light layer of sharp chocolate around the inside rim of the iris and on the skin.

Use sharp dark umber with light pressure on top of all the chocolate and on the pupil, reserving bare paper for the square highlight. Use it with medium pressure in the eyelid creases. Add sharp grayed lavender with medium pressure on top of the cloud blue in the inside corner, and add a little sharp nectar to define the innermost corner membrane. Add a light layer of sharp burnt ochre in the iris.

With very sharp warm gray 50% and black, add all the hairs around the eye—short and fine underneath with medium pressure, longer and thicker above with heavy pressure. Use sharp black with heavy pressure in the pupil, but keep the edge indistinct. Use sharp terra-cotta and Tuscan red with light pressure around the pupil and inside the border of the iris with medium pressure.

Use sharp dark umber and medium pressure to blend the pupil into the iris and around the inside edge of the iris. Use very sharp black to add more hairs as needed and create contrast in the eyelid creases. Use a colorless blender to smooth the iris. Then use white with light pressure to add a curved highlight next to the square one and in the lower half of the iris to suggest reflection of the landscape. Finish by using very sharp dark umber and light pressure to add the reflections of the eyelashes in the square highlight and the iris.

98 | Cat Eye

 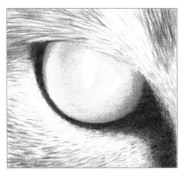 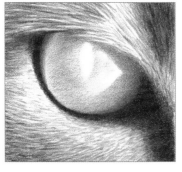 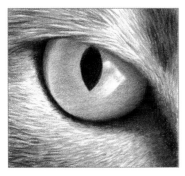

Wildcat eyes have round pupils, and domestic cat eyes have slit pupils. Some cat eyes change color slightly from day to day. Begin with a basic outline and a light layer of ginger root all around for the fur and a light layer of chartreuse for the iris; reserve bare paper for the highlight reflection.

Use very sharp light umber and dark umber with light pressure and short strokes to indicate the fur. Note that the hairs above the eye are longer than those below the eye. Use light umber with light pressure around the left and right inside border of the iris and a bit to the left of the pupil. Use dark umber with medium pressure around the under-eye rim and inside corner. Add a very light layer of jasmine to the iris.

Use very sharp sienna brown and chocolate with light pressure and short strokes to indicate more hairs. Use very sharp marine green with light pressure to adjust the color of the iris, applying more coverage under the brow and at the inside corner.

With sharp black and heavy pressure, fill the pupil and increase the contrast around the rim and inside corner. Use light pressure to add a few hairs. Then use very sharp mineral orange with light pressure to add a few more hairs. Use sharp dark umber with light pressure on the iris under the brow to increase the contrast there. Add more chartreuse to the iris if needed. If desired, finish by smoothing the iris with a colorless blender, avoiding the edges of the pupil and rim.

A horse's coat is very short, flat, and glossy, which enhances its muscles. Keep your pencils very sharp, and make all strokes very short and in the direction of the hair growth, which generally follows the horse's anatomy. You only need three colors for this example. Begin with mineral orange and light pressure. Indicate just a few hairs in the glossy area, and transition to more coverage where the coat is darker.

Use terra-cotta in the same manner. Add more coverage in the areas that will be darker in value.

Use dark brown with medium pressure to fully define the dark value areas, and fade to light pressure for a soft transition.

With medium-to-heavy pressure, keep adding terra-cotta strokes in the dark areas and mineral orange strokes in the areas between until the rich color is fully developed. If desired, finish with a colorless blender to reduce speckles.

100 | Horse Mane

 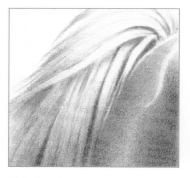 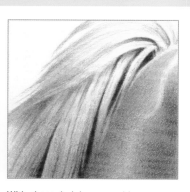

The main difference between a horse's mane and a human's hair is that the mane is coarser. It flows similarly, but the strands stand apart more. For this blonde Palomino, start with a basic outline of the flowing strands and a light overall layer of cream to provide a waxy base for a smooth blend of the colors to follow. The highlights will remain this color.

Make all your strokes in the direction of the strands. With sharp yellowed orange and light pressure, begin to indicate where layers of strands overlap, as well as the flyaway tips, which are darker away from the highlights. Use more coverage as the base color for the horse's neck.

With sharp burnt ochre and medium-to-heavy pressure, create the darkest gaps behind some of the strands. With light pressure, suggest subtle variations in the strands, and add smooth form to the horse's neck.

With sharp dark brown and heavy pressure, reinforce the dark gaps you created in the previous step. With light pressure, add a few strokes to suggest individual hairs. Add more strokes of yellowed orange and burnt ochre as needed to intensify the colors and strands. If desired, finish with a colorless blender to smooth the horse's neck and some of the strands; leave some strands rough to preserve the overall coarse-hair look.

Avoid overblending your horse's coat in the final step. Allow the slight roughness in the glossy area to remain and suggest a bit of sparkle in the highlight.

101 | Leopard Coat

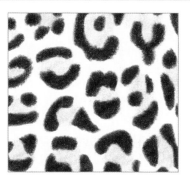

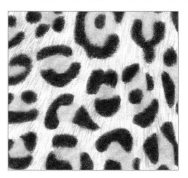

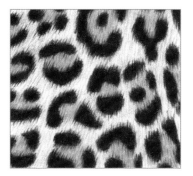

A leopard's coat is short and flat, like any short cat hair. What makes it interesting is its spot pattern. The spots are groups of blobs shaped like "C," "I," "L," and "U," as well as dots. The space inside a group is filled with brighter color. Begin with a basic outline of the dark blobs.

Use sharp ginger root with light pressure to fill the background, sharp beige with light pressure to fill the space inside each group, and sharp dark umber with medium pressure to fill the blobs. Allow the borders of the blobs to be indistinct for now.

Use sharp sand and medium pressure on top of the beige from the previous step. With very sharp light umber and light pressure, draw short strokes in the ginger root area to suggest hairs. Note that they don't all go exactly the same direction.

Use sharp mineral orange and light pressure as a third layer of color on top of the sand from the previous step. Then, with very sharp chocolate and medium pressure, draw short strokes in those areas to suggest hairs. With very sharp dark umber and medium-to-heavy pressure, draw very short strokes up from the tops of the dark blobs and down from the bottoms to suggest overlapping hairs at the boundaries. Use dark umber with heavy pressure to fully darken the interiors of the blobs.

102 | Elephant Skin

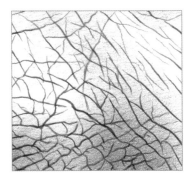

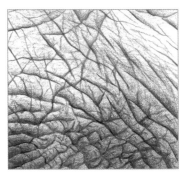

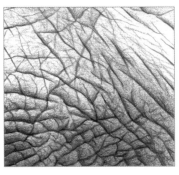

Elephant skin is surprisingly easy to draw, despite the number of wrinkles. There are a couple of key things to note: when a wrinkle is lit from above, the top edge has a shadow above it; and when a network of wrinkles crisscrosses, the puffy shapes they form may have shadows and crinkles on all four sides. The roughness works in the artist's favor, because you don't have to spend time creating smoothness. The skin is almost entirely grays. Begin with a light base layer of sharp warm gray 10%, warm gray 30%, and warm gray 50% to indicate overall light and dark areas.

With very sharp black and medium-to-heavy pressure, draw the creases, varying the thickness to indicate that some are deep and some are shallow.

With warm gray 70%, draw the shadows for the creases; use light pressure around shallow creases in the light, and medium pressure around deep creases in shadow. Use light pressure to draw some crinkles in the puffy shapes, and lightly scribble in the light areas to suggest roughness.

A dusty elephant isn't simply gray, so use sharp sandbar brown with light pressure over most of the skin. Finish with very sharp black and heavy pressure to reinforce some of the deepest creases.

103 | Snakeskin

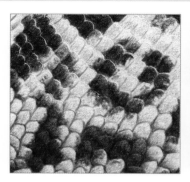
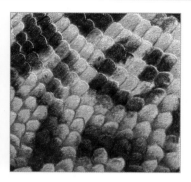

Snake scales overlap in rows that are slightly offset from each other, like shingles on a roof. Although they are hard and smooth, the coloration is uneven to lend camouflage, and the colors vary among individuals of the same species. For this example, begin with a basic outline of the scales.

Use a stylus to impress curves into the paper for the highlighted edges of scales that are lit from above. Then use sharp sand with light-to-medium pressure for an overall base layer, with more coverage toward the bottom where the snake's body curves under.

With sharp dark umber and heavy pressure, fill in the dark scales; use heavy pressure to outline them, and medium pressure to add blotches to the scales that aren't completely dark. With sharp chocolate and light pressure, indicate the edges of all the other scales, and add a slight amount at the base of each scale where it goes under another scale. Go darker with these lines and shading toward the bottom.

Add a light layer of Spanish orange to all the light scales. Use sharp cadmium orange with light pressure to add splotches to many of them and medium pressure to deepen the color of the scales toward the bottom. Use sharp sienna brown with very light pressure to darken the base of all the light scales so the overlap is more obvious, applying more coverage toward the bottom. Use very sharp sienna brown with light pressure to redefine the edges between scales if needed. Finish by sharpening edges and deepening overlaps as needed.

104 | Fish Scales

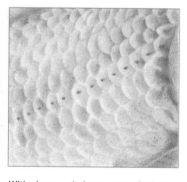

Fish scales are shiny and usually arranged in overlapping horizontal rows. For this example of a goldfish, begin with a light outline. Erase as much of it as you can while still being able to see it to ensure that the graphite lines won't show through the light colors to come.

Use sharp canary yellow and light pressure for an overall base layer, and then visit each scale with more coverage at the base where it goes under the scales to its right and below.

With very sharp yellowed orange and light pressure, enhance the base of each scale and fade the strokes outward, keeping the edges crisp. Note that there are slight variations in the colors of scales, since no two are exactly alike. Then use medium pressure around the gill at the right and along the base of the top and bottom fins.

With sharp cadmium orange, further enhance the bases of the scales closest to the gill and below the top fin, as well as some other scales throughout. Use medium pressure to add final brightness to the gill and the base of the top and bottom fins, and add the midline dots. Add a few touches of very sharp periwinkle on the bottom scales closest to the gill to suggest slight color variation. Smooth any roughness on individual scales with a colorless blender, and finish by sharpening scale edges as needed.

When using a stylus to indent in your drawing paper, be sure not to rough up the surface of the paper. Rips and tears can collect pigment unevenly.

105 | Feather

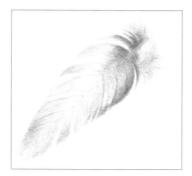
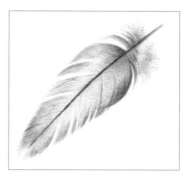

When drawing feathers, keep your pencils very sharp and stroke in the direction of the barbs of the shaft. For this example of a macaw, start with a basic outline. Erase as much of it as you can while still being able to see it to ensure that the graphite lines won't show through the light colors to come.

With powder blue and very light pressure, apply an overall base layer to the bluish areas of the feather. Do the same with goldenrod for the gold areas and cool gray 20% for the remainder. Use the cool gray 20% to draw the fluff near the base.

Draw the bluish barbs with ultramarine and very light strokes, varying the coverage so that some tips are darker and some separations become apparent. Do likewise nearer the base with light umber. Add a few light strokes of light umber in the center of the fluff.

Lightly apply indigo blue to the bluish barbs and tips to produce a lifelike variation of blues. Apply dark umber near the base. Add goldenrod in the gold areas and fade it along the shaft toward the tip. Finally, draw the base of the shaft with artichoke and dark umber, tapering the width to the tip.

106 | Butterfly Wing

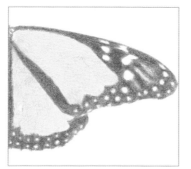
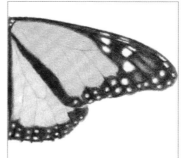
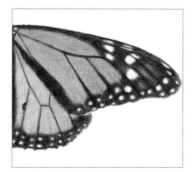

Butterfly wings are complex in structure and pattern. They aren't flat—the rigid veins and papery sections are like the ribs and cover on a hang glider. Seemingly flat areas of color are usually not, and spots vary among individuals of a species. For this monarch, begin with a basic outline.

For the first layer of color, use sharp sunburst yellow with light pressure throughout the sections, and light umber with light pressure for medium coverage in the margins. Don't draw the veins yet—save them until last to ensure they stay crisp.

Build multiple layers of color for a lifelike result. Lightly apply mineral orange throughout the sections, along with dark umber in the margins. Go over the veins in the margins with especially heavy pressure to make them visible. Use more mineral orange on the forewing than the hind wing.

For the final layer of color in the wing sections, use Spanish orange. Then draw the veins and pheromone spot with sharp dark umber, noting changes in vein width. Finally, use pale vermilion along the inside edges of each section, Add a few strokes midway between the veins to suggest slight ripples.

107 | Spiderweb

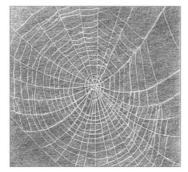
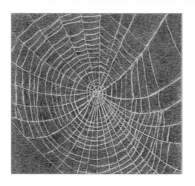
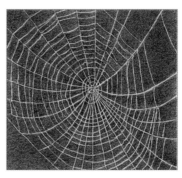

The shape, size, and structure of a spiderweb varies by the species and individual spider—no two webs are alike. Begin this garden spider web with an outline, and use it as a guide to impress the lines into the paper with a stylus. Then erase all the graphite with a kneaded eraser.

At this point you've already "drawn" the web, and you need only to make it appear with layers of color. Whatever colors you choose, use light pressure to build coverage, so as not to mash the paper down to the impressed lines and pollute them. For the first layer, use sharp kelp green all over.

For the second layer of color, use sharp black cherry with light pressure on top of the kelp green from the previous step.

For the third layer of color, use sharp indigo blue with light pressure on top of the black cherry from the previous step. If desired, continue with other colors.

108 | Burlap

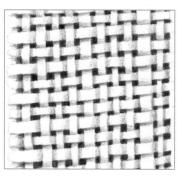

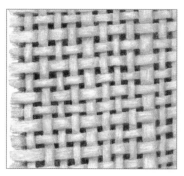

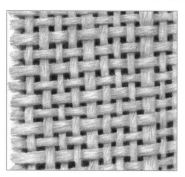

Burlap is a loose weave of very coarse jute threads of varying thicknesses, so precision is unnecessary. The hardest aspect is the first step—drawing the outline of the basic basket-weave pattern correctly, with gaps between the threads.

Use sharp dark brown with heavy pressure to fill the rectangular gaps between the threads. Then use sharp light umber and light pressure to define where each thread passes under another, crisp at the edges and faded toward the center of each section.

With the weave in place, use seashell pink and light pressure to color the threads; stroke in the direction of each thread so they begin to look fibrous. Then use medium pressure along the bottom side of each horizontal thread and along both sides of each vertical thread for a more rounded shape.

Use very sharp sienna brown and light pressure to stroke a few fine lines in the same direction as the threads to suggest fibers. Use this pencil to further define the rounded form of the threads and draw crisper edges where they pass under each other.

109 | Wool

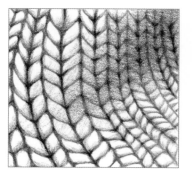

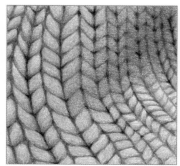

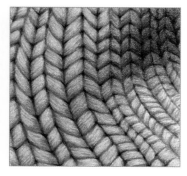

For this close-up example of thick herringbone stitches in a turquoise wool knit sweater, begin with a basic outline of the stitches.

With sharp indigo blue and medium pressure, outline the stitches so the points pull down and the edges are slightly rounded. With light pressure, shade the lower part of each stitch to begin giving it form, and shade the shadow from the fold in the fabric.

With light aqua and light pressure, add color to all the stitches, stroking in the direction of the yarn in each stitch. Create more coverage in the fold and less in the lit area below it. Use shading and medium pressure on top of the indigo blue lines.

Apply cobalt turquoise in fine lines over each stitch to suggest wool fibers. Further define the edges of each stitch. Use indigo blue to define the fold and stitch edges. Then stroke a few fine lines in some stitches to suggest more fibers. Finish with black at the intersections to increase contrast.

110 | Tweed

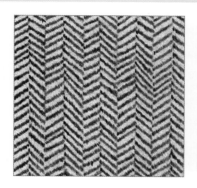

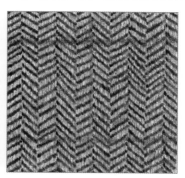

Tweed is a thick, woven wool fabric with a fine herringbone pattern in earth tones, usually with very subtle windowpane stripes of other colors. For this example, begin with an outline of the herringbone pattern; note that the ribs are offset from each other.

Use sharp peach beige with light pressure for an overall medium base layer. Allow the appearance to remain a bit rough, which will contribute to the woolen appearance.

With sharp dark umber and heavy pressure, draw the herringbone ribs in very short, vertical strokes. They don't need to be perfect.

Use sharp chocolate with light pressure to add very small vertical strokes between the dark herringbone lines to suggest threads in the weave. Finish with sharp terra-cotta and sharp Caribbean sea with medium pressure to add the subtle horizontal and vertical windowpane threads.

111 | Plaid

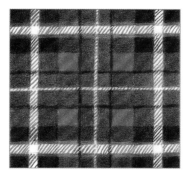

Plaid is a complex pattern, rather than a texture. There are hundreds of plaid patterns and color combinations, all based on overlapping perpendicular lines and squares with a transparent effect. Begin with a careful outline of all the lines and squares.

With sharp permanent red and heavy pressure, fill the four brightest squares, which are the focal point of the pattern. With light pressure, fill the four ribbons that intersect to produce those squares with a medium layer of color. Avoid the stripes that will overlap them, and keep the edges crisp.

With sharp Prussian green and heavy pressure, fill the four squares in the very center and the sets of four squares in each corner. With light pressure, fill all of the other squares with a layer of color. Again, be careful to avoid the stripes that will overlap them, and keep the edges crisp.

Add a second layer of color over all squares, except the brightest red and green ones at the center. Use the three previously used colors to draw sharp, parallel, evenly spaced diagonal lines across the remaining white stripes. Leave the intersections white. Finish by smoothing with a colorless blender.

112 | Denim

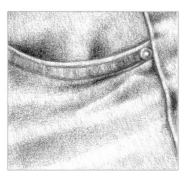

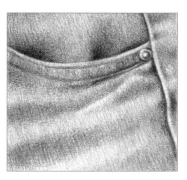

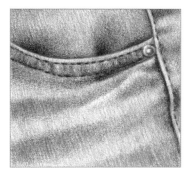

Denim is made in a variety of colors and washes, but they all have in common a heavy cotton weave, with noticeable vertical striations that are easy to draw. Start with a basic outline of the seams and pockets, and use very sharp indigo blue and medium pressure to place the darkest lines.

With sharp indigo blue and light pressure, create a monochromatic version of the jeans. Try to make the most of your strokes by following the direction of the fabric, and allow your pencil to get a little dull so that the appearance is a bit grainy.

Use sharp cerulean blue with light pressure on top of the indigo blue from the previous step, making long strokes to suggest the striations in the fabric. Create more coverage in the folds and creases. Use sharp black with medium pressure to increase the contrast along the seam and top of the pocket.

With very sharp indigo blue and heavy pressure, draw the stitches with short, evenly spaced strokes. Then use it with light pressure to enhance the subtle puckers between the rows of stitches and on both sides of the seam, and adjust the contrast of the creases as needed.

113 | Cotton

When drawing white cotton in color, a simple rule of thumb makes it easy. If the light is warm, the shadows are cool, and vice versa. Build the values; then add color. Apply a layer of white to provide a waxy base for blending. Then use warm gray 10% to wash over all but the brightest highlights.

Use warm gray 30% with light pressure to add midtones to the shadows and creases and medium pressure where the darkest shadows are.

Use warm gray 70% with light pressure to create contrast in the creases, and with medium pressure, create the darkest shadows. Now that the value range is complete, use cream with light pressure on the highlights to suggest that the fabric is lit by warm light.

Use sky blue light with light pressure on top of the grays on the shaded side of the folds and creases. Create more coverage in the midtones and less in transitions.

FABRICS & TEXTILES
114 | Silk

 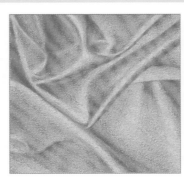 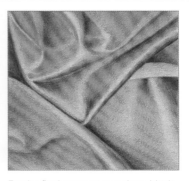

Silk is very smooth and shiny, but not as shiny as satin. The challenge is to create the smoothness; the process isn't hard, but it is time-consuming. Begin with a basic outline of the folds and an overall light layer of white to provide a waxy base for a smooth blend of the colors to follow.

The highlights will be the same color as the fabric rather than white, so use hot pink to apply an overall wash. Make it as smooth and even as you can to keep further applications of color smooth. If any blobs occur, dab them off with poster putty.

With sharp process red and heavy pressure, draw the darkest creases and folds. Then, with medium-to-light pressure, model all the other folds and creases. This is now a complete, but monochromatic, drawing.

For the final contrast, use sharp black grape in the deepest creases and folds. Then lightly add depth around these creases and folds. Finish with sharp white and light pressure to smooth any roughness in the highlights, and then smooth all over with a colorless blender.

115 | Satin

 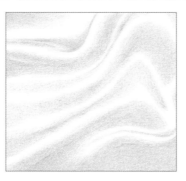 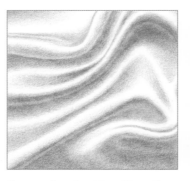 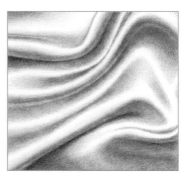

Satin is so smooth and shiny that its highlights appear white. The fabric reflects light from neighboring folds, so the darkest part is a band within the shaded side. For this example, begin with an outline of major folds so the lines won't show through the light colors. Then apply a light layer of white.

Working from light to dark will help create a smooth blend, so for the first layer of color, use very sharp electric blue with light pressure. Add more coverage in areas that will be darkened in later steps.

Use very sharp true blue with medium pressure to darken the deepest creases, and draw a stripe down the middle of the shaded side of each fold. Use light pressure to shade the forms between the folds.

Use very sharp indanthrone blue to add the final depth of the deepest creases. Use very sharp cerulean blue with light pressure to intensify the color between folds and the stripe down the middle of the shaded side of each fold. To finish, smooth all over with a colorless blender.

116 | Velvet

The thick plushness of velvet lends it very rich color. This is one instance when heavier pressure and coverage works well. Begin with a basic outline of the major folds and an overall light layer of white to provide a waxy base for a smooth blending of the colors to follow.

With sharp permanent red and light pressure, create an overall medium wash. This is the warm undertone for the fabric.

With sharp pomegranate and light-to-medium pressure, smoothly model the folds, avoiding the highlight edges. Use heavier pressure in the darkest creases.

Use sharp black grape over the pomegranate to increase the contrast of the folds, again avoiding the highlights. Use medium pressure in the darkest creases. Use lemon yellow to draw a subtle highlight along the two brightest edges. Finish by smoothing overall with a colorless blender.

117 | Leather

 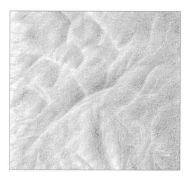 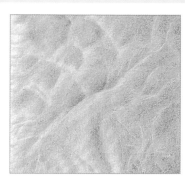 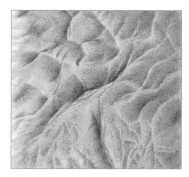

Tanned leather has crinkles, creases, and a warm undertone. For this example, begin with an overall medium layer of eggshell to provide warmth and a waxy base for blending later. Use a stylus to impress a few faint crinkles, which will show up later.

With pumpkin orange, lightly block in the major creases and crinkles, such as the diagonal across the center, followed by the minor ones. Then shade everything else around them, gradually building the value range and slightly lumpy forms. Shade according to the direction of the light source.

To warm the tone more, use sharp Spanish orange and light pressure overall, except in the brightest creases.

Use burnt ochre to tone down the overall orange. As the impressed lines begin to appear, shade one side of them to increase contrast in the texture using sienna brown and dark umber. Finish by smoothing with a colorless blender, working alongside but not across the creases.

118 | Sequins

Individual sequins are not completely flat, due to their attachment points. Depending on the light, their color may be solid or graded. This is most noticeable in the brighter—but not brightest—sequins. They overlap as the fabric moves. For this example, begin with an outline of most of the sequins.

Reserve bare paper for the brightest sequins. With canary yellow, fill the second-brightest sequins. With goldenrod, fill the third-brightest sequins. Use goldenrod to lightly shade some of the canary yellow sequins. Don't worry too much about staying within the lines in this step.

With mineral orange, fill the fourth-brightest sequins. With terra-cotta, fill the fifth-brightest sequins. Use terra-cotta with light pressure to slightly darken some of the mineral orange sequins. Fill gaps with mineral orange, and lightly add it to a few of the goldenrod sequins.

With dark umber, darken some of the terra-cotta sequins to create the darkest sequins. There should be equal amounts of dark and white. To finish, clean up edges and use poster putty to dab away any dark crumbs that have contaminated the white sequins.

119 | Lace

 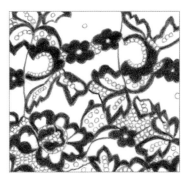 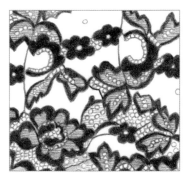 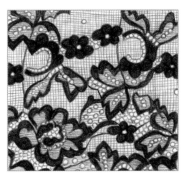

Lace can be intimidating because of its complexity of patterns and stitches. The key is to divide and conquer, working from major shapes to details a section at a time to avoid getting lost. Start with a fairly detailed outline.

With very sharp indigo blue and light pressure, go over the entire outline. Then fill the solid shapes with medium-to-heavy pressure. Keep the lines and edges crisp, sharpening your pencil often.

Use indigo blue to lightly draw all the horizontal lines in the leafy sections. They don't need to be perfectly straight—there are always slight imperfections in lace—but keep them evenly spaced. Note that some sections of the design have closer-spaced lines than others.

With very sharp indigo blue and light pressure, draw the grid around the leafy sections. Again, perfection is not necessary, but keep the horizontal and vertical lines evenly spaced overall. Finish by outlining all the solid areas with very sharp black grape and heavy pressure.

69

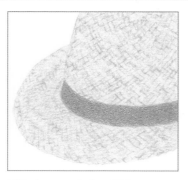

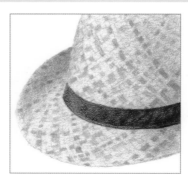

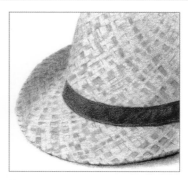

The weave of a straw hat can be challenging, not only because of the pattern but because it curves in multiple directions. The key is not to try to draw every strip, but to draw some and only suggest others. Begin with a fairly detailed outline of the weave.

With sharp eggshell and light pressure, create a light wash for the straw. Do the same with nectar for the band.

Use sharp yellow ochre and sharp beige sienna, both with light pressure, to give form to the hat, with even more coverage where the brim curls. Use sharp chestnut with light-to-medium pressure to give form to the band and sharp black raspberry with medium pressure to add puckers. Then use very sharp yellow ochre, artichoke, and beige sienna, all with light-to-medium pressure, to fill some of the rectangular strips in the weave, which spiral around the hat in both directions. Try to keep the edges crisp.

With very sharp dark brown and light pressure, enhance the shadow-side edges of some of the rectangular strips and the corners where some of them cross, as well as along the edge of the brim. Finish by drawing a shadow under the hat with warm gray 20% and warm gray 90%.

121 | Woven Basket

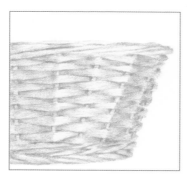

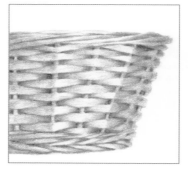

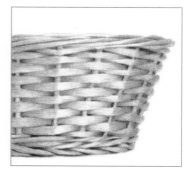

For this example, begin with a detailed outline, and then use sharp cream for an overall light base layer. This will provide both a warm undertone and a waxy base for a smooth blend of the colors to follow.

For the remaining three steps, always stroke in the direction of the strips. With sharp yellow ochre and light pressure, shade the strips where they pass behind or under anything, and where the basket curves away from the light source.

With very sharp burnt ochre and light pressure, further enhance the contrast where the strips pass behind or under, closer to those intersections. Keep the edges crisp.

Use sharp mineral orange and light pressure to blend any roughness in the burnt ochre from the previous step and create a warmer look where the basket curves away from the light source. Finish by increasing the contrast of the darkest intersections with very sharp chocolate and light pressure.

The key to a successful basket weave, regardless of the pattern, is to remember that strips are always darker where they pass under or behind and lighter where they pass over or in front.

122 | Clear Glass

 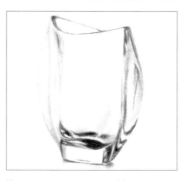 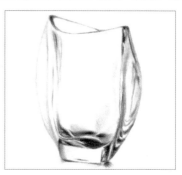

If you keep track of the refraction lines and curves where light bends inside it, clear glass is surprisingly easy to draw. For this example, we'll use only cool grays to show that even with colored pencils, no color may be needed. Start with an outline of the vase and its major refractions. Be sure to erase as much of it as you can and still see it, so the graphite won't show through the light colors to come.

Reserve the bare paper for the clearest, brightest highlights. Use sharp cool gray 10% with light pressure to draw the lightest areas that are not completely clear or highlights.

Use very sharp cool gray 30% with light pressure on top of some of the previous gray to increase the contrast and suggest subtle shifts in value. Use very sharp cool gray 90% with medium pressure to create the darkest areas in the base. Use light pressure to define the rim, the base where it meets the table, and some refraction lines along the sides.

Now that the lightest and darkest areas are defined, use very sharp cool gray 50% with light pressure to add the middle-value refractions along the sides and in the base. Make final adjustments to contrast in any of the grays as needed.

123 | Stained Glass

The challenge of stained glass is that it has very saturated color and is translucent. Start with light, bright colors before adding darker tones. Also, add the very dark strips between the panes last so the edges stay crisp and dark crumbs don't pollute the panes. Begin with an outline of the panes and strips. Erase as much of the outline as you can and still see it, so the graphite lines won't show through the light colors to come.

For the first layer of color, keep all your pencils very sharp and apply with light pressure to get to medium coverage. Use lemon yellow, pale vermilion, hot pink, carmine red, chartreuse, apple green, light aqua, and electric blue.

Apply the second layer of color in indistinct blobs to suggest the outdoors on the other side of the glass. Keep all your pencils very sharp and apply with light-to-medium pressure. In the same order as the previous colors, use sunburst yellow, henna, mulberry, crimson lake, spring green, cobalt turquoise, grass green, and Mediterranean blue. To suggest textured glass, apply the mulberry and the Mediterranean blue in uneven lines, and use very sharp white with medium pressure to enhance the contrast above these lines.

Finish with very sharp black and heavy pressure to draw the strips between the panes. Try to keep the edges very crisp—sharpen the pencil often. It's OK for the thickness of some strips to vary a bit, because real stained glass window strips usually vary as well.

 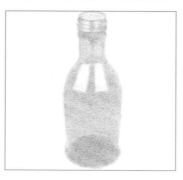 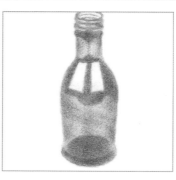 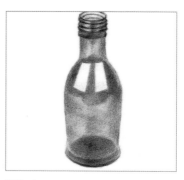

Like a translucent balloon, colored glass is smooth and reflective, but it's more transparent and refractive, like clear glass. For this example of a cobalt blue bottle, begin with a basic outline of the bottle and the major reflections. Erase as much of it as you can and still see it, so the graphite lines won't show through the light colors to come.

With very sharp light cerulean blue and light pressure, create an overall light wash, with more coverage in the areas which will be darker, such as the collar and base.

With very sharp cobalt blue and light pressure, enhance the more saturated color areas—the collar, base, and shoulder—with medium coverage. Use it very lightly near the edges to begin giving the bottle form.

With sharp violet blue and medium pressure, give final intensity to the deepest blues of the collar, shoulder, and base. Use it lightly near the edges to give the bottle its final form. Then use very sharp indanthrone blue with medium pressure to define the screw-top rings at the opening and the bottom of the base. Add hints of it in the center of the base and along the sides to enhance the transparent look. Clean up edges as needed, and finish with a colorless blender to smooth overall.

125 | Porcelain

 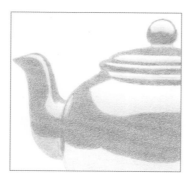 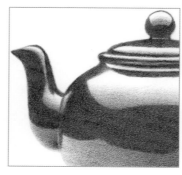 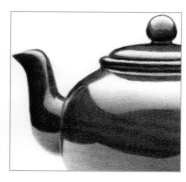

The challenge of porcelain is its saturated color with a very smooth, shiny glaze that produces reflections and smooth gradations. It calls for both very light and heavy layers. Begin with a basic outline that includes the reflective areas.

Use very sharp powder blue with light pressure to create a base for the gradients in the highlight reflections. Use very sharp Caribbean Sea with light pressure to create a medium wash in the rest. Apply both as smoothly as you can.

Use very sharp ultramarine with very light pressure on top of the powder blue in the highlight reflections. Use it with medium pressure in the rest. Keep the edges and borders very crisp.

Use very sharp indanthrone blue with medium-to-heavy pressure to model the forms in the dark areas—the undersides of the handle, lid, and spout, and the border of the pot. Also, use it to darken the lower part of the dark band around the center. Use more very sharp Caribbean Sea with light-to-medium pressure to smooth the highlight reflections, and sharp white with light pressure to smooth them to the brightest highlights. Finish with a colorless blender to completely smooth overall.

126 | Gold

 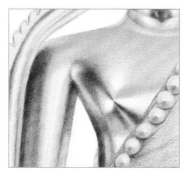

Shiny gold is surprisingly easy to draw, and you need just four colors. Begin with an outline and an overall medium wash of sharp canary yellow, reserving the bare paper for the brightest highlights.

Use very sharp yellowed orange with light pressure on top of most of the canary yellow, except where it is very bright near the highlights.

Use very sharp sunburst yellow with light pressure to create an intense transition zone between the previous two colors, particularly down the arm and next to the highlights. Also, layer it lightly across the upper chest.

With very sharp burnt ochre and medium pressure, add the dark areas that give form to the sides of the arm, the side of the body, and under the chin, and fade them into the surrounding color with light pressure. Then, for final contrast, use sharp chocolate with medium pressure along the outside edge of the arm, in the armpit, and along the side. Use it with light pressure in the center of the burnt ochre areas on the chest and under the chin. If desired, smooth with a colorless blender.

127 | Polished Silver

 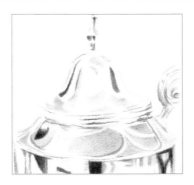 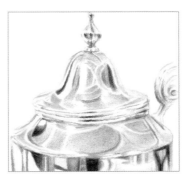

When polished, silver is almost as reflective as a mirror. This makes it surprisingly easy to draw with cool grays and blues, as long as you keep track of the reflections and highlights. Begin with a basic outline. Erase as much of it as you can and still see it, so the graphite lines won't show through the light colors to come.

First identify shapes that contain blue and fill them with a light layer of powder blue. Then identify shapes that are the lightest gray and fill them with a light layer of cool gray 10%.

Use very sharp blue slate with medium pressure on top of the powder blue on the left-side shapes and very sharp periwinkle with light pressure on the right-side shapes. Identify the very darkest shapes and fill them with sharp cool gray 90% and medium pressure. Identify the next-to-lightest gray shapes and fill them with very sharp cool gray 30% and light pressure. Reserve the bare paper for the highlights.

Identify the next-to-darkest gray shapes and fill them with very sharp cool gray 70% and medium pressure. Now that all of the basic shapes are filled, continue looking for more shapes and details and draw them with the appropriate blue or gray. Finish by cleaning up the edges of all the shapes and dabbing with poster putty to recover highlights as needed.

128 | Pewter

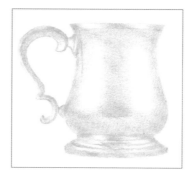

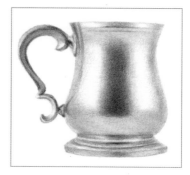

Pewter is an alloy of tin and either copper or antimony, with a silvery color and a dull, nonreflective shine. It's easy to portray with just four grays. Begin with a basic outline. Erase as much of it as you can and still see it, so the graphite lines won't show through the light colors to come.

With cool gray 10% and light pressure, create an overall light wash.

With cool gray 30% and light pressure, begin to model the round form of the cup by shading where it curves away at the edges, underneath the lip, and above the base. Use more coverage down the center where it is darkest.

With cool gray 70%, lightly build contrast by shading around the curves of the cup, base, and the underside of the handle. Apply more coverage down the center. Add touches of cool gray 90% in the center of the dark area and along the handle details. Finish by smoothing with a colorless blender.

129 | Copper

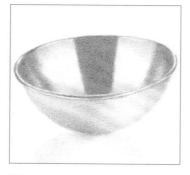

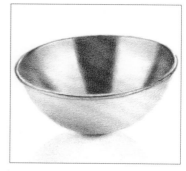

Although colored pencils are available in metallic copper colors, they're of little use in creating a realistic copper texture. Five colors together work much better. Start with a basic outline of the pot and interior reflections. Lighten the graphite so the lines won't show through the light colors to come.

With sharp light peach and light pressure, create an overall light wash, with more coverage in the dark reflection areas and underside and less in the light reflection areas.

With nectar, add the dark reflection in the center, allowing its edges to be a bit soft. Use it with lighter pressure to add the dark reflections at the sides, and note the slightly lighter areas in their centers. Next, lightly shape the inside and underside of the bowl. Then sharpen the tip and add the rim.

Use cadmium orange hue to brighten the center of the dark reflection and the dark reflections at the sides. Then use sharp Tuscan red with light pressure around the cadmium orange. The side reflections are more orange. Define the rim with Tuscan red. Smooth any roughness with a colorless blender.

130 | Wrought Iron

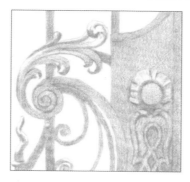

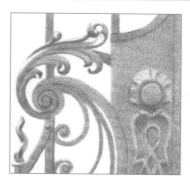

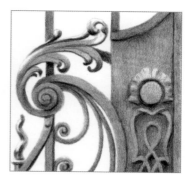

Although you might think of wrought iron as black, it often has a dark, bluish-gray patina, which we will produce in this example with just three colors. Begin with a basic outline.

For the first layer, use sharp cool gray 30% and light-to-medium pressure to create a monochromatic drawing with more coverage in shadow areas. Keep the edges crisp.

Repeat the previous step with sharp slate gray and light-to-medium pressure on top of the cool gray 30%.

Repeat with sharp cool gray 90% over the slate gray. Allow the coverage to be a little uneven for a realistic patina. Then use the sharp cool gray 90% to draw the darkest lines and shadows. Finish by smoothing with a colorless blender; allow a little roughness to remain for the patina.

131 | Clay Pottery

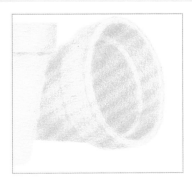 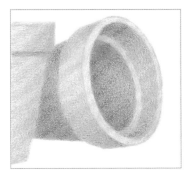 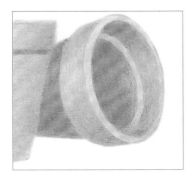 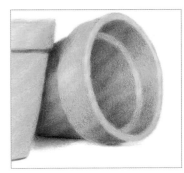

Terra-cotta clay pottery has a dull finish that lends itself to a different technique for blending. Begin with a basic outline and a light wash of yellow ochre, with more coverage where the pot curves away from the light on the inside and outside.

Use sharp cadmium orange hue with light pressure on top of the yellow ochre, again with more coverage where the pot curves away from the light. Don't worry if the color is a little rough—the next step will take care of it.

Moisten a paintbrush or cotton swab with odorless mineral spirits and gently apply it to dissolve the wax binder, staying within all the lines. This prevents speckles of paper from showing through. Allow the mineral spirits to evaporate completely (about 15-20 minutes).

With the wax dissolved, blending will be easier. Use cadmium orange hue and peach to even out blotchiness and clean up edges. Add dark shadows to the pots with terra-cotta. Add dull highlights with light peach. To finish, add a shadow under the pots with various cool grays.

132 | Rusted Steel

 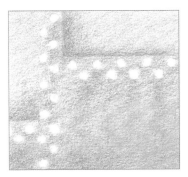 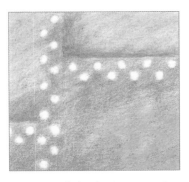 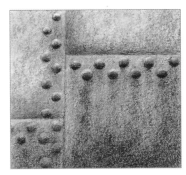

Rust ranges in color from light orange to dark reddish-brown. It's easy to render its coarseness without drawing every speck. Start with a basic outline of the seams and rivets.

Apply layers of periwinkle and mineral orange that blend into each other with dull points, and don't worry about unevenness. Note that rust migrates downward, so there should be more orange toward the bottom.

Moisten a paintbrush or cotton swab with odorless mineral spirits and apply it overall to dissolve the wax away. This will ensure that subsequent darker colors don't blend into the light colors and stay rough. This is the base color for the rust.

With light pressure, hold the pencils on their sides and apply thin, sparse layers of cadmium orange hue and Tuscan red, focusing on the joints and bottom. Use the same two colors to draw the rivets, using Tuscan red for the side away from the light and cadmium orange hue in the center.

133 | Brick

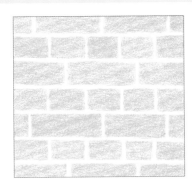 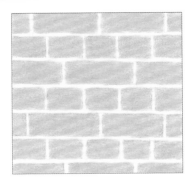 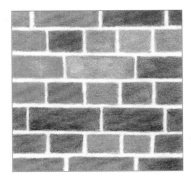 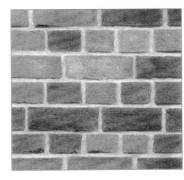

Old bricks are fun to draw because they are rough, imperfect, and uneven in color—and the colors vary from brick to brick. Begin with an outline of the brick pattern and a medium wash of peach on the individual bricks.

Moisten a paintbrush or cotton swab with odorless mineral spirits and gently apply it to the bricks to dissolve the wax and keep speckles of paper from showing through. Don't worry about blotchiness. Allow the mineral spirits to evaporate completely (15-20 minutes) before proceeding.

In this next step, apply all the colors with a dull point: nectar, henna, beige sienna, chestnut, and black raspberry. Experiment with layering any two of these colors, in either order, for a given brick. Allow them to be coarse, but keep the edges crisp. Use a colorless blender to smooth the bricks a bit.

Draw the mortar with dull French gray 20% and medium pressure, allowing it to be coarse. Finish by drawing the bottom edge of each brick with very sharp French gray 90%; make some of the edges and corners a little irregular to suggest that chips have broken off.

134 | Marble

Marble's translucence allows underlying veins to show through. This makes it easy to draw; blotchiness and jagged lines only add to the realism. Begin with an overall light wash of white for the base. Then block in faint blurry areas with sharp grayed lavender and cloud blue using light pressure.

With very sharp beige and light-to-medium pressure, create the basic veins with jagged lines that cross each other in a few places. Darken some places in the cloud blue area with sharp periwinkle and light pressure.

Continue adding thin, faint veins. Reinforce a few small segments of veins with very sharp beige sienna and light pressure. Also, add a few very faint veins with sharp lilac and very light pressure. Continue building the bluish and purplish values throughout, including between some of the veins.

With sharp sepia and light pressure, reinforce some of the intersections of veins and indicate some veins at the surface. Finish with a colorless blender to smooth some of the bluish and purplish areas and some of the faintest veins—this adds to the translucent effect.

135 | Pearl

Much like marble, pearl has a translucent quality, but the gleaming surface is low contrast. Begin with an overall light wash of white for the base. Then draw the basic curves and shadows with cool gray 10% and light pressure.

With sharp pink rose and light pressure, tint any areas that have even a hint of pink. Don't worry about your lines being perfect; keep the form organic.

With sharp cloud blue and light pressure, tint any areas that have even a hint of blue. In some places, draw on top of the pink rose to build a purplish tint.

With cool gray 50%, lightly draw the darkest creases. With cool gray 30%, darken the shadow side of the undulations. Add more pink rose and cloud blue to intensify the shadows. Where there are several layers of color, smooth with a colorless blender; where there are fewer layers, blend with white.

136 | Amethyst

The keys to successfully drawing any cut gemstone are to keep the pencil points very sharp, which requires frequent sharpening, and to keep the edges of very crisp. Begin with an outline of all the facets and refractions of facets that you can see.

For this amethyst, we will use only purples and white. First identify the pure white highlight facets, and fill them with white. Then identify the very darkest facets, and fill them with dioxazine purple hue. Fill the top facet with a medium wash of lilac. Use these two colors to add a few more facets.

There are likely a couple of other distinct colors in the facets, so identify them and fill them with dahlia purple and imperial violet. Smooth facets with a colorless blender as you go.

Continue filling facets with the four purples and light-to-medium pressure. Some facets are indistinct. Some facets transition between two colors. Some need a bit of white for a lighter tint. Finish by sharpening any edges that became soft during blending.

137 | Smooth Wood

 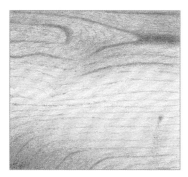 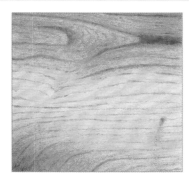 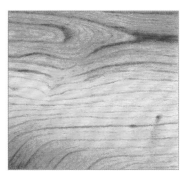

Smooth varnished or stained wood has a warmth and richness that shows off the wood grain. Apply all pencil strokes in the direction of the wood grain. For this example of pine, begin with a wash of sand. Then use sharp burnt ochre and light pressure to suggest the areas where the wood is darker.

Use sharp goldenrod with light pressure on top of the burnt ochre to add warmth. With very sharp chocolate and light pressure, draw the grain lines. Don't worry about detail yet.

Moisten a paintbrush or cotton swab with odorless mineral spirits, and gently apply it in the direction of the wood grain to dissolve the wax. This will intensify the colors and keep speckles of paper from showing. Allow the mineral spirits to evaporate completely before proceeding.

To finish, use very sharp burnt ochre and chocolate with light pressure to reinforce some of the wood grain lines, Then use very light pressure to add some fainter grain lines.

138 | Aged Wood

 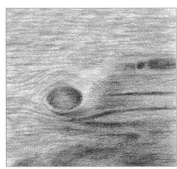 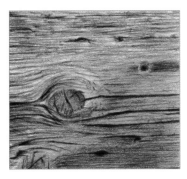

Weathered wood is fun to draw because it rewards rough, heavy-handed treatment. Where it is very dry and cracked, it's rough; where newer wood is exposed, it's smoother. Begin with dull mineral orange to plan areas of the knots and newer wood. Bring some streaks into the old wood area.

Use somewhat dull French gray 30% and medium pressure to fill the areas of the old wood. Overlap into the mineral orange a little, and bring some streaks into the new wood area; they will be hard to see.

With sharp French gray 70% and medium pressure, add long, uneven, jagged lines in the direction of the wood grain in the old wood area. Do the same with Tuscan red in the newer wood area, and start to indicate streaks and the inside perimeter of the knots.

Use a colorless blender to smooth the newer wood. Then use dark umber to create cracks and nail holes. Flow lines around the knots. With Tuscan red, draw grain lines in the newer wood. Add touches of Tuscan red and mineral orange in the old wood, and mark across the grain with dark umber.

139 | Wooden Barrel

 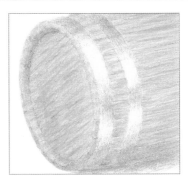 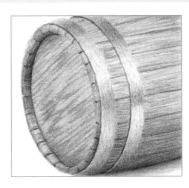

Barrels are most commonly made of oak, held together by steel hoops. For this example of a relatively new barrel, begin with a basic outline.

Use sharp sand and light pressure to create an overall medium wash for the oak. Use warm gray 10% and light pressure for the hoops and shadow, with more coverage where they are less reflective.

Use sharp mineral orange to lightly draw many fine lines of varying length and thickness for the staves' wood grain. Define the bold grain pattern on the lid, and add contrast under the top of the rim. Keep the hoop edges crisp. Use sharp warm gray 30% to enhance the darks of the hoops and shadow.

Add fine wood grain lines in the staves with sharp terra-cotta. Enhance shadows along the rim and the grain pattern on the lid. Use warm gray 70% to stroke in the direction of the hoops for more contrast. Allow it to look a little rough. To finish, deepen the shadows and refine the edges.

140 | Smooth Bark

Sycamore bark is interesting because it is smooth, but it also has subtle, irregular color shapes—like a jigsaw puzzle. Begin with a light outline. The shapes don't need to be exact, because nature isn't exact.

Cover the area with a light wash of cream. This provides a slightly warm color base and a base for later blending. Indicate the darker patches with a light layer of 20% French gray. Since the trunk surface isn't perfectly smooth, add some touches in the surrounding areas to create texture.

The darker patches should have a cooler tone than the surrounding areas, so add a bit of slate gray, as well as light touches in the surrounding areas. Use this color to begin defining the knots. With a very sharp point and very light pressure, draw the bottom edges of some of the patches.

To finish, use black grape to lightly reinforce some of the areas and edges on which you used slate gray. This will produce a shallow 3-D effect, just like real bark.

141 | Rough Bark

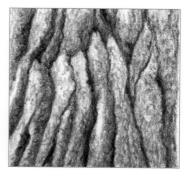

Pine bark is very rough, with deep, uneven grooves and subtle color all over. Begin with a basic outline of the deep grooves.

This is one of the few occasions when it works best to use the side of the colored pencil instead of the point. Cover the whole area with a light and very uneven layer of cool gray 20%. Allow a few spots to remain white—these will be the bark highlights.

Use cool gray 70% on its side to roughly define the deep grooves. Use a tiny scribbling motion to darken the lighter gray areas. With a dull light umber point, add dabs of color everywhere except the highlight. These dabs are flecks of bark that have fallen off, showing fresher bark beneath.

Use a tiny scribbling motion with black raspberry to create color inside the grooves. Add dabs and scribbles where you previously dabbed light umber. Use a black pencil to sharply define thin cracks and deep recesses. With a scribbling motion, darken the grooves next to the sharp lines for depth.

142 | Thatched Roof

A thatched roof is made of palm fronds or bunches of grass, attached in vertical, overlapping layers. Strokes for these steps should be vertical, following the direction of the grasses. Begin with a light layer of cream, applied in uneven vertical strokes. The unevenness will create highlights later.

Use beige to define the edges of the thatch layers with quick strokes that begin heavy at the top and fade to light. Vary your pressure and allow the strokes to overlap. Make some heavier, shorter strokes closest to the edge as needed.

Further define the edges of the thatch layers with light umber. Make some strokes from the edges upward to start defining the tips of the grass.

With a very sharp point, use burnt ochre to add fine strokes to multiply the blades of grass. Add a few heavy, short strokes upward and downward from the edges of the thatch layers. Use chocolate to suggest more blades of grass. To finish, deepen the shadows along the edges of the thatch.

143 | Pine Needles

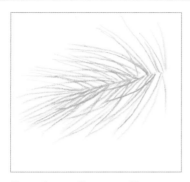 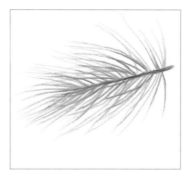 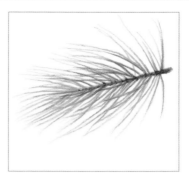 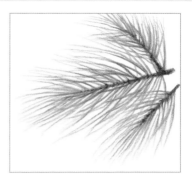

Since pine needles are as thin as pencil points, don't start with an outline. Instead, begin with color. Use limepeel with a very sharp point to make quick outward strokes from what will be the stem. Let the strokes overlap and vary in length and direction.

Repeat step one with a few strokes of very sharp sap green light. Retrace some needles with very sharp olive green on the sections nearest the stem to add dimension. Draw the stem with green ochre, making it thicker at the base and fading into the needles where they overlap its tip.

Each needle attaches to the stem, and the stem is rough. Use very sharp black raspberry to mark some of these attachment points, and make some marks on the stem. Enhance a few needles, as some are in various stages of growth.

Repeat these steps to create more pine needles as desired. Note that some species have long needles and some have short needles; some have dark green needles and some have light green or bluish needles; some needles are thick and some are thin. Know your tree before you draw!

144 | Pine Cone

 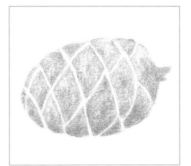 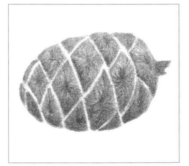 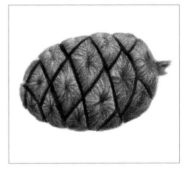

Cones vary between species of pines and evergreens, from compact forms the size of a ping-pong ball to elongated forms the size of a football. The largest of all trees, the giant sequoia, produces the smallest cone, shown here. Start with a basic outline of the shape and segments.

With a sharp point and light pressure, apply a layer of sandbar brown, darker in the centers and around the edges of the segments, and even darker along the bottom of the cone. Don't worry about staying within the bounds of the segments.

With a sharp point and medium pressure, apply a layer of sienna brown, darker in the centers and around edges of the segments, and even darker along the bottom of the cone. Radiate the strokes outward from the centers and inward from the edges of the "faces" to create highlights.

With a sharp point, add radiating strokes of black grape and dark cherry to develop the wrinkled faces of the segments. Add light strokes of black to enhance the centers and darken the bottom. Finish by using black to fill the gaps between the segments, stopping short of the cone's perimeter.

145 | Palm Frond

 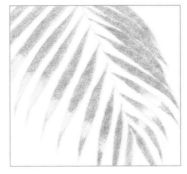 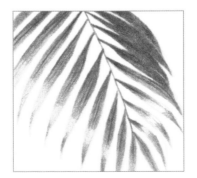 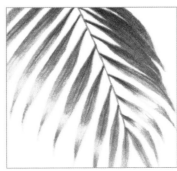

The leaves of this palm have thin ribs and are offset from each other down a thin, strong stalk. They attach at a tiny point, flare, and then taper to a graceful, sharp tip. It's important to keep your pencils very sharp to convey these crisp lines. Draw the basic outlines with very sharp limepeel.

With a sharp point and light pressure, fill in the outlines with limepeel. Leave highlights blank or stroke even more lightly. Stroke in the same direction as the leaf growth.

With a sharp point and light pressure, use marine green to darken the tips and part of the bodies of the leaves. Then, with a very sharp point and medium pressure, draw the stalk, the leaf attachments, and some of the ribs. Clean up the leaf edges.

To finish, use a very sharp point and medium pressure with black grape to enhance the stalk, the attachments, some of the ribs, and the base of the darkest leaves. If there is any roughness in the highlights, go over them with white to smooth.

146 | Grass Field

Remember the following points: (1) keep all strokes vertical, including distant grass; (2) use multiple colors; and (3) make subtle tufts, rather than flat color. Block in the sky with sky blue light, the trees with limepeel, the grass with yellow chartreuse, and the path with French gray 20%.

Use medium pressure with Prussian green to indicate the dark shapes in the trees. Use very sharp limepeel with light pressure to indicate the darkest areas of the grasses. Use sharp sandbar brown and medium pressure to darken the path.

Darken the trees using heavy pressure and black cherry. Then sharpen the tip and stroke in the darkest clumps of grasses, working upward. Add a light layer along the edge of the path. Draw clumps of short, light, upward strokes of indigo, spring green, chartreuse, and limepeel throughout the field.

With sharp Prussian green, enhance the clumps and repeat any of the colors used in step three. To finish, use the sharp tip of a craft knife to scratch out lines in the dark clumps to bring back the look of light blades of grass. Use a colorless blender to smooth any rough spots.

147 | Fern

 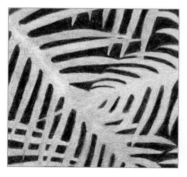 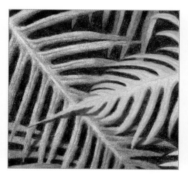 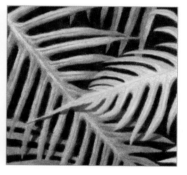

There are many types of ferns that vary in shape, size, growth pattern, and color. The leaves of this particular fern grow downward and both the leaves and their lobes are symmetrical, tapering to very slim points. Begin with a light outline.

The front leaf is closest, so it is lighter and brighter. Use very sharp chartreuse with light pressure to fill it in. Use very sharp limepeel with light pressure to fill in the other leaves. Fill in the gaps with black using medium pressure. Try to keep the edges sharp, refining them as you go.

With sharp Prussian green, darken the lower edges of the lobes and draw the ribs. Then create shadows of overlapping lobes. Add a light layer of yellow chartreuse to the nearest leaf to brighten it further, and use sharp sap green light to darken the trailing edges of its lobes and draw the ribs.

Go over the light areas of the back leaves with sharp yellow chartreuse and the dark areas with sharp chartreuse. Use a colorless blender to further smooth. Finish by adding a second layer of black to the background with heavy pressure for depth. With a very sharp point, refine all edges.

148 | Moss

There are many kinds of moss and they vary in shape and color. This particular moss is often found on trees in damp woods and has a blobby form, brilliant color, and soft, fuzzy texture. Start by roughing in the tree bark around the moss with the side of a cool gray 20% pencil.

Make the bark appear rougher with the side of a cool gray 50% pencil, and indicate cracks in it with heavy, jagged strokes of black. Fill the moss areas with an even layer of chartreuse. Indicate areas where the moss has browned with an overlay of sienna brown.

Create blobby forms in the moss with very sharp limepeel followed by very sharp Prussian green, using light pressure and a scumbling stroke to keep the look soft. Use heavier pressure in the darkest areas.

Apply a layer of chartreuse over the moss to blend and add color. This is more effective for producing a soft look than simply starting with a heavier layer of chartreuse. Use sharp sepia to enhance the shadows of the moss and bark. Apply a few tiny strokes to suggest the fuzziness of the moss.

149 | Flower Petals

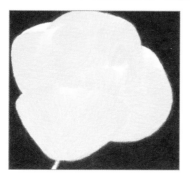 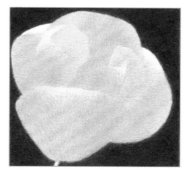 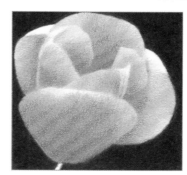 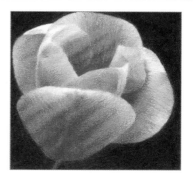

All flower petals grow outward from a base, so your pencil strokes should follow this. Lightly outline the blossom. Then fill the background with dark green. Lightly spray workable fixative over your work to keep the dark color from getting into the blossom. Fill the blossom with sharp lemon yellow.

Go over almost all of the lemon yellow with a wash of a sharp Spanish orange. The two washes together provide a waxy base for a smooth blend of the darker colors to come.

Go over almost all the Spanish orange with a wash of very sharp pale vermilion. Then use medium pressure to indicate the darker parts of the petals and begin to give them form. Notice that the blend is becoming smooth.

Layer crimson lake over most of the pale vermilion. Darken toward the center of the blossom and at the innermost petal edges for depth. Use light strokes of crimson lake and pale vermilion to suggest subtle ridges in the petals. Tighten up any fuzzy edges. Finish by using a colorless blender.

150 | Fall Foliage

 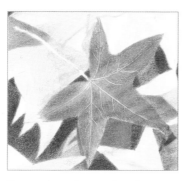 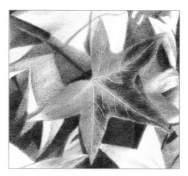 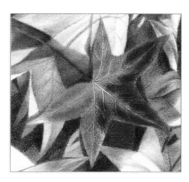

Because they are naturally uneven in color, autumn leaves are easy to draw. Start with a light outline, and apply a light layer of cream over all the leaves.

Use a stylus to impress lines for the leaf's veins. Then fill the leaf with carmine red to make the veins appear, stroking in the direction of the leaf "fingers." Fill the background with green ochre. Use sand to lightly block in the shadows of the dry leaves and give them some form.

Add discolorations on the red leaf with sharp black raspberry. Use it to darken the shadows cast by leaves onto other leaves, as well as to darken the shadows cast by leaves onto the grass. Add the leaf stem with carmine red, and then apply black raspberry on the shadowed part of the stem.

Add crimson red heavily over the leaf (lighter near the edges) and black raspberry to discolorations. Press the tip of carmine red into the veins to reduce contrast. Blend the dry leaf colors and shadows with sand. Create dry leaf veins with black raspberry. Clean up edges with black raspberry.

151 | Fire

 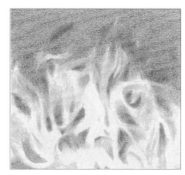 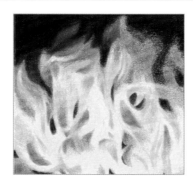 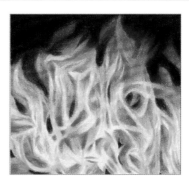

Fire is made up of curls and swirls that change often. Luckily, it calls for only a few colors, ranging from white or blue to red. Start with a medium base layer of canary yellow under the entire extent of the flames. The shapes don't need to be exact; we will refine them as we go.

Use sharp crimson lake with medium pressure to fill the background. Use sharp orange and permanent red with light pressure to define the major shapes and swirls within the flames.

Use black with heavy pressure as a second background layer. Identify the darkest/reddest flames, particularly at the top, and create them with sharp crimson lake and heavy pressure.

Continue creating smaller and smaller shapes and swirls within the flames with medium-to-heavy pressure and sharp canary yellow, Spanish orange, orange, permanent red, and crimson lake. If needed, finish with a colorless blender to achieve smooth blends.

NATURE
152 | Mountain Rock

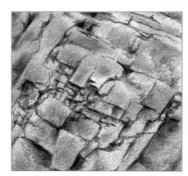

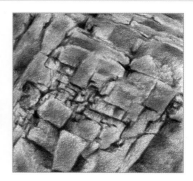

Mountain rocks are typically very rough, irregular, and jagged, which makes them surprisingly easy to render without stressing over exacting details. Use dull cool gray 20% on its side to create an overall rough look.

Use dull slate gray and sandbar brown to block in some angular shapes, varying the pressure from light to medium.

Now give the rocks form and dimension. With sharp indigo blue and heavy pressure, define the darkest cracks and gaps. With medium pressure, create some shadows under and between the blocks. With light pressure, tint some of the larger areas irregularly to indicate crumbling.

Use sharp sienna brown to add some irregular color areas to the front surfaces. Finish by using very sharp sepia with heavy pressure to further define some of the darkest of the dark cracks, and light pressure to further darken some of the shadows and a few block surfaces.

153 | Smooth Rock

Smooth rock is made up of uneven tones and shapes. Create overall soft areas of color before adding the cracks and edges. Use sharp putty beige for a base color, making some areas dark. Fill the deepest shadows with black and spray a layer of workable fixative to keep the pigment in place.

Use French gray 50% and light pressure to develop the rock forms and edges. Some unevenness is good; it helps suggest the imperfections of the rock surface.

Now that the basic soft imperfections of the surface are in place, use very sharp sepia with varying pressure to draw cracks. Use heavier pressure where the cracks are darkest and lighter pressure for the softer edges. Use sepia with light pressure to darken areas that are lit more obliquely.

To warm the rocks where they undulate slightly and where they reflect light, add hints of sandbar brown with light pressure. Use French gray 50% again to add back a bit of reflected light in the lower boulder's shadowed area. Finish by sharpening the silhouette edge and cracks with black.

154 | River Pebbles

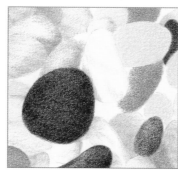

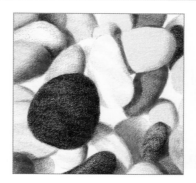

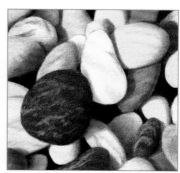

River pebbles come in a variety of shapes, sizes, and colors. What they all have in common are very smooth surfaces and rounded forms. Start with a light outline. The shapes don't need to be exactly like your reference.

Block in the base color for each pebble with light pressure. For this example, use canary yellow, seashell pink, nectar, blue slate, warm gray 20%, and black cherry.

Enrich colors with a second layer of color. Add cream to the lightest pebbles. Add yellow ochre to yellowish pebbles, carmine red to reddish pebbles, slate gray to bluish pebbles, warm gray 70% to grayish pebbles, and black grape to purplish pebbles. Round the forms with sienna brown.

Use black to fill the gaps between the pebbles. Further deepen each cast shadow with warm gray 70% next to the overlapping edge. Darken the edges of the purplish pebbles with black. Blend with a colorless blender. Finish with touches of white and warm gray 70% for striations.

155 | Sand

Grains of sand are primarily white, tan, red, brown, or black. It's easy to portray sand's coarseness without drawing every grain. Start with a layer of light peach and French gray 30%. Then moisten a paintbrush or cotton swab with odorless mineral spirits, and apply it overall to dissolve the wax.

Getting rid of the wax ensures that subsequent darker colors won't blend into the light colors; they will stay rough. With very light pressure, hold the pencils on their sides and apply thin layers of light umber, Tuscan red, and sandbar brown.

Use dull light umber for undulations in the sand, noting their lack of sharp edges. Sand in the foreground appears coarse, whereas sand in the background appears fine. To show this, use the pencil on its side in the lower region, and use the pencil point to fill in pigment gaps in the upper region.

Add more small, subtle undulations in the same manner as you did in step three. Finish with hints of dark umber and Tuscan red to increase the contrast of the larger undulations, again using the sides of the pencils in the lower region and the points in the upper region.

156 | Seashell

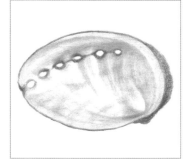
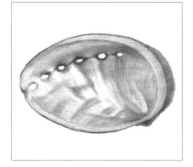

The pearly iridescence of a seashell is easy to create by overlapping light colors. Start with a light graphite outline. Use poster putty to dab away as much graphite as you can and still see the outline. Apply white over the whole shell to create a waxy base layer, which will allow for smooth blends.

Lightly create areas of color with very sharp light cerulean blue, light green, and pink rose, allowing some of them to overlap in a few places. Reserve the highlights, which are mostly in the center.

Use a sharp grayed lavender to begin. Add more of each color to increase intensity, and add curved streaks toward the innermost depression at the bottom right. Continue to reserve the highlights. Use sharp artichoke and sandbar brown to define holes and the rim of the shell.

To increase contrast in the ripples and suggest depth around the inside of the rim, use slate gray and medium pressure. Use sharp lavender to punch up the areas of pink rose. Use sandbar brown and dark brown to deepen shadows and sharpen the holes and rim. Smooth with a colorless blender.

157 | Ocean

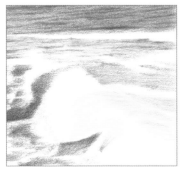
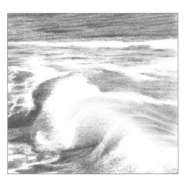
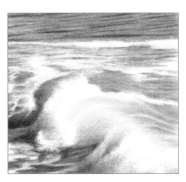

Start with a medium layer of Caribbean sea in the distance and in the darkest areas under the curl of the breaking wave. With sharp sky blue light and medium pressure, create the middle ground, and use sharp gray green light to create the curl of the wave, reserving the crashing foam.

With very sharp marine green, lightly add ripple lines in the distance and middle ground, and use medium pressure to deepen the areas under the curl of the breaking wave. Add a few touches on the back of the wave.

Use sharp muted turquoise and slate gray to add more ripples in the distance and middle ground, deepen the area under the curl of the wave, give more form to the curl, and define the foamy areas on the water surface. Also, use these pencils to indicate parts of the spray that are in shadow.

With sharp cool gray 90%, create the wave's darkest shadows and darken some distant ripples. Much of the foam on the water's surface is not bright white because it is thin. Use sharp cool gray 10% to reduce the foam's brightness and to soften and form the spray. Smooth with a colorless blender.

NATURE

158 | Still Lake

Still water contains vertical reflections, horizontal ripples, and indistinct shapes. Work on the vertical and horizontal aspects separately. Begin with a medium layer of the base colors: chartreuse, kelp green, and sky blue light, keeping all strokes vertical. Overlap the chartreuse and kelp green.

Add a second medium layer of colors over the first: artichoke, marine green, and cool gray 20%, respectively. Again, keep all strokes vertical. Allow the coverage to be uneven.

Moisten a paintbrush or cotton swab with odorless mineral spirits and apply it overall to dissolve the wax away and produce more even color. After the mineral spirits have evaporated completely, enhance the darkest areas with espresso and the golden trees with areas of beige sienna.

Spray a layer of workable fixative so you can mark light over dark. Once dry, use horizontal strokes to break up the edges of the tree shapes and add ripples. Use white, cool gray 20%, cool gray 30%, sand, marine green, and espresso. Smooth with a colorless blender.

159 | Rippled Lake

 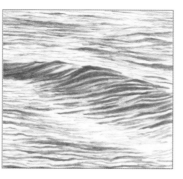 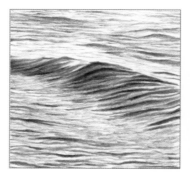 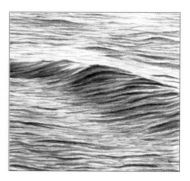

To draw rippling, waving water, start with major features and work toward progressively smaller details. Begin with a layer of white to provide a waxy base for smooth blending, followed by the base color, sky blue light, applied with a sharp point and light pressure.

Ensure that all your strokes taper to points. Identify the most prominent ripples in the wave, and draw them with Mediterranean blue. Do the same for the most prominent foreground ripples. Use peacock blue to draw the most prominent background ripples. Now draw some of the lesser ripples.

Use indigo blue to enhance the contrast on the most prominent ripples. Use peacock blue between some of the major ripples in the wave to develop its form. Use both pencils with light pressure to suggest smaller ripples within ripples in the foreground and in the leading trough of the wave.

Continue developing ripples as in the previous step, and add more with a Mediterranean blue. You may want to go back over some previous ripples to darken or widen them. Your ripples don't have to match your reference; they only need to look like ripples, so don't try to draw every detail.

160 | Running River

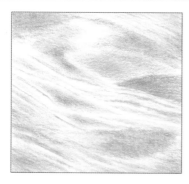 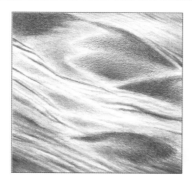 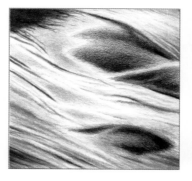 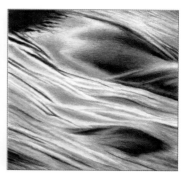

Running water features flowing lines of colors, and rocks with water flowing over them have blurred edges. Apply a layer of white to provide a waxy layer for smooth blending later. Then use blue lake and cool gray 10% to plan the rocks around which the water flows, avoiding outlines.

Give more form to the rocks with sharp cool gray 30%, and indicate some darker ripples in the water with this pencil and sharp slate gray. Enhance the bluest areas with more blue lake. Notice that these blue areas are always surrounded by highlights; reserve these highlights.

Enhance the rocks further with sharp cool gray 70% and medium pressure. Then add streaks (ripples) in the water by tapering your pressure from light to medium to light again.

Develop the blue areas of water with blue lake and slate gray, adding streaks of colors. Use cool gray 90% to give final contrast to the rocks and the darkest streaks in the water. Use sharp white to smooth the boundaries between the blues and highlights. Smooth with a colorless blender.

161 | Clouds

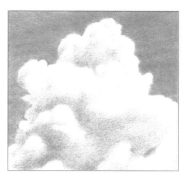

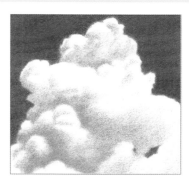

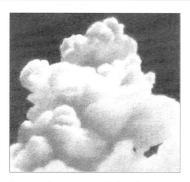

Clouds often contain many colors, but for this example you only need blues and gray. Begin with a light layer of cloud blue light to define the sky behind the cloud and some of the shapes within it.

Add a second layer to the sky with sharp blue lake and medium pressure. Clouds have very irregular outlines, so your drawing doesn't have to look exactly like your reference. Give some form to the shapes in the cloud with very sharp periwinkle and very light pressure.

Add a third layer to the sky with sharp Copenhagen blue and heavy pressure. The three layers together produce a bright, smooth blue like a summer sky. Keep the cloud border very crisp. Continue lightly adding smaller forms in the clouds with periwinkle, and add more periwinkle in the darkest areas.

Deepen the recesses in the cloud forms with more periwinkle. Then use cool gray 10% to add the lightest puffy shapes, reserving bare paper for the highlights. Then use cool gray 10% with light pressure to smooth the periwinkle throughout the clouds. Sharpen the cloud border with Copenhagen blue.

162 | Raindrops on Water

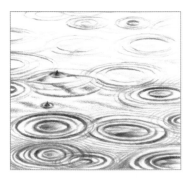

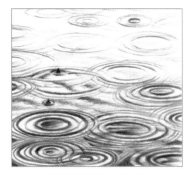

The hardest aspect of rendering raindrops on water is drawing the rings they create with clean, sharp lines. Begin with a light layer of white to provide a waxy base for a smooth blend of the darker colors to come, and a light, even layer of cloud blue light applied in horizontal strokes.

The longer it has been since a droplet hit the water, the wider the ring and the shallower and closer together the rings are. Any droplet that has just hit causes a little pyramid with a very small ring around it. With periwinkle, lightly draw the basic rings and impacts.

With sharp indigo blue, draw the tiny impact pyramids with heavy pressure, enhance some of the existing rings, add more rings between other rings with light pressure, and add more extensive peripheral rings with very light pressure. Lightly add a few ripples in the undisturbed water.

Use very sharp black to enhance the fattest rings in the foreground, using the same pressure that you used for those same rings in the previous step. Finish with light touches of black to enhance contrast in the foreground.

163 | Raindrops on a Window

To successfully render raindrops on a window, create the blurry background. What makes the droplets visible is that they invert the scene behind them. Outline the droplets with cool gray 10% and use it as a base layer for the background blur to promote a smooth blend in the colors to follow.

This background includes an overcast sky, shrubs, and wet soil. With sharp marine green, sandbar brown, and light umber, fade the colors into each other around the lower half of droplets. Use sharp sepia to darken between the green and brown. Use cool gray 20% to darken the overcast sky.

Form the outlines and reflections on the upper half of droplets with cool gray 30% and on the lower half with marine green, using medium pressure. Reserve bare paper for the brightest areas of the droplets.

Define the upper half of the droplets with marine green over gray and the lower half with light umber over green, using light pressure. Smooth the transitions to white with cool gray 10% and medium pressure. Lightly define the dark edges with sepia. To finish, sharpen the droplet borders.

164 | Red Wine

 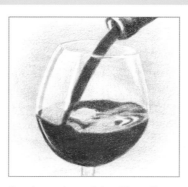 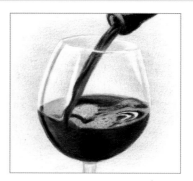

The challenge of red wine is that it is transparent in a small quantity, but darkly opaque in a large quantity. The key is to layer the colors so that the red shows through from underneath. Begin with a basic outline.

Clear glass is almost invisible without something dark behind it, so use sharp cool gray 20% and light pressure to create the background, reserving the bare paper for the brightest highlight on the side and around the rim.

Use sharp crimson lake with medium pressure to create an even, medium-heavy layer for the pour stream and the wine below the surface. Use it with light pressure for the surface foam. Reserve the bare paper for the bright reflections on the surface. Use sharp dark green to block in the bottle, reserving the bare paper on the lip for the next step.

Use very sharp black with heavy pressure for a few strokes in the pour stream and the dark highlight below the surface near the left side. Also, use it to darken the wine below the surface, allowing red to show through on either side of the center and along the right edge. Use it in the same manner on top of the green on the bottle. Use pink rose with medium pressure to darken some of the surface foam and for the light highlight below the surface near the left side. Dot some crimson lake in the surface foam to suggest bubbles. Use sharp kelp green with light pressure for the lip of the bottle. Finish by brightening some of the pour stream and some small areas of the surface with touches of permanent red.

165 | Black Coffee

 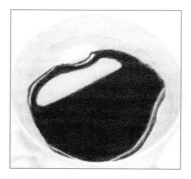 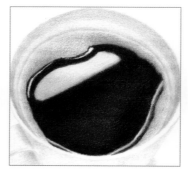 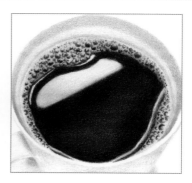

The key to successfully drawing black coffee is not to use black! Coffee is a very rich, dark brown, while black pigment is flat and dull. Begin with a basic outline of the cup, coffee, bubble rim, and reflection.

For the first layer, use sharp cool gray 10% and medium pressure for the cup, sharp beige and light pressure for the bubble rim, sharp chocolate and medium pressure for the coffee, and sharp warm gray 10% and light pressure for the big reflection. Reserve the bare paper for the strongest highlights on the rim of the cup and a band next to the bubble rim.

Use sharp cool gray 30% and light pressure to draw a line where the bubble rim meets the cup, and to darken the inside of the cup. With sharp beige sienna and light pressure, darken the bubble rim where it meets the coffee. Use sharp dark umber and heavy pressure on top of the chocolate, allowing some of the chocolate to show through in the center. Use sharp French gray 20% and light pressure to slightly darken half of the big reflection and blur its boundary on the flat side.

With cool gray 50% and light pressure, create final contrast around the inside and outside of the cup. Finally, use very sharp dark umber and light-to-medium pressure to create the bubbles—crescents of various sizes, with dots filling some of the spaces between. Note that there are no visible bubbles at the boundary with the cup.

166 | Citrus Fruit Rind

The dimpled skin of any citrus fruit, such as oranges and lemons, is easy to render without drawing each individual dimple. Begin with a basic outline. Erase as much of it as you can and still see it, so the graphite lines won't show through the light colors to come.

For the first layer of color, use sharp sunburst yellow and light pressure for an overall wash on the exposed cuts, and a medium wash on the surface reserving the bare paper for the highlights. Then use the point of the pencil to make dots in the highlights—darker where the light is strongest.

Where the underside of the cut rind is visible, darken it with goldenrod and light pressure. Use sharp yellowed orange and light pressure with small, overlapping, circular strokes on top of the sunburst yellow on the surface. Add a few more dots at the edges of the highlights.

Use cadmium orange hue with small, overlapping, circular strokes over the yellowed orange on the lower half of the rind curls for contrast. Use heavier pressure at the bottom edges. Add dots in the middle of the curls. Then use sunburst yellow to add dots where the exposed cuts meet the surface.

167 | Cut Citrus Fruit

The segments inside any citrus fruit are packed with little sacs of juice that radiate out from the center. All strokes should also radiate from the center. Begin with a basic outline of the segments. Erase as much of it as you can so the graphite won't show through the light colors to come.

With sharp lemon yellow and medium pressure, create short and long strokes out from the center, reserving the bare paper for highlights. They don't need to exactly match your reference. Also, use lemon yellow for the skin and around the outside edge of the rim cut.

Identify some of the darkest striations in the juice sacs, and use sharp yellow ochre with light pressure to enhance their contrast. Because the sacs bulge upward a bit, create more coverage near the borders of each segment for dimension. Use yellow ochre to shade the skin and draw the edge of the rim.

Continue adding lemon yellow striations, with yellow ochre strokes on top that don't completely overlap, until you are happy with the contrast. Be sure to reserve bare paper as highlights for a few striations. Smooth with a colorless blender, if desired.

168 | Peach

Peaches have blushing color with soft transitions. Begin with an outline. Erase as much of it as you can so the graphite won't show through the light colors to come. Use sharp eggshell for an overall light base layer on the peach, sharp limepeel for the leaves, and sharp sandbar brown for the stem.

Where the peach skin is yellowish, apply sharp Spanish orange with light pressure, following the contours, and fade it out into the areas that will be reddish. Create more coverage in the more intensely yellow areas. Use sharp spring green as the second layer on the leaves.

Where the peach skin is reddish, apply smooth carmine red. Follow the contours. Apply more in dark areas, fading out toward the yellow. Allow streaks and blotches for realism. Use dark green to add contrast to the leaves and a shadow on the peach. Add a bit to the stem for contrast.

For the areas of dark red, smoothly apply pomegranate. Apply it over the dark green in the leaf cast shadow and on the stem for contrast. Use cool gray 20% to add a little patch of fuzzy appearance on the shoulder next to the leaf shadow. Finish by smoothing completely with a colorless blender.

169 | Apple

 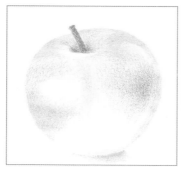 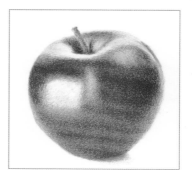 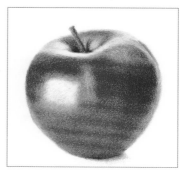

Apples are surprisingly easy to draw by taking a short detour through some unexpected colors, which help produce a more accurate final color and texture. Begin with a basic outline. Erase as much of the highlight outlines as you can and still see them, so the graphite lines won't show through later.

Lightly block in the yellow areas with jasmine. Underpaint the dark red areas with dark green. Underpaint the light red areas with pink rose. Where there are strong highlights, use sharp white to preserve them and provide a waxy layer for smooth blending later. Fill the stem with burnt ochre and medium pressure.

Use sharp scarlet lake with a full range of pressure everywhere the skin is red—heavy pressure over dark green, light pressure over pink rose, and very light pressure over jasmine and next to the white. Fill the tooth of the paper smoothly. The dark green underpainting produces a convincing shadow!

Use sharp scarlet lake with medium pressure to further shade the contours near the darkest areas, and to add the shadow on the stem. Finish by smoothing all over with a colorless blender.

170 | Grapes

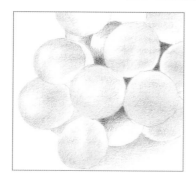 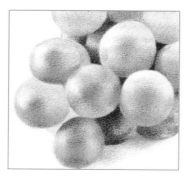 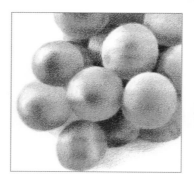 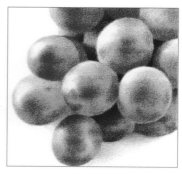

Grapes have a translucent glow and a waxy coating. Keep your pencils very sharp, and use light pressure to make small, overlapping circular strokes. Begin with a basic outline and a light wash of white for a blending base. In the darkest recesses, apply dark green. Apply pink rose over waxy areas.

On top of the dark green in the darkest recesses, apply raspberry. Use magenta to carefully model the grapes with more coverage in the centers, where they are most intensely colored, and where they touch neighboring grapes.

On the darkest grapes in shadow, apply grayed lavender with medium pressure. Also, apply it with light pressure wherever you see waxiness. Reserve the bare paper for the brightest highlights. Apply permanent red on top of the most intense areas of magenta to begin producing the glow.

For final contrast, apply a small amount of raspberry over the permanent red in the centers of the grapes and where they touch neighboring grapes. Use it to make a few splotches to represent where the waxiness is worn away. Finish by sharpening any blurry edges and smoothing with a colorless blender.

171 | Strawberry

 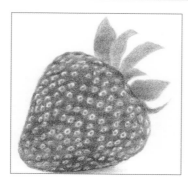 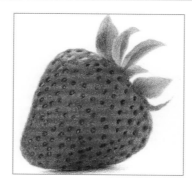 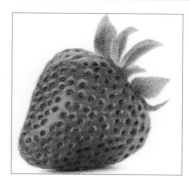

The key to success in rendering a ripe red strawberry is simply not to let the seeds scare you. Begin with a basic outline that includes the location of each seed.

With yellow ochre and heavy pressure, draw dots for seeds. Then use permanent red and medium pressure to draw a circle around each seed and fill the gaps between the circles. Use heavier pressure at the bottom where it meets the table. Block in the basic leaves with dark green and limepeel.

Use dark green to fill each circle around the seeds; for those near the bottom, darken the seeds as well. Use crimson red to fully darken the berry and add dimples next to the seeds. Finish the leaves with dark green and light pressure; they should be darkest where they meet the berry.

Spray the drawing with workable fixative so you can add soft highlights over the red pigment. Use white to draw curves around the seeds not in shadow and down the center. The seeds should appear recessed; if they don't, use crimson red to restore a gap between the seed and the highlight.

172 | Pineapple

 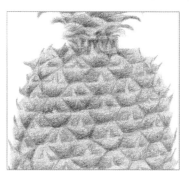 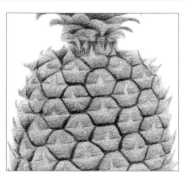 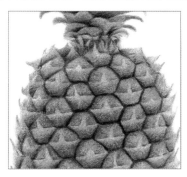

The surface of a pineapple is a complex structure of hexagonal segments, each with an upward flap and a center spine. Ripe segments are greenish on the lower half and orangey on the upper half. Begin with a basic outline and a wash of yellow ochre. Use celadon green to block in leaves.

With sharp green ochre and light pressure, fade the lower half of each segment and, more lightly, the upper halves from the flap upward. Also, use it as a light second layer on the leaves.

Use Spanish orange to fade the upper half of each segment and the lower halves from the flap downward. With dark umber, draw gaps between the segments. Use the same pencil to lightly enhance the edges of the flaps and spines and to draw the darkest shadows under the leaves.

Use sharp burnt ochre to add a reddish blush to the top half of each segment, heavier at the edges. Follow up with a light wash on the lower halves. Add green ochre to the lower half of each segment. Then smooth the leaves and any excessive roughness with a colorless blender.

173 | Coconut

 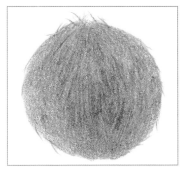 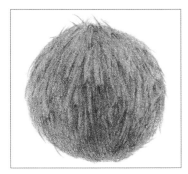 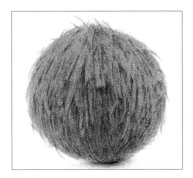

The very fibrous shell of a coconut is easy to draw because it's so coarse that the fibers almost suggest themselves. Begin with a very simple outline.

With sharp burnt ochre and medium pressure, make long strokes that follow the contour of the coconut. In the center third, press harder to make darker lines to suggest fraying fibers. Make a few short, tapered strokes around the perimeter as well to suggest fraying fibers.

Use the lines from the previous step and a bit of imagination to "see" more and more frayed ends and fibers. Enhance them by using sharp Tuscan red and chocolate with medium-to-heavy pressure to darken the spaces between and underneath them. They don't need to match your reference.

Use a colorless blender to smooth most of the fibers to enhance the color without flattening the texture completely. Finally, use very sharp dark umber and medium-to-heavy pressure to increase the contrast even more between and underneath many of the fibers you created in the previous step.

174 | Walnut Shell

 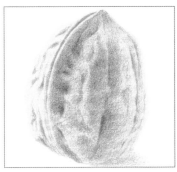 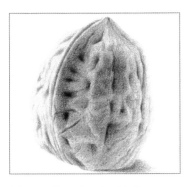 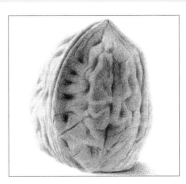

Walnut shells, like the nutmeat inside, are known for their undulating form, each one unique. For this example, begin with a basic outline and an overall medium wash of eggshell, applying lighter coverage on the lit side.

With sharp light umber and light pressure, block in the basics of the undulating shapes and creases. They don't need to exactly match your reference.

Add warmth and contrast to the shadowed undulating shapes with sharp burnt ochre and light-to-medium pressure, with more coverage in the richest-colored areas. Use very sharp dark brown with medium pressure to define the darkest creases and dimples.

Use sharp yellow ochre and light pressure overall, and then smooth with a colorless blender, being careful not to blur the shapes and creases. With very sharp dark brown and light-to-very-light pressure, draw the finest creases and enhance the contrast around the undulations.

175 | French Baguette

Bread can seem daunting because of the air pockets and holes. But you don't need to draw every single hole or follow your reference exactly to render French bread. Begin with a light outline and an overall light wash of cream on the bread and putty beige for the shadow.

Use yellow ochre to lightly block in the major holes and give shape to the loaf. Add more where the crust is more toasted and where the holes are deepest. For the shadow, add a light layer of chocolate, with more coverage closest to the loaf. Also, use it to draw the gap between the loaf halves.

Use mineral orange to create a more toasted look for the crust edges and seams. Use light umber to increase contrast in the major holes on the top loaf, and add semi-random squiggles for smaller holes. Apply it over yellow ochre on the end of the lower loaf to darken and increase the contrast.

Use burnt ochre to enhance the jagged, toasted seam and the bottom edge of the top loaf. Use it on the crust for golden-toasted look. Allow the look to be a little rough for realism. Add more yellow ochre and light umber as needed. Finish by darkening the shadows under and between loaves.

176 | Frosting

Cake frosting is low contrast and, where folds face each other, the color is multiplied. These steps also work for drawing ice cream. Begin with a basic outline. Erase as much of it as you can so the graphite won't show through the light colors to come. Apply a light wash of white for a blendable base.

Use sharp hot pink and very light pressure to model the forms of the swirls, with more coverage in the dark creases. For the cupcake, use sharp chocolate and medium pressure.

Use sharp pink and light pressure on top of the hot pink to alter its color and increase the contrast in the darkest creases. For the cupcake, use sharp burnt ochre and medium pressure on the lit side. Keep the edges crisp.

Use permanent red for contrast in the darkest creases. Smooth pigment-heavy areas with a colorless blender, and smooth other areas with white. Use dark umber on the shadowed side and under the frosting, and use white on the side in light. Then use dark umber and small marks to create a spongy texture.

177 | Dark Chocolate

 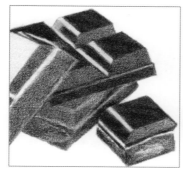 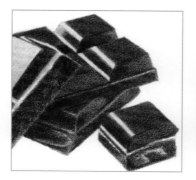 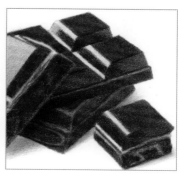

To draw convincing dark chocolate, don't use black and save heavy pressure for later steps. Dark chocolate is a very rich, dark brown; black pigment is flat and dull. Begin with an outline of the chocolate pieces.

Preserve the almost-white highlights with sharp French gray 10% and light pressure. Then use sharp chocolate with medium pressure over the faces; they really are that color and will not change much. Use it lightly over the front faces, where more colors will be added to darken. Keep the edges crisp.

On the front faces, which received only a light layer of chocolate in the previous step, add sharp dark brown with light-to-medium pressure, applying more coverage where the candy is in shadow. Also, draw sharp lines with heavy pressure where segment faces meet.

Where there are breaks, use beige and burnt ochre to draw the light crumbs. Use sharp French gray 50% to suggest the soft reflection of ambient light on the front faces; if it's too gray, layer with dark brown. For contrast, use dark umber in the darkest shadows. Smooth with a colorless blender.

Section III
OIL & ACRYLIC

MIA TAVONATTI

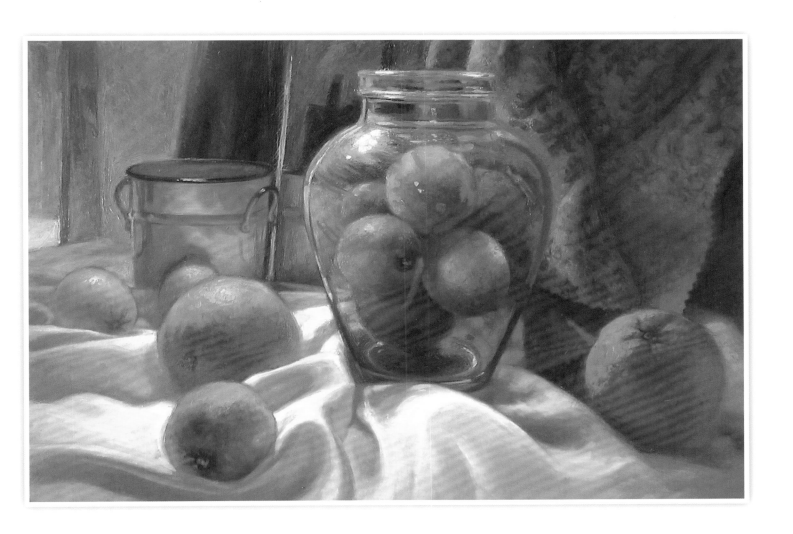

Tools & Materials

Sketch Pads

Some of the textures demonstrated in this section start with a basic sketch; however before putting paint to canvas, it's best to work out your textures on paper. Sketch pads are ideal for this purpose. They come in all shapes and sizes, and they are easy to carry. Whenever you see an interesting texture that you'd like to paint, draw a quick sketch. Then use your sketch as a reference to draw the texture directly on your support, or transfer it using tracing or transfer paper. Just make sure to choose paper that will support the weight of your paint without too much buckling. When working in acrylic, use watercolor, acrylic, or mixed-media paper; when working in oil, use paper designed to hold oil paint and its mediums.

Tracing & Transfer Paper

Tracing and transfer paper are used to transfer the outlines of a work to a support. Transfer paper is coated on one side with graphite (similar to carbon paper). Simply place the transfer paper facedown on your support; then place the artwork you wish to transfer faceup on the transfer paper. Use a pencil to trace over the lines of the artwork, pressing firmly. The outlines will transfer to your support. To use tracing paper, coat one side of the tracing paper with graphite and follow the same process.

Drawing Pencils

Artist's pencils contain a graphite center and are sorted by hardness, or grade, from very soft (9B) to very hard (9H). Pencil grade is not standardized, so it's best to have a set of pencils from the same brand for consistency.

- Very hard: 5H–9H
- Hard: 3H–4H
- Medium hard: H–2H
- Medium: HB-F
- Medium soft: B–2B
- Soft: 3B–4B
- Very soft: 5B–9B

Paintbrushes

Paintbrushes are classified by hair type (soft or stiff and natural or synthetic), style (flat, filbert, and round), and size. Flat brushes are great for producing straight, sharp edges. Medium and large flats are good for quickly filling in large areas. Small round and small filbert brushes have pointed tips that are suitable for adding details, and larger rounds and filberts are perfect for sketching rough outlines and general painting. When purchasing round or pointed brushes, opt for those with particularly long hairs or bristles.

Use the following brushes to create the examples in this section:

- ⅛-inch, ¼-inch, ½-inch, ¾-inch, and 1-inch flat brushes
- #1 round, #2 round, #3 round, #4 round, and #6 round brushes
- 1-inch #2 striper brush

Filberts

Flats

Brushes aren't the only tools you can use to apply paint. Cotton swabs and blending stumps (which were used to create the texture Sequins, #212) are also useful. Cotton swabs are also great for removing paint from your surface.

Rounds

HAKE BRUSH A hake brush is handy for blending large areas. While the area is still wet, use a clean, dry hake to lightly stroke back and forth over the color. Be sure to remove any stray hairs before the paint dries and never clean your hake in thinner until you're done painting, as it will take a long time to dry.

CLEANING BRUSHES A jar that contains a coil will save time and mess by loosening the paint from the brush. For removing oil paint, you need to use turpentine. Once the paint has been removed, you can use brush soap and warm water—never hot—to remove any residual paint. When painting with acrylic, use soap and water to remove paint from the brush. Reshape the bristles and lay flat to dry. Never store brushes bristle-side down.

Selecting Paints

There are different grades of oil and acrylic paint, including "student grade" and "artist grade." Artist-grade paints are a little more expensive, but they contain better-quality pigment and fewer additives. The colors are also more vibrant and will stay true longer than student-grade paints.

Acrylic paints are water-based, so they clean up easily with warm water and soap. You can also use water to thin the paints. Oil paints are oil-based and require solvents, such as turpentine or mineral spirits, for cleaning up and thinning the paint. Oils also call for a well-ventilated work area and specific ways of disposing of materials, such as solvent-soaked rags.

Painting & Palette Knives

Palette knives can be used to mix paint on your palette or as tools for applying paint to your support. Painting knives usually have a smaller, diamond-shaped head; palette (mixing) knives usually have a longer, more rectangular blade. Some knives have raised handles, which help prevent you from getting paint on your hand as you work.

Mixing Palettes

Whatever type of mixing palette you choose—glass, wood, plastic, or paper—make sure it's easy to clean and large enough for mixing your colors. You can purchase an airtight plastic box to keep your leftover paint fresh between sessions.

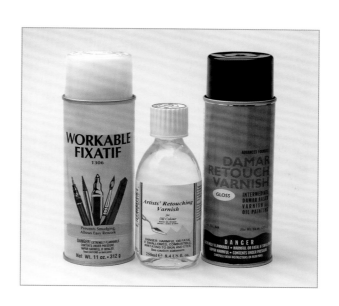

Varnishes

Varnishes are used to protect your painting—spray-on varnish temporarily sets the paint, and brush-on varnish permanently protects your work.

Supports

The surface on which you paint is called the support. Ready-made canvases are available in a variety of sizes and come pre-primed and either stretched on a frame or glued over a board. Watercolor illustration boards work well with acrylic paint, providing a smoother surface. When working with oil paint, artists generally use canvas or wood. When using wood or any other porous material, you will need to prime the surface first (see below) to keep the paint from soaking through.

PREPARING YOUR OWN SUPPORT It's economical and easy to prime your own supports. Acrylic gesso—a polymer product with the same base ingredients as acrylic paint—is a great coating material because it primes and seals at once. It's also fast-drying and is available at any art supply store. Gesso is usually white, but it is also available in other colors. Apply gesso directly to your support with a brush; a palette knife; a spatula; or any large, flat application tool.

Additional Supplies

Paper towels and lint-free cotton rags are invaluable for cleaning your tools and brushes. They can also be used as painting tools to scrub in washes or soften edges. In addition, you may want to use a mahlstick to help you steady your hand when working on a large support. Silk sea sponges, old toothbrushes, drawing stumps, and cotton swabs are also useful for rendering special effects. You will also want to wear old clothes and an apron when working with paints.

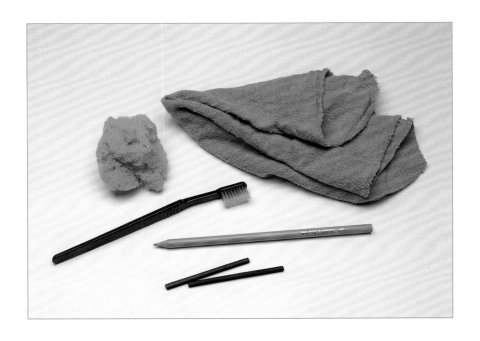

Painting Techniques

The way you apply paint to your support contributes to the overall mood and style of a piece. Arm yourself with a variety of effects by getting to know the following techniques. You'll also need to use many of them to recreate the textures in this section.

PAINTING THICKLY Load your brush or knife with thick, opaque paint and apply it liberally to create texture.

THINNING PAINT Dilute your color with water (if using acrylic) or medium (if using oil) to create transparent layers of paint.

DRYBRUSH Load a brush, wipe off excess paint, and lightly drag it over the surface to create irregular effects.

SCUMBLING Lightly brush semi-opaque color over dry paint, so the underlying colors show through.

SCRAPE Use the tip of a palette knife to scrape color away. This can create an interesting texture or represent grasses.

LIFTING OUT For subtle highlights, wipe paint off with a paper towel or blot it with a tissue. To lighten the color or fix mistakes, use a moistened rag (use thinner with oil paint).

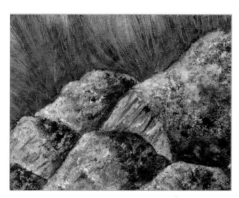

SPONGING Apply paint with a natural sponge to create mottled textures for subjects such as rocks, trees, or foliage.

BLENDING Lay in the base colors, and lightly stroke the brush back and forth to pull the colors together.

WET-INTO-WET Apply color next to another color that is still wet. Blend the two by lightly stroking over the area where they meet. Use your brush to soften the edge, producing a smooth transition.

STIPPLING For highlights, use a stiff-bristle brush and hold it straight, bristle-side down. Dab on color quickly, creating a series of dots.

WIPING AWAY To create subtle highlights or simply remove paint from canvas, wipe away the paint using a paper towel, tissue, or soft cloth.

SPATTERING To spatter, load a brush—or toothbrush—with paint and tap your finger against the handle. The splattered paint creates the appearance of rocks or sand.

Glazing

Glazes are thin mixes of paint and water or medium applied over a layer of existing dry color. An important technique in painting, glazing can be used to darken or alter colors in a painting. Glazes are transparent, so the previous color shows through to create rich blends. They can be used to accent or mute the base color or alter the perceived color temperature of the painting. When you start glazing with acrylic, create a mix of about fifteen parts water and one part paint. When working with oil, use equal parts paint and turpentine to start. Add more turpentine as needed until the paint is the consistency you desire. It's better to begin with glazes that are weak than ones that are overpowering, as you can always add more glazes after the paint dries. Occasionally, you can use semi-glazes, which are more opaque and slightly thicker than traditional glazes.

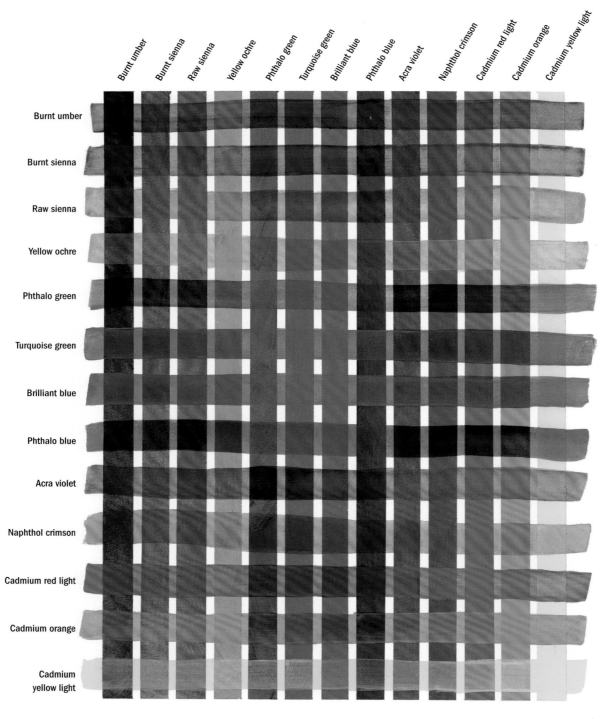

GLAZING GRID In this chart, transparent glazes of 13 different colors are layered over opaque strokes of the same colors. Notice how the vertical opaque strokes are altered by the horizontal translucent strokes.

Applying an Underpainting

An underpainting is a thin wash of color applied to the support at the beginning of the painting process. An underpainting can be used to tone the support to help maintain a desired temperature in a final painting. For example, a burnt sienna wash would establish a warm base for your painting; a blue wash would create a cool base. An underpainting can also provide a base color that will "marry with" subsequent colors to create a unified color scheme. You can also use an underpainting to create a visual color and value "map," giving you a guideline for applying future layers. An underpainting can help provide harmony and depth in your paintings. Experiment with various underpaintings to discover which colors you prefer.

Magenta

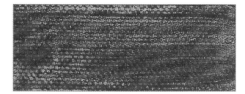

Burnt sienna

Purple

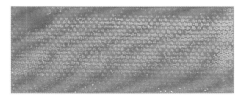

Phthalo violet

Pounce Technique

The pounce technique is an easy way to eliminate visible brushstrokes to achieve smooth, even areas of color. To begin, cut a square of soft cotton cloth (such as jersey or T-shirt material). Ball up the cloth by folding back the edges to create a creaseless round pad. Use this pad to dab at an area of color on your canvas. For best results, work in an up-and-down motion and avoid smearing paint to the side.

Impasto Strokes

Impasto strokes are thickly applied brushstrokes that add dimension and textural variation to your work. You can apply impasto strokes with a heavily loaded brush, or you can apply them with painting knives. To use a painting knife, scoop up your paint with the flat blade and spread a thick layer of paint over the surface. The resulting texture is great for mimicking rough elements, like stone walls or rocky landscapes.

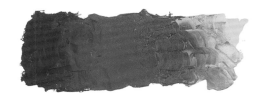

Working from Dark to Light

A common approach to oil painting involves working from dark to light, which refers simply to applying the darks and shadows first and leaving the lights and highlights for the later stages. This eliminates the need to apply each intricate shadow individually, allowing you to focus on the illuminated areas and saving brushstrokes in the long run.

Transparent vs Opaque Paints

Pigments are classified according to their transparency. Transparent pigments allow light to pass through, whereas opaque pigments blocking light from passing through. Working with this quality can help you suggest depth in your textures. Transparent paints tend to recede, so they are ideal for building shadows. Opaque paints appear to come forward, so they are ideal for painting highlights and the raised areas of a texture.

Soft skin has a fine texture with smooth gradations of warm and cool tones. Create a mix of two parts burnt sienna to one part sap green, and thin it down on your palette. Cover your drawing with this transparent mixture using a ½-inch flat brush, spreading the color smoothly. Use the pounce technique to remove all brushmarks, leaving as smooth a surface as possible. (See "Pounce Technique," page 99.) Finally, roll a small piece of soft cloth and wipe off paint from the lightest areas of the image, such as the background and neck.

Mix equal parts burnt sienna, black, and white to create a cool skin tone. Using a ¼-inch flat brush, paint the shadow and middle-value areas of the back, under the chin, and over the back of the neck with short, impressionistic strokes to simulate the texture of skin. To lighten and warm the color, slowly add more white and reduce the black for the lighter areas of the skin.

To add subtle texture and build up the middle values, use a ½-inch flat brush to apply mixes of burnt sienna and white. Wipe off the excess paint from your brush onto a cotton rag before laying on short, impressionistic drybrush marks that give the impression of skin texture. Next lay a painterly layer of white in the background areas, and use a fine, soft, dry brush to trace the lines of the front and back of the neck. This will soften and blur the edges to create more depth.

Continue to work from dark to light using short, impressionistic strokes. Slowly build up the light layer by layer with a simple mix of burnt sienna and white. The lightest area will eventually have the thickest paint, which is a traditional way to build depth in a painting. For the lightest skin tones, cool the mix with a touch of phthalo blue to complement the warm shadows.

179 | Aged Skin

Aged skin features deep wrinkle lines with strong contrast between the lights and shadows. To capture this, create a mix of one part burnt sienna to two parts sap green, and thin it down on your palette. Use a ½-inch flat brush to cover your drawing with this transparent mixture, and use the pounce technique to thin out your color until you can see your drawing through the paint. Next, using an old ¼-inch flat brush that has splayed out slightly from use, dab the end of the brush into the same paint mixture and then dab it into the shadow areas of your drawing, leaving a stippled texture that resembles pores in skin. (See "Stippling," page 97.)

Mix burnt sienna with a small amount of black to create a dark skin tone. With a small round brush, paint the darkest areas, including the deepest parts of the wrinkles, the shadows under the nose, and where the nose and cheek meet. Trace over the wrinkle lines with a clean brush to soften the lines and blend the color out into the softer shadow areas, such as the dimple on the nose.

To begin building the middle values of this rough, wrinkled skin, mix equal parts of purple lake and raw sienna and varying amounts of white to lighten. Working with a value very close to your darkest shadow color, slowly dab in spots of color, working from the shadows into the light. Both a ¼-inch flat brush and a small pointed brush would work well, depending on the size of the area you are working on. Do not blend the colors together on the painting, but rather leave separate marks, which add to the detail in the wrinkles and pores.

In this final layer, focus on bringing up the light hitting the nose, cheek, and lips, in addition to the light edges of the wrinkles. Using a very neutral, cool skin tone mixed with purple lake, burnt sienna, and white, continue to work from the previous middle value toward the lightest highlights using a ¼-inch flat brush. Wipe most of the excess paint off your brush onto a cloth. Use the flat edge for larger strokes and the corners for tiny areas, using the drybrush technique to pull out the texture of the canvas or board to mimic the roughness of aged skin. (See "Drybrush," page 96.)

180 | Straight Hair

To create long, flowing red hair, start with equal parts of burnt sienna and sap green to create a warm, golden, transparent brown for the middle to dark values. Rotate a flat brush and use the long, thin edge to paint long, smooth strokes from top to bottom in the direction of the hair.

Paint the deep shadows with a mix of equal parts of black and burnt sienna, using the thin edge of the same brush and long strokes from the top to bottom. Use pure burnt sienna to paint in the middle-value areas of the hair to achieve a warm, rich red tone. Go over your strokes for smooth, silky lines.

Continue building the middle and lighter strands of red hair using a long, fine-pointed brush loaded with a mix of burnt sienna, cadmium yellow medium, and white. If needed, thin the paint for better flow. Use a darker mix of equal parts burnt sienna and ultramarine blue to redefine shadows.

Bring up the values where the light is strongest, such as the sides of the head. For light strands of hair, use a red-orange mix of white, cadmium yellow medium, and burnt sienna. For the cool reflective lights on the back, use crimson and burnt sienna with white to lighten or ultramarine to cool.

181 | Curly Hair

 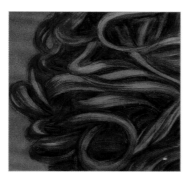 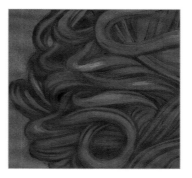 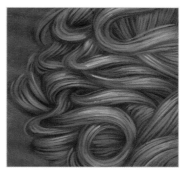

For "dirty" blonde curls, mix burnt sienna and sap green for a warm, transparent, middle-value brown. Use a flat brush to cover the drawing; then pounce to thin the color until you can see your drawing through the paint. Use an eraser cloth to remove color where the light is strongest.

Using a flat brush and equal parts black and burnt sienna, paint the darkest shadows and curls. Stiff bristles create wiry hair, whereas soft brush hairs yield silky strands. Soften the brushmarks by wiping the brush and retracing your strokes. Distant curl edges should be softer for depth.

Continue building middle values using a fine-pointed brush and varying blends of ultramarine blue, burnt sienna, and white. Redefine shadows and darken the ends of the curls where they move in and out of shadow. Keep your edges soft to create a general impression of curls rather than strands.

Highlights on curls are brighter than those on straight hair because the light is concentrated on smaller sections. Use blends of yellow ochre and white to detail the curls. Use a light touch and thin paint to bring individual hairs into focus. Hit the brightest highlights with thicker paint.

182 | Wavy Hair

Mix a warm, golden, transparent brown for the middle-to-dark values. Cover your drawing with this transparent color mixture and pounce the color until you can see your drawing through the paint. Wipe away some of the color from the negative space and from areas where the light hits most.

For the shadow areas, mix equal parts raw sienna and black. A ¼-inch flat brush and long, sweeping strokes work well to create smoothness while giving you enough control for the smaller negative spaces between the waves and at the ends of loose strands around the edges.

Build middle and light brown values using varying blends of burnt sienna and cadmium yellow medium. Use sweeping strokes with a long, fine-pointed brush. Redefine shadows with a dark mix of sap green and burnt sienna, blurring the edges. To paint negative space, use white and green gold hue.

Build up middle values using a long pointed brush. Each stroke should start with a point (less pressure) and widen (more pressure) as you reach the center of the wave. Use less pressure again as you near the shadow end of the wave. For the highlights, use equal parts raw sienna and white.

183 | Facial Hair

Mix two parts burnt sienna to one part sap green, and thin the paint on your palette. Using a ½-inch flat brush, cover your drawing with this transparent color mixture, spreading the color as smoothly as possible. Use the pounce technique to remove all brushmarks. Next use your eraser cloth to remove some of the color from the areas where the light hits the mustache and beard, or where there is more gray hair.

Create the darkest shadow areas, including under the lips and nose and between the mustache and beard, with the thin edge of a ¼-inch flat brush and a mixture of equal parts burnt sienna and black. By adding a small amount of alizarin crimson and white to lighten, you can create a dark pink lip color that still integrates with the beard and other skin tones.

Fill in the middle value of this red beard and mustache using a fine-pointed brush and a thinned mix of equal parts raw sienna and burnt sienna. With burnt sienna and sap green, redefine your shadows and soften edges where needed. For the cheek, lighten burnt sienna with varying amounts of white and use your small pointed brush to create fine, impressionistic strokes that disappear as they merge with the beard along the hairline.

Start by adding lighter whiskers on the cheek and lower parts of the beard with a fine-pointed brush and variations of raw sienna, burnt sienna, and white. To capture the variation of hair growth in longer, untrimmed beards and mustaches, paint in short strands against the direction of the main hair growth, especially in the shadow areas and over the lips. Finally, add the lightest strands, starting at the end of the hair and stroking back toward the follicle for a thick-to-thin line, creating the illusion that it is disappearing into the beard.

184 | Eye

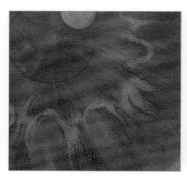 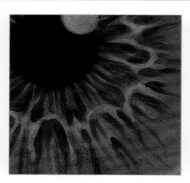 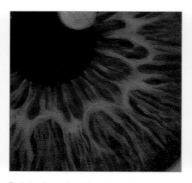 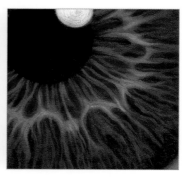

The iris of the eye has intricate detail and soft, stringy areas that can be treated almost like hair at the beginning. There is so much depth and color variation, but the edges of these areas need to be kept defined yet soft to retain the watery effect in the eye. Start by laying a smooth layer of two parts burnt sienna mixed with one part sap green using your soft ½-inch flat brush. Use the pounce technique to smooth out the brushstrokes and follow up with the eraser cloth, removing color along the light edges of the gold area that flares out from the pupil. Do the same with the circular highlight, as it is difficult to achieve a bright white over dark color.

The pupil comes to life with a simple mix of black warmed up with burnt sienna. After painting in this area with your ¼-inch flat brush, use the same brush to drag this color outward in loose, squiggly lines that radiate from the center of the pupil. This will soften the edge of the circle and begin to establish the warm brownish areas of the iris pattern. With a small pointed brush and a lighter mix of equal parts black and burnt sienna, paint the remaining dark parts of the iris using loose, painterly lines with soft edges. Wipe off your brush and trace over your strokes to make the eye appear smooth and moist.

To introduce the blue tones in the iris, use a long, fine-pointed brush and various blends of white with Payne's gray for a more neutral color, or ultramarine blue for brighter eyes. Thin this color so your marks flow smoothly to retain a blurred, watery affect. Working from the center outward toward the edges of the iris, create loose, squiggly lines in varying opacities to replicate the complex patterns and depth of the iris.

For the final touches on the iris, fill in the white of the circular highlight with a #3 round brush. Then punch up the color on the golden rays fanning out from the pupil using a #1 or #2 round brush and a mixture of yellow ochre, burnt sienna, and white.

185 | Smooth Canine Fur

 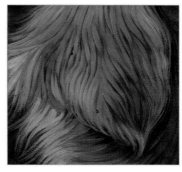

To create long, smooth canine fur, lay in a medium value of thinned burnt sienna and sap green using a flat brush. This mix will show through the fur as you paint layers. Remove color in the lightest areas by picking out color with a dry pointed brush.

To build a good base for rendering the soft, light fur, darken the shadows with equal parts of raw sienna and black using a soft flat brush. For the background, add white to create a warm gray and work from the edges toward the fur, lessening your stroke pressure for blurred ends.

To build the middle tones, start by mixing cadmium yellow medium, yellow ochre, and a bit of black. Using a pointed brush, twist and turn your wrist as you stroke in the direction of hair growth. Go over your brushmarks with a soft, dry brush to minimize texture.

For the final layer, mix raw sienna, white, and cadmium yellow medium to create a lighter color. Load a pointed brush and wipe off the excess paint onto a dry cloth. Start with the bottom layers of fur and work upward so each brushstroke lays over the previous.

186 | Curly Canine Fur

The easiest way to capture the depth of curly canine fur is to work from dark to light, beginning with a base of shadows. Create a thin mix of burnt sienna and black; then use a flat brush to lay in a flat area of color. Pounce to smooth out the brushmarks.

To create the soft edges of curly hair, start by painting a thin layer of medium (if using oil) or water (if using acrylic) directly over the dried underpainting. For shadows, dab black and burnt sienna into the spaces between the curls and under the ear, using squiggly marks. Allow the paint to dry.

For softer brushstrokes, wet your entire painting again. Mix equal parts yellow ochre, burnt sienna, and black for the middle values of this curly fur. Using a flat brush, build the lighter values with random, squiggly lines that vary in thickness, moving from top to bottom. Repaint shadows if needed.

For the last layers, mix equal parts raw sienna and white. Using the corner of a flat brush, gently and loosely build up the lighter areas of hair. Build from dark to light slowly for a soft effect. Add a small amount of cadmium red light to warm the fur or white to lighten. Remember to work loosely.

187 | Coarse Canine Fur

Start by painting your darkest shadow color using burnt sienna darkened with black. Thin the color until it's soft and smooth. Apply the wash with a flat brush and pounce to eliminate brushmarks. Define the fur along the edges by lifting color with a dry, fine-pointed brush and short strokes.

Short, choppy strokes with the edge of a flat brush work well for capturing coarse hair. Always work in the direction of hair growth and allow some underpainting to show through to start building depth and detail with minimal effort. Use a darker version of your mix of black and burnt sienna.

Mix equal parts yellow ochre, cadmium red light, and cadmium yellow medium for the middle values of the fur. Use the palette knife point and its edge to lay in the color for a coarse texture. Scratch into the paint with the tip of the palette knife to spread the color in the direction of hair growth.

Now use the drybrush technique. Load your flat brush and wipe off excess paint on a rag. Then, with your brush on its side, stroke lightly across the texture marks so you only pick up the raised parts. Then use a palette knife to build up more texture in the light areas, working in the direction of hair growth.

Start colorful fur for a long-haired cat simply by establishing a warm undertone that provides depth and contrast under the cooler gray and white of the longer hairs. Use a thin mixture of two parts raw sienna to one part black and a ½-inch flat brush to paint long, smooth strokes in the direction of fur growth. Clean your brush and pull up some of this color along the lighter areas. This will make it easier to build up your white later.

Using a mix of two parts black to one part raw sienna, start to define the fur by building up the shadows between the individual sections. Use long, thin strokes with a small pointed brush, and vary your pressure or spin the brush slightly in your hand to create thicker and thinner lines that add variation and a sense of realism.

Now create the warm white and gray tones in the fur with various mixtures of black, white, and yellow ochre. Continue using the long strokes of a pointed brush, varying the pressure for more interesting marks that suggest the soft, flowing nature of long hair.

Now that you have established the middle values, simply continue to build up the lighter values by adding more white to black and yellow ochre. Using the same pointed brush, wipe off the excess paint, and hold your brush from the very tip to ensure more natural, varied strokes. Twist and turn your brush and use varying pressure to create thick and thin lines. By adding a touch of black, you can create cooler, darker grays along the outer edges and anywhere you want the fur to recede. Trace over your strokes with your brush as many times as it takes to achieve your desired softness.

189 | Short Cat Hair

When painting hair or fur, work from dark to light and leave the detail work for the lightest areas. First apply the warm shadows using a ½-inch flat brush and a thin mix of two parts raw sienna to one part black. This transparent layer will provide a dark underpainting while allowing the drawing to show through. Clean your brush and pat it dry, and then use it to lift color from the lightest areas of the fur. This will make it easier for you to build clean, bright whites over the dark background.

To create soft edges within the fur, apply quick, soft marks that you can build on. Use the flat edge of your ½-inch flat brush to loosely paint the darker parts of the fur with ½-inch to 1-inch long strokes and a blend of two parts raw sienna and one part black.

To create the multiple layers of fur in short-haired cats, use the thin edge of a ½-inch flat brush in a zigzag pattern and work your way down the canvas. Build up the basic middle value areas with cadmium yellow medium, a small amount of cadmium red light, and raw sienna to create an orange color. For the white fur, use white mixed with a little bit of black and yellow ochre.

Lastly, address the fine detail and brighter lights, switching to a small pointed brush. Thin equal parts white, cadmium orange, and raw sienna just enough to make your color flow smoothly. Use short, delicate strokes that flow in the direction of the hair growth to pull up the highlights in the orange fur. Reload your brush when your marks begin to get rough. Add new brushstrokes to fill in the gaps and suggest depth in your painting. To lighten the white areas of fur, add a small amount of your mixed orange to white, and continue to build up short marks.

190 | Horse Coat

Using raw sienna with a small amount of black and a ½-inch flat brush, lay down your underpainting with short strokes in the direction of the hair growth. Unlike cat or dog fur, horse hair is very short and lays flat on the muscle, creating a smooth texture. To achieve this, do not leave too many visible brushstrokes.

To build up the darkest shadow values of this horse coat, use a ½-inch flat brush and a mixture of equal parts burnt sienna and sap green. With a light touch, apply your brushstrokes in the direction of the hair growth. Keeping your dark values transparent helps them to recede, resulting in the illusion of more depth.

Next build up the reddish middle values of this chestnut coat using an old, stiff #5 round brush. This is where those old, roughly handled brushes come in handy! Mix variations of cadmium orange and burnt sienna lightened with white, and dab your brush into the paint as you spread the bristles apart. This helps create lines in your strokes that resemble hair. Work in the direction of the hair growth, paying close attention to the various muscles and vascular areas under the skin.

To bring up the lightest areas, use a #1 round brush and various mixtures of burnt sienna, cadmium orange, and white. Work from dark to light and use short, delicate strokes in the direction of the hair growth to add detail and give volume to the muscles and veining prevalent in the lean contours of the horse's anatomy.

191 | Horse Mane

To create the long, somewhat coarse texture of this mane, start by painting the darkest shadows, using a ½-inch brush loaded with two parts burnt sienna and one part black. Apply the paint in long, full-length strokes that start at the ridge and move toward the ends of the hairs. Use a soft, dry blending brush to trace over the strokes to blur and soften the edges. Clean your brush and pat it dry and then use it to pick out color from the lightest areas. Use the edge of the brush and less pressure as you reach the ends of the hairs to create fine-pointed tips. Wipe your brush clean after every few strokes.

Use the same ½-inch brush to paint the middle value of reddish brown in the mane and on the neck, using a mix of equal parts raw sienna, black, and burnt sienna. Cut into this color with a darker color mixed from equal parts black and burnt sienna to define the dark negative spaces between sections of hair.

The only difference between the hair of a horse's mane and human hair is that horse hair is coarser. Using the same long, fine-pointed brush you would use for human hair, apply a mix of raw sienna, cadmium red light, and white to create the reddish colors in the mane. Turn your painting whichever direction is most comfortable for you to paint the entire length of the individual hairs with long, soft, smooth brushstrokes. Work back and forth, arcing your hand to delicately create the curves of the flowing mane.

Now add the final highlights. Mix two parts white to one part cadmium yellow medium, and add a small amount of raw sienna to neutralize. Thin the mixture to create longer, smoother lines. Rotate your painting in whatever direction allows you to get the most natural arch. Start at the origin of the hair growth—in this case, the lightest area—and reduce the pressure of your brush as you reach the ends, lifting your brush right off the painting to achieve fine, soft, wispy ends. If you find that these marks contrast too much with the darks, darken the mix with burnt sienna. Work your way up into the lightest areas gradually.

ANIMALS
192 | Dolphin Skin

Dolphin skin is smooth, wet, and reflective. Lay in a smooth, transparent layer of phthalo blue, darkened and neutralized with a bit of black. Apply this middle value using a soft brush. Use the pounce technique to eliminate any brushmarks and soften all the edges of color.

To build the dark values, mix phthalo blue with a very small amount of black. Using a flat brush, work in long, smooth, sweeping strokes. For the lighter, pinkish-gray areas, mix burnt umber with white in varying amounts and retrace your strokes until smoothly blended.

Add middle values of blue in the lower left with a flat brush and a mix of phthalo blue, white, and cobalt blue. This cool blue is found where the skin reflects the water below. For warmer, lighter areas, add more white and a touch of Venetian red. Blend the edges between colors using long strokes.

Using a round brush, loosely create reflections of water on the dolphin's smooth, wet skin with a mix of alizarin crimson and phthalo blue, brightened with white. Thin the color so it glides on smoothly. Recreate the appearance of water patterns in the darkest shadow areas where most clearly seen.

193 | Elephant Skin

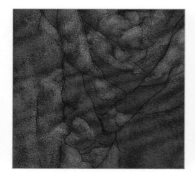

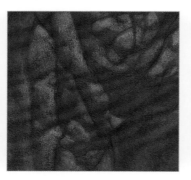

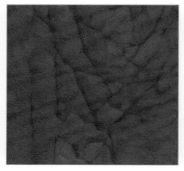

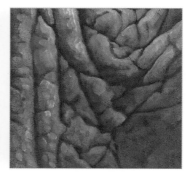

To paint rough, deep wrinkles, start by painting an even layer of burnt sienna cooled down with sap green. These are transparent colors, so they'll allow the drawing to show through while creating a warm undertone. Using an eraser cloth, remove color from the lightest areas of skin.

For the deepest creases and shadows, mix equal parts black and burnt sienna, with a bit of white to increase opacity. Using a flat brush, render the lines and shadows with loose, drybrush texture and soft edges. Wipe off excess paint from your brush before you stroke to help achieve texture.

For the middle-value gray that makes up the bulk of elephant skin, mix white with a bit of black. Using a flat brush and short, square strokes, gently paint the rest of the skin. Use a light touch and capture the texture of your surface, allowing bits of the warm underpainting to show through.

Once your previous layers are dry, add more white to the gray mix and warm it with yellow ochre. Continue using your flat brush and wipe off excess paint to add the lightest highlights. Build texture by drybrushing short, impressionistic strokes. Don't blend; leave your marks very painterly.

194 | Zebra Coat

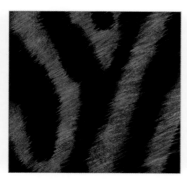

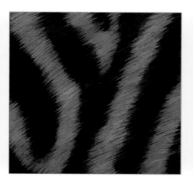

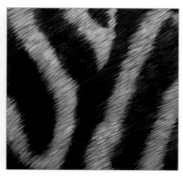

Before you begin, create a warm, dark underpainting using black and burnt sienna. This adds variety and depth to the overlaying values. Use a fan brush moistened with mineral spirits (if using oil) or water (if using acrylic) to pull out color in the white stripes for a scratchy texture.

Warm some black with raw sienna and use the edge of a flat brush to paint the darkest areas of the stripes. Apply short, thin strokes in the direction of hair growth to produce the fine, lighter hairs of the black stripes. The pattern will appear integrated because they share the same warm underpainting.

Mix black with a bit of white and use the brush edge to create straight marks that move from the black areas into the white areas. For the white stripes, use the same brush and a mix of white with a bit of yellow ochre. Follow the hair growth and stretch your marks into the surrounding areas.

Add highlights in the white stripes. Mix white with a bit of black and cadmium yellow medium to create a light, warm gray. Build up the whites in several layers. Let the previous layer of paint dry before adding another. Also, make sure your lines extend into the black stripes a bit to create soft edges.

195 | Leopard Coat

 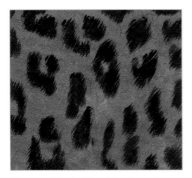 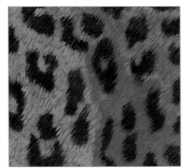 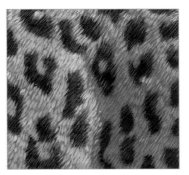

To add warmth to the leopard pattern, start with a wash of three parts raw sienna to one part black. Thin the color so you can still see your drawing through the paint.

Warm up black with a bit of raw sienna and use a pointed brush to create the dark spots of the pattern. Working in the direction of hair growth, use a light touch at the beginning and end of each stroke to create fine hairs. Allow some underpainting to show through.

With a fine-pointed brush, create highlights in the black fur using black lightened with a bit of white. For the middle values of the white fur, use white with a bit of yellow ochre and black to create short, fine marks in the direction of hair growth.

Enhance the brightest highlights with your finest pointed brush. Add a bit of raw sienna to white and use small, short, pointed brushstrokes to paint the highlights in the fur, working in the direction of hair growth. For the dark shadows, add black to the mix and more raw sienna, if needed.

196 | Snakeskin

To paint this raised snakeskin pattern, apply an even layer of transparent burnt sienna with a flat brush. Pounce to remove any brushmarks. Darken the burnt sienna with a bit of black and, using a small pointed brush, paint the dark shadow area between each scale.

Next focus on creating the shadow side on the left and bottom of each individual scale. Use a fine-pointed brush loaded with a mix of equal parts burnt sienna and black. To blur the edges and start modeling the roundness of the scales, lightly brush over the scales with a soft, dry brush.

Snakeskin texture is shiny and often colorful with hard edges. Using a flat brush and a mix of yellow ochre and cadmium red light, lay in the middle value of each scale. Use a mix of raw sienna and cadmium yellow medium between the raised scales. Round any corners that have become angular.

Add the final highlights. Mix black and white, adding yellow ochre or raw sienna for warmth. Using a small pointed brush, wipe off excess paint and apply highlights along the top and right edge of each scale. If the white is too strong, tap down the color with your finger to blend it.

197 | Starfish

Begin by using a flat brush to lay down an even, reddish layer made from burnt sienna and black. Pounce to eliminate brushmarks. Dampen the end of a cotton swab with mineral spirits (if using oil) or water (if using acrylic) and pat it dry. Then gently dab to lift out circular areas of color.

Create the shadows found on the right sides of the raised bumps by using the corner of a small flat brush or a cotton swab to dab on a darker mix of black and raw sienna. Build the texture in the flatter areas with this same technique, allowing some marks to be more subtle than others.

For the raised round bumps, mix yellow ochre, cadmium red, and white. Dab a cotton swab into the mixture and onto your painting. Each time you dab with the swab, the mark will be softer. Dab over spots with a dry swab to soften and suggest depth. Add more white to the mix and add lighter values.

To create the lightest bumps, use cotton swabs or switch to a small round brush. Mix white with a small amount of cadmium yellow medium to create warm highlights. Try not to cover up previously applied colors. Keep the brightest whites and sharpest edges where you want to attract the viewer's eye.

198 | Feathers

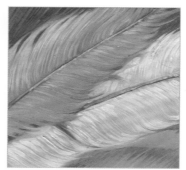

First, establish the shadow colors. Mix a neutral purple of alizarin crimson and Payne's gray. Thin it enough to create a transparent middle value wash. With a flat brush, work in the direction of the feather's pattern with long, smooth strokes.

Create a thin mix of white and yellow ochre for the lightest feather. Tap a small fan brush into the mix and work from the center stem outward. Finish each stroke with a quick sweep to the right as you lift the brush off the canvas. Add burnt umber for darker feathers, and overlap the feathers wet-into-wet.

To clean up the edges and add more specific detail, use a round brush and a mix of black and white to paint shadows between and around the separated parts of the feather. Use the same mix to paint the stems before adding final highlights with pure white.

199 | Butterfly Wing

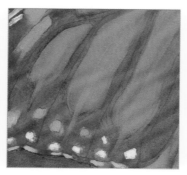

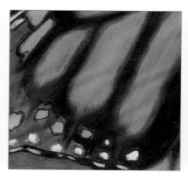

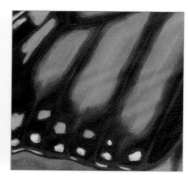

Start with a semi-transparent orange mixed from cadmium yellow light and cadmium red light. Thin the paint while retaining its vibrance, and paint over the entire wing. Use a cotton swab or piece of cloth to pick out white areas of the wing. Use the pounce technique to eliminate your brushmarks.

Next focus on the lightest oranges and whites. You may need to apply multiple layers of white for brightness. Let each layer dry before adding another. Add cadmium yellow light to your orange mix to increase the opacity and build up variation in lighter orange sections.

Load a round brush with a mix of black, cadmium orange, and cadmium red light. Trace around the colored sections with soft, drybrush lines that act as a transition edge between the darkest blacks and the bright colors. Add more black to the mix and fill in the remaining black areas.

Once you've finished massing in the warm blacks, add a touch of white to the mix and use a round brush to add the fine detail along the veining between each section of color and along the edge of the wing. Keep these lines soft and subtle so they read as highlights falling on raised areas.

200 | Spiderweb

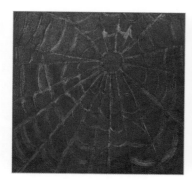

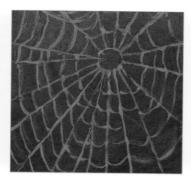

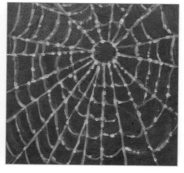

First, lay in the background. Use a flat brush to paint an even layer of green made of sap green and yellow ochre. Pounce to remove any brushmarks. Pull out some of this green with a round brush that is damp with mineral spirits (if using oil) or water (if using acrylic). Wipe off the color on a cloth.

Before painting the brightest lights of the spiderweb, establish lines with a bright green mix of cadmium yellow light and green gold hue (or an equivalent). Thin it so you can draw fine lines with a round brush. Note how the strands sag toward the web's bottom to make it feel more natural.

To capture the effect of dew resting on the web, use a fine round brush with a very delicate touch. Use a thin mixture of white and a bit of cadmium yellow light to retrace some of the lines, especially where they meet and reflect sunlight. Dab tiny spots at random places along the threads for dew.

FABRICS & TEXTILES

201 | Burlap

 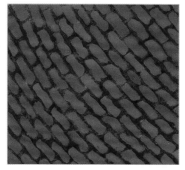

Mix burnt sienna and sap green for a warm brown underpainting. Once dry, use a stronger version of this color to block in the weave. Use a flat brush on its edge to paint a gridlike pattern of shadows between the threads.

Begin painting the weave of burlap by applying short, organic strokes that cross over two squares of the grid. Use a ¼-inch brush and a mixture of equal parts burnt sienna and yellow ochre. As you lay down the strokes, stagger each row by one square, as shown.

To create the cross sections of the weave, mix burnt sienna, white, and yellow ochre. Use a flat brush to create short strokes across the mid sections of the opposing threads. Work in the opposite direction of your first set of marks.

The final details and highlights bring the separate weaves together to appear more cohesive. Using white and yellow ochre, hatch in one direction so the strokes line up. Then rotate the painting and hatch in the opposite direction to form a cross on top of each section.

202 | Wool

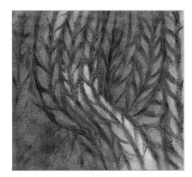 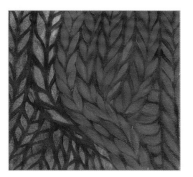 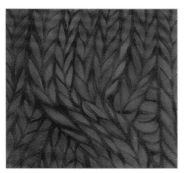 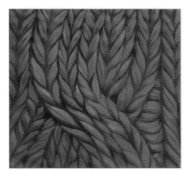

Wool features a signature pattern. Mix burnt sienna with sap green and thin the paint. With a flat brush, paint an even, transparent layer of color over the surface. Then establish the pattern using a round brush. Wipe off the excess paint from the brush and loosely draw lines between threads.

Use a round brush and a mix of burnt sienna and sap green to redraw shadows. Mix yellow ochre into the shadow color for a warm middle value. For each braid thread, place the brush tip in the top corner and apply pressure to thicken the stroke; then lift to end the stroke.

Blend and soften the edges and reestablish the shadows by tracing over the drawing with a round brush and a thin mixture of burnt sienna and sap green.

Once dry, use the same brush to add brighter highlights and more texture to your pattern. Mix yellow ochre with a touch of white, and wipe off the excess paint from your brush before stroking. Add two or more strokes on some sections to create the look of yarn.

203 | Tweed

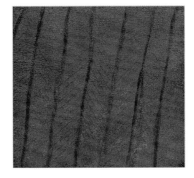 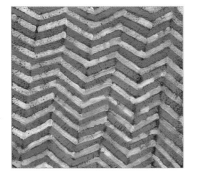 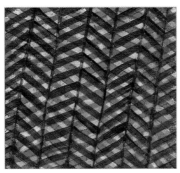

To start the herringbone pattern of classic tweed, begin with a dark, transparent layer of burnt umber and ultramarine blue. Pounce to eliminate brushstrokes and even out the color until your drawing shows through. With a round brush, draw shadow lines between the rows of the pattern.

Working in the opposite direction of the pattern you created in step one, use a round brush loaded with pure white to paint the cool light areas of the herringbone pattern. Any color combination will work, depending on how traditional you want to be. Reload your brush after each stroke.

For the neutral yellow threads, use a round brush loaded with a mix of two parts yellow ochre to one part white. Reload for every section, and keep your strokes loose and organic, allowing the dark underpainting to peek between the stripes.

For the final dark sections, mix a glaze of black and ultramarine blue brightened with a bit of yellow ochre or white. Use a round brush to paint stripes in the opposite direction of the previous gold and white stripes. Clean up the rows between sections with fine strokes of the dark glaze.

204 | Plaid

Painting plaid patterns calls for layering transparent colors. Begin with the blue base color. Use ultramarine neutralized with a bit of Payne's gray, thinned to a light-to-medium value. Using flat brushes, lay in the color, stroking in the direction of the stripes. Allow this layer to dry.

Use the same brush to establish the red stripes. Thin cadmium red light to a medium-to-light consistency, and load your brush with enough paint to complete one whole stripe with a single brushstroke. If you must retrace your stripe, do so softly and quickly to avoid overworking and pulling out color.

Bring the plaid pattern into focus by painting the finer stripes. Using a round brush loaded with a glaze of ultramarine blue and alizarin crimson, work from one end to the other, painting over the other colors. Avoid overworking glazes, and let them dry between each layer.

Add one more diagonal stripe using a thinned version of the glaze from step three. Then use a fine-pointed brush loaded with thin white paint to add a few final strokes. Plaids can be as complex as you want; keep adding stripes, colors, and layers to achieve any desired combination.

205 | Denim

 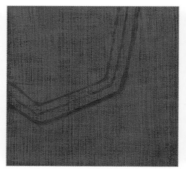 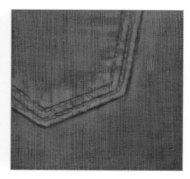

Apply a layer of gesso to your board with a bristle brush. Use long strokes to create a texture of vertical lines that will show up later as the thread texture. Once dry, stain the surface with a wide flat brush and a transparent mix of thin raw sienna, painting in the opposite direction of your surface's texture.

For the blue cross-weave, use a thin mix of ultramarine and black. Use a large flat brush to sweep across the grain of the surface texture, covering the underpainting. Then use the edge of a large, flat sponge to lift some of the blue glaze, exposing warm tones and creating horizontal striations.

To build the texture and lighter blue threads of the denim, add more ultramarine and white to your previous mix. Wipe off the excess paint from a flat brush and softly drag it across the support in horizontal strokes. Lay your brush as flat as you can. The paint will catch only the tops of the texture.

For the lighter, worn areas around the stitching, add more white and yellow ochre to the mix. Use a round brush to carefully add detail with the drybrush technique to emphasize the texture and avoid covering the colors from your first layers. Use yellow ochre lightened with white for the stitching.

206 | Cotton

To create simple, white cotton cloth, start with a warm gray underpainting made from a mix of equal parts black, ultramarine blue, alizarin crimson, and white. Using a soft rag, paper towels, or cotton swabs, wipe off some of the color in the lightest areas.

For middle values, mix black, ultramarine, and white. Use a flat brush to work from light areas in long strokes that follow the folds. Work toward shadows, blending into the darkest parts of the underpainting without fully covering it. Keep shadows semi-transparent and lights thicker.

Continue to build your lighter values by adding more white to your mixture and using a ¼-inch flat brush to cover the rest of your drawing and underpainting. As you move into the lighter values, don't be afraid to use more paint and allow for more texture.

For bright light along the folds, use pure white with a touch of yellow ochre. Use a flat brush to work in long strokes, keeping your brush flat in relation to the support for more texture. Drybrush over the bottom of each fold in the shadows to enhance the reflected light.

207 | Silk

 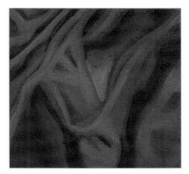 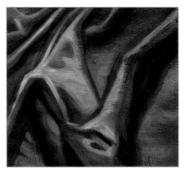

For this bright purple silk, start with a thin underpainting of ultramarine blue and alizarin crimson. Use a balled-up cotton cloth to pounce out the brushstrokes without removing color. To establish the highlights on the folds, roll up a small piece of cloth into a point and gently wipe away color.

For cool purple midtones, mix ultramarine blue, phthalo blue, and alizarin crimson. Use a flat brush and work in the direction of the folds in long strokes, avoiding the lights. Add more alizarin crimson and black to your mix for the darkest shadows. Work wet-into-wet to create transitions.

Cover the lightest areas with a bluer mixture of phthalo blue, alizarin crimson, and white. Use a flat brush on its side and edge, depending on the width you need. Keep your turns more angular with less blending at this stage.

For the final reflective highlights, mix phthalo blue with white. Use a flat brush to create quick, unblended marks across the curves of the folds, switching to a round for the ridges. Leave your marks painterly and allow the lines of your brush hairs to suggest light hitting the silk's weave.

208 | Satin

Using a flat brush, create a thin mix with equal parts cadmium orange and cadmium red light for the underpainting. Pick out the lighter areas with a small cotton cloth rolled to a point. Be careful not to let the rest of your cloth touch the wet paint on your canvas.

For the pinkish middle values, mix cadmium orange, alizarin crimson, and white. Use a flat brush and work in the direction of the folds, avoiding the lights. Darken the mix with alizarin crimson for shadows. Work wet-into-wet for soft, blended edges between the midtones and shadows.

Continue building lighter values by adding white to the previous mix and creating a base for the final highlights, which will bring out the shine of the satin. Cover the remaining areas of the underpainting, tracing over your long strokes to blend the edges into the darker areas.

To finish the lightest areas, add white in various amounts to your previous mixture and, using a round brush, build up impasto strokes along the ridges of the folds with long, soft, blended marks. Keep your curves round and smooth to illustrate the heavy weight and thickness of satin.

209 | Velvet

Using a ½-inch flat brush, apply the deep, rich shadows of this blood-red velvet with an even layer of equal parts black, Venetian red, and alizarin crimson. Use the pounce technique to eliminate brushstrokes and create a soft, even texture similar to that of velvet.

To create the tones of velvet while capturing its texture, work from dark to light with variations of black and Venetian red. Add more red after you have completed the shadows and move toward the highlight areas, working wet-into-wet for soft, blended edges.

Next add more Venetian red and white to continue building your values from dark to light using the drybrush technique for a velvety effect. Keep all your forms very curvy and soft, blending smoothly between values.

Use equal parts cadmium red light, Venetian red, and white for the final highlights. After wiping the excess paint from your #3 round brush, softly brush across the tops of your support's texture to capture the graininess of velvet and to build depth and contrast.

FABRICS & TEXTILES
210 | Leather

Lay down a thin but rich blend of equal parts burnt umber and burnt sienna with a 1-inch flat brush. Go over your marks to eliminate the brushstrokes. To create the texture of the leather, use a smooth, damp sponge to lift color from the surface. A flat sponge with holes of various sizes works best.

Because the creases in leather suggest realistic wear and tear, take some time to pull out their details with a #3 round brush and thin burnt umber. Keep the lines organic and natural, varying thickness. If they are too strong, simply use your finger to soften them.

To enhance the light falling on the mottled surface, mix a reddish gray with burnt sienna, black, and white. Using a round brush, add highlights to the bottom and left edge of each line. Drybrush where the light source is strongest.

For the lightest lights, mix burnt sienna and white grayed with a bit of black. With a flat brush, drybrush to add light to the areas of leather that reflect the most light. Highlight the top and right edges of the creases. Allow the warm underpainting to show through.

211 | Patent Leather

Lay down a layer of solid black. Let this dry, and then use a white colored pencil to sketch the main shapes on the black.

To build reflections of light, add a bit of white to your black. Using a flat brush, wipe off excess paint and fill in the reflections. Pay close attention to their shapes and blend the edges by swiping an almost-dry brush from the center of the reflection out into the black, lifting the brush for a gradation.

Once dry, continue to build up the lighter highlights with a ¼-inch flat brush, and add more detail to the seams with a #2 round brush. This will create a base for your final highlights.

Using pure white, add the final highlights to the thin piping of the patent leather with a #2 round brush. Use a ¼-inch flat brush for the larger areas after wiping the excess paint from your brush. Apply a thick dab of white for the brightest highlight, softening it with a dry brush.

212 | Sequins

Establish your middle value first with a thin, even layer of equal parts ultramarine blue and alizarin crimson. Use a ½-inch flat brush and then eliminate the brushstrokes with the pounce technique or by softly stroking over them with a very soft, dry 1-inch flat brush.

Cut the pointed end off a blending stump to create a flat, round end. Use this tool to create repeated circles of paint, starting with the darks. Mix black, alizarin crimson, and ultramarine, and spread a thin layer on a palette. Roll the edges of the stump in the paint, and then roll it on your painting.

Once dry, mix a lighter purple with ultramarine and alizarin crimson lightened with white. Dab the end of the stump in the paint, roll the excess paint off the edges, and press it on the center of each ring made in step two. Before they dry, use a round brush to remove texture from each circle center.

Add highlights along the upper edges using mixes of alizarin crimson, phthalo blue, and white. The greater the contrast, the more reflective they'll look. Use a fine round brush and dark purple mixed from ultramarine and alizarin crimson to add threads from the center to the edge of each sequin.

213 | Lace

Semi-transparent colors will allow the base color to show through, resulting in a more integrated pattern. For this white floral lace, paint a skin tone with black, cadmium red light, and white. To hint at the netting shadow, lift color with a dry piece of paper towel.

Paint a thin, semi-transparent layer of white over the underpainting and let it dry. Add a small amount of black to the base color and, using a fine round brush, draw the basic outlines of the lace. These darker lines should be soft but clear, acting as subtle shadows cast around the thicker parts of the lace.

Once the previous layer is dry, use a round brush and thin white paint to mass in the flat, medium-value white of the primary lace detail.

Bring out the final details by enhancing the thicker, whiter stitched edges within the lace. Use a round brush loaded with white to trace over these edges and add dimension within the pattern.

214 | Straw Hat

Start by applying a thin, even layer of burnt umber with a ½-inch flat brush. Use a soft, dry brush to blend your brushstrokes until you can see your drawing through the paint.

Next add more detail to the shadows between the rows in the weave using a #3 round brush and thin burnt sienna. Hold your brush toward the end of its handle, and allow it to make natural lines of varying thickness and density.

Now paint the gray shadows of the hat and the individual rows of woven straw using equal parts of raw sienna and black, lightened with a small amount of white. Wipe excess paint off your brush before working row by row in a zigzag motion, allowing the browns to show through.

Create various mixes of yellow ochre, burnt sienna, and white. Use a round brush to dab thick spots of loose color where the light hits the rows. Create the impression of woven straw by using the end of a palette knife to scratch into the dabs of paint, spreading them and blending them into the grays.

215 | Woven Basket

Create a detailed drawing that will act as a guide for the darks. Use a flat brush to lay in an underpainting of black, ultramarine blue, cadmium red medium, and white. Thin the paint until you can see the drawing through the color. Next use a dry flat brush to pull color off the weave's lightest areas.

After your underpainting is dry, create a mix of one part ultramarine blue, two parts alizarin crimson, and six parts white. Lay in the middle values of the purple in each individual section of the pattern using a flat brush.

Next lighten your mixture with more alizarin crimson and white to add warmer, lighter values to each section using a flat brush. Darken the shadows between sections using thin burnt umber and a round brush.

Now mix alizarin crimson, ultramarine blue, and white for the highlights. Use a round brush to add this color along the lightest edges. Add striations to suggest detail. Start at the top of each section and complete each highlight in one smooth stroke.

 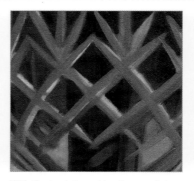 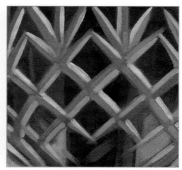

For beveled crystal, pay close attention to the shapes etched into the surface, and build your painting from a transparent background to a more opaque foreground. Start with a transparent glaze of gray mixed from black and very small amounts of alizarin crimson and ultramarine blue. Loosely lay in the shadow areas. Retrace your strokes to eliminate any visible brushmarks, but allow variations in the values to create depth and suggest light coming through the glass.

Continue to build the cuts of the glass with thin washes of black. A small 1/8-inch flat brush or #4 round brush will give you the control you need, but don't worry about being too meticulous at this point; you can always clean up your edges in the last layers of detail work.

With the background in place, switch to a smaller 1/8-inch flat brush or #2 round brush to begin painting the darker sides of the glass cuts. Create a purple-gray using white tinted with small amounts of black and Venetian red, thinning the mixture to ensure a fluid line as you work from one end of the cut to another.

Finally, using a #2 round brush, add a light blue mix to the light side of each cut, cleaning up the shape of each beveled edge as you go. Create each section in one clean stroke from the top to bottom, resulting in a natural gradation as the paint becomes thinner on your brush.

217 | Clear Glass

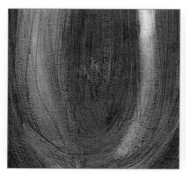 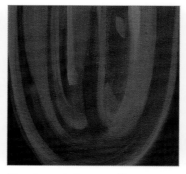 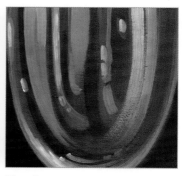

For clear glass, start with a wash of ultramarine blue, a touch of alizarin crimson, and Payne's gray. Thin down this mixture to a medium-value wash. Use a large, soft flat brush to quickly lay in the midtones using long strokes that follow the contour of the glass. Note: If you would like to eliminate drying time in the early stages of an oil painting, you can always paint your first layers with acrylic, then add oils on top of them. However, you can't paint acrylics over oils.

Before you move on to the lighter values and reflections of the glass, create a dark background that will contrast with these details. Various mixtures of black, white, and ultramarine blue are perfect for the neutral blue-grays of this glass. Thin your mixtures and use a 1/2-inch flat brush to sweep smooth color onto your surface in long, broad strokes that follow the curves of the glass. Retrace your marks to knock down the brushstrokes to achieve clean, blended edges that recede into the darker background.

Glass is purely the sum of its reflections, which respond to the surrounding environment. Any colors that are nearby or behind will reflect in the glass. Mix brighter versions of your background colors and thin them to create semi-transparent glazes. When painted over the glass surface, these semi-glazes will allow the underlying colors to show through. Study the reflections in your glass and use a 1/2-inch or 1/4-inch flat brush to capture them with long, smooth strokes that originate at the top edge of the glass.

After all your previous layers dry, add more white to your colors and stroke in a few stronger, more opaque reflections. A few well-placed dabs of dramatic color will also add to the reflective quality of the glass.

218 | Amber Glass

To lay the foundation for the golden-brown oranges of amber glass, mix equal parts burnt sienna and yellow ochre, darkening with a small amount of sap green. Then use a 1-inch flat brush to sweep your color in full-length bands across the subject, creating smooth color without brushmarks. You can use a soft, dry brush to soften the edges left behind.

Next add the darker browns found in the shadows of your form using a mixture of equal parts burnt sienna and black. Then lighten your mixture with more burnt sienna and yellow ochre, and use your ½-inch flat brush to mass in the rest of the oranges that make up the foundation color of the amber glass. Work in long, broad strokes from side to side, and smooth out the brushmarks by retracing them or using a soft, dry brush to lightly knock them down.

With the shadow and middle values of the amber in place, focus on the highlights and final details. Mix equal parts yellow ochre, white, and cadmium orange, thinning the mixture for a smooth flow. With a ½-inch flat brush, fill in the center area with long, smooth, seamless strokes from side to side, overlapping and blending them with the darker neighboring values. Add more defined reflections on the surfaces facing your light source with a smaller ¼-inch flat brush.

Finally, after your previous layers dry, add a few strong opaque highlights mixed from cadmium yellow and white. Stroke where the light bounces off the curved surfaces to really bring the glass to life and enhance its reflective quality. Hold a #2 round brush by the end and lightly add a few squiggly lines with thick paint. Do not blend the edges; instead, allow them to be dramatic and bright against the more subtle colors and textures beneath.

219 | Cobalt Glass

Begin this cobalt glass with a wash of ultramarine blue to create a middle value that will serve as a foundation for building deeper layers and reflections.

With the base color in place, continue to mass in the entire surface using dark, cool ultramarine blues warmed with a touch of phthalo blue and thinned for flow. Work wet-into-wet and allow your ½-inch flat brush to create loose brushmarks that mimic the natural surface variations found in cobalt glass.

Continue to add lighter values of blue mixed with cobalt blue and small amounts of white. Using a ½-inch flat brush will help you keep your brushstrokes loose and not overworked. Bring reflected light onto the sides of the glass and where the light shows through the dense areas.

To give the cobalt glass its reflective surface, add strong, white highlights with a #2 round brush where the light hits the object directly. Also, add more white to your cobalt blue mixture and, using a ½-inch flat brush, intensify the large reflection across the center of the glass to finish your painting.

Cobalt glass is rich in color and contains interesting variations of blue—not just one hue. This example uses ultramarine blue, phthalo blue, and cobalt blue paints.

HARD SURFACES

220 | Porcelain

 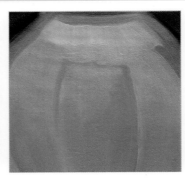 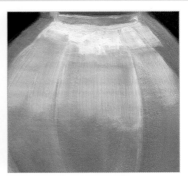

Most porcelain is milky white with a reflective surface. It is a good idea to build your values and opacity slowly so that you can create depth and variety by controlling the transparency and temperature of the paint. Using a 1-inch flat brush and long, curved strokes that extend from the top to the bottom, apply a thin underpainting with equal parts black and white.

Once your initial layers dry, add more white to your paint and continue to build the lighter values where the light source hits the surfaces more directly. Also, indicate where the strongest white highlights will be added later using a ½-inch flat brush.

Continue the process of building the lighter values of each separate surface with a lighter variation of thinned white mixed with a touch of black. By building your whites with semi-glazes that are allowed to dry between layers, you will achieve a very translucent surface that resembles porcelain. Pay attention to how the separate sides of your object relate to the light source.

After your previous layer dries, finish your porcelain by adding another more opaque layer of white where the reflections are the strongest along the top edge. Work your strokes down toward the center of the vase to show its form. It may take many layers to achieve bright whites, so add as many as needed for the desired value.

221 | Gold

Smooth, shiny gold is highly reflective with very dramatic reflections that follow the contours of your form. To start establishing the light logic of your object, create a thin mixture of greenish orange with equal parts cadmium orange and sap green. Use a ¼-inch flat brush to achieve the large, flat areas and thin, linear sections. Paint along the flow of the reflections—not against them—and retrace your marks until you have knocked down the texture and blended the edges.

Now that you have gotten to know your subject and its patterns, continue to mass in the different sections of reddish and darker greenish oranges with mixes of sap green, cadmium orange, cadmium yellow, and cadmium red. A ⅛-inch flat brush gives good coverage while offering enough control for detail. Twist and turn your brush to create thicker and thinner marks that flow smoothly along the curves of the reflections.

Having established the darkest reflections and midtones of the gold, start adding and refining the lighter values on the surfaces that are affected most strongly by the light source. Use variations of cadmium yellow and cadmium orange lightened with small amounts of white. Wipe off the excess paint from your #2 round brush and then apply color to the top edges of each curved section, blending the edges of your marks by retracing them.

To really bring the gold to life, use pure cadmium yellow and white to highlight the spots that reflect the strongest light. Wipe the excess from your brush and then lay down the paint in long, smooth strokes that blend with the underlying colors at the edges. The more contrast you have between your light and dark values, the shinier and more reflective the gold will appear.

222 | Polished Silver

The most important characteristics of polished sterling silver are its reflectivity and bright silver color. The strongest reflections respond to the detailing and shapes of the silver, while the softer gradations are reflections of the surrounding environment. Start with a mix of three parts black, one part white, and one part ultramarine blue, thinned slightly for flow. Apply these to the darkest shadows and reflections using a ½-inch flat brush and follow along the contours of the form. Keep your edges soft at this stage.

Unless you have colors from surrounding objects reflecting onto the surface, basic variations of black and white work well for the grays found in silver. Equal parts black and white create a medium value that is ideal for massing in the midtone areas. Use a ¼-inch brush and work in long strokes that follow the curve of your subject.

Next add more white to your color, and using a ¼-inch flat brush, begin to paint the lighter middle values along the rim and on the flat center of the plate. Hold your brush at the end of its handle to create loose, organic marks. Your brushstrokes should follow the curves of your form.

Finally, with either a #2 round or ¼-inch flat brush and pure white paint, add the final layer of highlights on the surface of the silver and along its detailed edges. Carefully observe the patterns that reflect within the silver, and add some to your painting to make it more realistic. Finally, mix a dark gray from black, white, and raw sienna to liven up your shadows and add depth.

223 | Pewter

 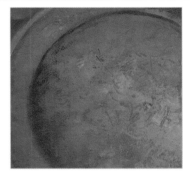 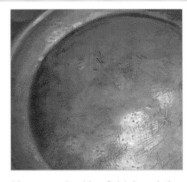

Pewter has a dense, soft appearance that is much less reflective than stainless steel or silver. Also, pewter tends to show quite a bit of wear; the older the object is, the more pock marks and scratches it will have on its surface. Begin by mixing a basic warm, dark gray using black and small amounts of white and burnt sienna. Then use a ¾-inch flat brush to paint the darkest areas with strokes that follow the curves of the form. On the flatter surface areas, drybrush short, impressionistic strokes in various directions to simulate transitions between light and shadow.

After your underpainting dries, switch to a ½- or ¼-inch flat brush and continue to build up the dark to middle values of gray. Use a mixture of three parts black to one or two parts raw sienna, lightened with a small amount of white. Start building the irregular surface texture of the pewter with short, impressionistic strokes that vary in direction. Scratch and tap into the paint with the pointed end of your brush handle to simulate the scratches found on most antique pewter.

Next bring up the values in the lighter areas of the pewter with various blends of ultramarine blue, white, and small amounts of yellow ochre. Add more texture to these areas with short, impressionistic strokes in random directions. Scratch and stab into the wet paint to give the illusion of wear and tear. These marks will become more obvious as you add highlights over them in the next step.

After your paint dries, finish by painting the light reflecting off the surface. Add more white to the previous gray mixes on your palette and use a ¼-inch flat brush to drybrush the paint onto the surface, turning the marks and scratches from step three into dark details. The edges of light should be soft due to the rough surface of old pewter. Add more scratches to the lightest areas, working over them until you're satisfied with the texture.

The older the copper, the more varied and reflective the surface. Start with a rich reddish brown underpainting of burnt sienna darkened with black. To create the watery transitions indicative of copper, first apply a thin layer of medium (if using oil) or water (if using acrylic) to your surface; then apply the underpainting with loose, impressionistic strokes using a ½-inch or ¼-inch flat brush. Your strokes will melt into the prepared surface.

Mass in the burnt oranges that make up the bulk of the middle values. Create a mixture of equal parts burnt sienna, cadmium orange, yellow ochre, and sap green. If this is too dark, reduce the sap green to brighten. Use a ¼-inch flat brush and medium-length, impressionistic strokes from side to side along the curve of your form. Work wet-into-wet to keep your transitions soft.

The lighter reflections that fall on copper are either cool, light oranges or saturated yellows and whites. First add the cooler reflective lights found on the undersides, where color is bouncing onto the surface from the surrounding environment. Simply cool down your orange mix from step two by adding a little white, and then use a ¼-inch flat brush to add squiggly reflections over the uneven copper surface.

Now bring out the reflective quality of the copper by dabbing on the lightest highlights where the light source hits the surface most directly and where other objects may be reflecting onto the surface. With a #2 round brush, apply small, impressionistic strokes along the contours of the forms with cadmium orange, bits of cadmium red light, and mixes of cadmium yellow and pure white.

225 | Hammered Brass

To capture the depth and color variety of hammered brass, use a ½-inch flat brush to apply a smooth, transparent underpainting of sap green mixed with a touch of cadmium red light. Then remove all the brushmarks with a soft, dry brush. Wrap a small piece of cloth tight over your index finger to pull out rounded sections of paint.

Now that you have established the dappled texture of hammer marks in the underpainting, soften it by glazing various combinations of yellow ochre, cadmium red light, green gold hue, and sap green (to darken) over the entire surface. This will partially cover your underpainting and integrate it with the middle values.

Next apply a more opaque layer of color that gradates from warmer, lighter golds (top) to cooler, darker burnt oranges (bottom) using white and yellow ochre darkened with burnt sienna and sap green. Blend this layer with a soft, dry fan brush. Then mix slightly darker variations of your colors and use a ¼-inch flat brush to accentuate the recessed areas with single brushstrokes. These shapes should vary in shape and size.

The final layers will bring your hammered brass to life. The more dramatic your color variations, the more reflective the surface will appear. For example, if your brass is next to a red object, add a bit of red into the divots with a ¼-inch flat brush. If your brass is next to a blue object, reflect blues into the brass. Push these reflected colors randomly into the darker divots with soft, round marks. Finally, punch up the light hitting the raised areas around the divots using the thin brushstrokes of a ¼-inch flat brush and light values of white and yellow ochre.

226 | Clay Pottery

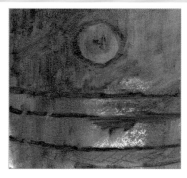 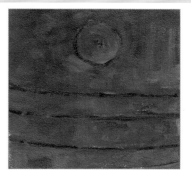

Clay pottery comes in grays and oranges, and—unless it has been glazed—it features a somewhat chalky surface texture. The older and more weathered the pottery, the more variation you will find in its patina. Begin by applying a cool gray underpainting using a ½-inch flat brush and thinned black. Use a slightly stronger wash to define the shadowed ridges and details.

Using various mixtures of Venetian red, white, and black, create the cool red midtones of the clay with the drybrush technique. Wipe off the excess paint from your flat brush and then drag the bristles across the surface of your image, holding the brush handle as low to the support as possible to pick up the texture of the painting surface. Work in short sections of color and stroke in different directions to build more visible texture.

With your cooler shadows in place, start to suggest the pattern of light by drybrushing lighter, warmer blends of cadmium orange, white, and small amounts of Venetian red over the surface. Again, wipe off the excess paint from your brush before dragging the brush over the surface, creating a coarse texture and allowing the colors beneath to show through.

Finally, with a mix of two parts white, one part yellow ochre, and one part cadmium orange, use a ¼-inch flat brush and a #2 round brush to add brighter color where the light hits your object most directly. Be careful not to cover the colors beneath as they will lend a natural sense of texture and depth to the overall painting.

227 | Rusted Steel

Begin by creating a thin mix of burnt sienna darkened with black for the reddish-brown areas of rust. Dab an old, worn round brush into the color and stipple it onto your surface.

Next build up the rust-colored spots with various mixtures of cadmium orange and yellow ochre for the lighter oranges, adding black for the darker areas. Then create a gray mix of black and white and loosely brush it into the areas of steel. Use a small, worn round brush or the corner of a ¼-inch flat brush to stipple more rust colors into the gray steel to suggest the spreading of the rust. Rust also features small dots of white oxidation, which you can create with a simple mix of white and a bit of black.

At this point, work on filling in the grays of the steel and creating the transitions between the steel and rust. Using a mix of black and white, dab small spots of medium gray wherever the steel shows through the rust.

Now that you have created the subtle colors of rust as it creeps into the grays of the steel, smooth out some of the areas of gray steel and clean up their edges. Use a small #3 round brush and a light gray mixture.

 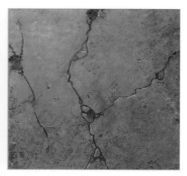

To make realistic looking concrete, build a mottled gray color that has some minor cracks and holes in it. A palette knife is perfect for creating the rough edges and smooth surfaces found in concrete. To begin, mix one part white to two parts black and add a small amount of raw sienna for warmth. Using a small palette knife, scrape paint across your surface in various directions. Be careful to knock down all the texture so you won't have trouble adding layers later. If you do have problems, you can always try sanding down the paint, which can create interesting effects that add to your texture.

Once your first layer dries completely, use your palette knife to continue building up the surface with a mixture of black and white warmed with a touch of raw sienna. Allow the palette knife to determine the texture as you scrape thin layers of paint across your surface in various directions using different pressures. Lay on the paint and scrape it off until you like what you see.

When your previous layer dries, add more white to your mixture and use your palette knife to burnish color onto your surface. The lightest areas should be where the light is strongest and where the concrete moves into the distance, as this area shows less detail and texture. Work the paint back and forth or in a circular motion to blend and thin the layer.

Now that you have completed the main texture of your concrete surface, all you need to do is add the fine line cracks and pits. Create a dark, warm gray mix and load a long striper brush. Hold the brush at the end of its handle to create natural lines and add a few simple, thin cracks to the surface. Apply sparse white highlights along the light edge of each crack to increase realism and depth.

229 | Stucco

Basic stucco is a very muddy, greenish gray and can feature various textures depending on how it is applied. Generally, it has a mix of smooth and bumpy areas throughout. Start with the darkest areas and build the rougher texture with a mixture of equal parts black, sap green, and white. Thin the mixture and stain your surface using a ½-inch flat brush, creating texture with loose variations of light and dark values.

Real stucco is applied with trowels, which are essentially large palette knives. To recreate this texture, switch to a small rounded palette knife to scrape and spread the color across your surface. Apply a mix of equal parts black, white, and raw sienna, allowing the raw edges to remain. Add a few dark patches to break up the surface.

After the painting dries, add more white to your previous color and continue to build the surface texture with a light gray. Use a light touch and allow the palette knife to create natural edges as you dab color onto the surface.

In this final step, focus on adding highlights along the upper edges of the thicker sections to make them stand out from the base layers. Use a very fine round brush loaded with pure white, being careful not to overwork your strokes. Another way to pull up the texture is to drybrush white over the surface by laying your flat brush almost parallel to your image and lightly pulling it across the tops of the highest edges.

230 | Brick

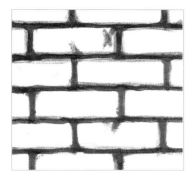 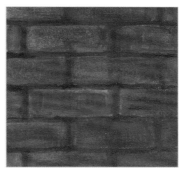

Painting brick is easy by building color and light over the darkest shadows. Begin by painting the rough mortar between the individual bricks using the edge of a ¼-inch flat brush and thin black paint. Keep your marks sketchy and round the corners of the bricks to suggest wear.

Using various mixtures of black, Venetian red, and white, paint the basic middle values of the bricks with a ½-inch flat brush. Lay the brush flat on its side and drag it across your surface to achieve the coarse texture of natural brick.

To add characteristic rustic reds and grays to the brick surface, use variations of Venetian red lightened with small amounts of white and cadmium red light. Then apply Venetian red darkened and grayed down with small amounts of black. With a ¼-inch flat brush, paint loose, short, impressionistic strokes that allow the underpainting to show through in areas. Each brick should feature variations of color and value.

Now add the lightest reds to the face of each brick using equal parts Venetian red, cadmium red light, and white. Use short drybrush marks that add to the natural texture of the surface. To finish, add highlights on the top and left side of each brick. Use a #2 round brush with white to add thin, broken lines along the edges, allowing some color beneath to show through.

231 | Cobblestone

 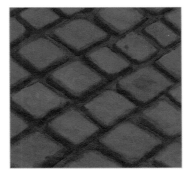 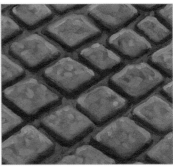

Begin by using a ¼-inch flat brush to paint the darkest shadows between the cobblestones. Create a thin mix of equal parts black and burnt sienna. Apply an even layer of transparent color; then reload and wipe the excess paint from your brush before loosely sketching the grid of shadows. Continue to blend around the edges of the stones, rounding the edges to suggest years of wear.

In this step, simply mass in the middle values of dark, warm gray with a ¼-inch flat brush and a mixture of one part burnt sienna, three parts black, and a touch of white. Keep the gray strokes soft as they roll over the edges and into the shadows.

Now mix equal parts black and burnt sienna and use the corner of a ¼-inch flat brush or a #6 round brush to darken the sides and bottom of each cobblestone. Then add white to this mix to create a middle-value gray for the top surfaces. Keep the cobblestones rustic and textured, varying the values to suggest the worn, irregular surfaces of the stones.

Finally, add more white to the gray mixture from step three and use a ¼-inch flat brush to stroke highlights over the raised areas of each cobblestone. The more texture you add, the older the stones will look.

HARD SURFACES

Marble features soft, mottled textures and stronger striations that cut across its surface. To achieve soft transitions, work wet-into-wet or blend with a very soft, dry brush—or use a combination of the two techniques. Use a thin, milky gray mixture of black and white to stipple your surface with an old, worn round brush.

With the darker variations in place, build the whites of the marble. Create a semi-opaque glaze by thinning white. Paint it over your entire surface using a large flat brush. Add as many layers as you desire, but let them dry between applications and avoid completely covering the grays below.

Now that you have created the luminous, transparent whites over the darker variations, add some of the darker veins that run through the marble. Use a long striper brush and a thin black glaze to paint long, thin lines diagonally across the surface. Use a soft, dry brush to softly blend and integrate them with the previous layers.

Finally, once your painting dries, evaluate your texture. Determine whether you want to bring up the value of any of the whites and add layers where needed. Also, if any gray details are too strong, simply glaze over them with a thin layer of white. The more layers you add, the more depth the marble will have.

233 | Pearl

The most unique qualities of pearls are their iridescent, swirling colors. First establish a cool, semi-transparent underpainting of reddish purple mixed with equal parts black, alizarin crimson, and white. Thin this color and use a ½-inch flat brush to create long curves that follow the form. Add more white for lighter values, and blend everything softly at this stage.

Pearls reflect many different colors, including pinks, blues, golds, and many variations of white. Begin with a soft ½-inch flat brush and mass in the primary base colors of salmon pink using blends of Venetian red and yellow ochre lightened with small amounts of white. Then create the more purple sections by mixing ultramarine blue with small amounts of Venetian red and white. Thin the paint so you can create long, smooth, sweeping strokes.

Pearls are basically white with other soft pastel colors reflected onto their semi-translucent surfaces. Mix various lighter values of pink and purple with mixtures of white tinted with yellow ochre, cobalt blue, or alizarin crimson; then add these where the light is strongest. Enhance the subtle pattern that swirls around the natural variations in the pearl surface.

Once everything dries, focus on adding the brightest highlights. Add more white to your mixtures and, with a #2 round brush, accentuate the lines and nodules that receive the most light.

234 | Diamond

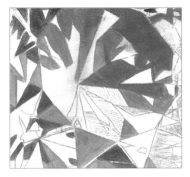 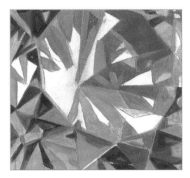 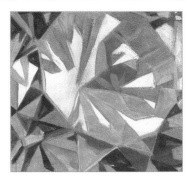 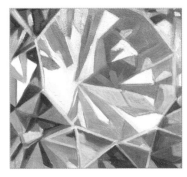

Diamonds come in many different types of cuts, but all of them reflect various colors from their surroundings. After carefully drawing the multifaceted surface, start by painting the darkest facets with cool purple-grays mixed with various blends of black, alizarin crimson, ultramarine blue, and white. Thin your colors to create semi-glazes that you can easily control with a #4 round brush. Eliminate your brushmarks using a small, soft, dry brush.

With variations of blue and purple-grays, continue to carefully paint the triangles that make up the individual facets of the diamond with a small #2 round brush. Mix any other colors that may be reflecting onto them from surrounding objects or light sources. Remember to keep the top face of the diamond lightest and clearest, with darker shadows around the edges.

In this step, continue to fill in the various facets with whatever colors you desire. If the darks on the face of the diamond compete with those on the receding sides, tone them down with a light bluish-white mixed from cobalt blue and white.

For the final details, load a long striper brush loaded with pure white that has been thinned slightly for flow. Clean up the edges of each facet by adding a fine highlight line between each section. This will integrate the facets to create the illusion of one diamond, rather than a collection of individual cuts.

235 | Wrought Iron

Although wrought iron is black or dark gray, make it more interesting by adding a little color from the surrounding environment. This will help you integrate the colors in your painting for a sense of color unity. Begin by using a ½-inch flat brush to lay in a middle-value gray wash of thinned black.

Next paint the darkest gray areas of the wrought iron with a #4 round brush and a mixture of black and small amounts of burnt sienna, lightened with a touch of white. Build as much texture as you'd like.

With the darkest grays complete, add small amounts of white to the mix to create various lighter grays. Use a #4 round brush to fill in the rest of the iron, paying close attention to the location of your light source and how the light hits the various forms of the wrought iron. Now clean your brush and create various mixtures of sap green, white, and a bit of black for the neutral green background.

Now add the final lights and highlights to the wrought iron using a #2 round brush and mixes of white and black. Include trace amounts of sap green and burnt sienna in your gray mixes to unify the painting and give life to the wrought iron.

HARD SURFACES
236 | Smooth Wood

Quickly capture the look of smooth wood using a flat brush and layers of semi-glazes. Start with a mix of burnt sienna and yellow ochre, thinned to a milky consistency. Work side to side with soft, horizontal lines that mimic the wood grain. Paint one stripe at a time, overlapping for soft edges.

Now build lighter middle values using a thin mix of yellow ochre, burnt sienna, and white. Keep your marks loose. Sweep side to side in curving bands that simulate wood. Work from top to bottom, with each row responding to the previous row.

After the paint dries, use the same ½-inch flat and a mixture of equal parts burnt sienna, yellow ochre, and white to add lighter details to the wood pattern.

Lighten areas of the wood grain. Add more white and yellow ochre to your previous mixture and thin the paint. Use your flat brush to stroke over the highest parts of the grain with a layer of color, punching up the highlights.

237 | Aged Wood

The texture and neutral color variations of aged wood call for a loose, impressionistic style. Lay in the underpainting and dark horizontal bands with a ½-inch flat brush and a thin mixture of equal parts black and burnt sienna. Work from side to side in long, continuous strokes.

Next build up the base colors with texture using the edge of a ¼-inch flat brush. Mix equal parts ultramarine blue, black, and white for the cool gray areas of the wood, and mix burnt sienna with yellow ochre for the warmer, lighter areas. Work from side to side in choppy, horizontal strokes.

After the paint dries on your canvas, add more white or yellow ochre to the mixture from step two and continue to paint the lighter areas with short, organic strokes from one side to the other. Keep your strokes coarse and broken to let the darker colors beneath show through.

The most important details of your aged wood are the highlights found along the top edge of each plank. Add these highlights carefully using a fine #2 round brush and a thin mix of equal parts white and yellow ochre.

238 | Wooden Barrel

 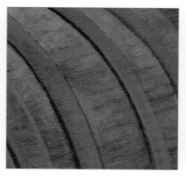 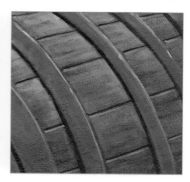

When painting a wooden barrel, begin painting the wood first and the metal banding second; this ensures that your wood grain flows realistically. Build the middle values of the wood with a thin mix of burnt sienna and black. Loosely lay down a layer of glaze, keeping your curved brushstrokes parallel.

Add light grays and browns over the aged wood using various mixes of black, white, and burnt sienna. Use the edge of a flat brush to work in horizontal stripes, using lighter grays near the top and warmer middle values near the bottom.

Next load a round brush with a thin mix of burnt sienna and a bit of black, and draw thin, curved shadows behind each metal band. Add white to this mix and use a flat brush to paint the top surface of each band, stroking from top to bottom. For light values of wood, add more white and burnt sienna.

Add color accents to the metal bands by drybrushing with raw sienna. Then use the tip of a round brush to stroke in plank separations with a mix of burnt sienna and black. Drybrush light values over the wood, stroking along the grain. Finally, add highlights below the plank separations and along the metal bands.

NATURE
239 | Tree Bark

Start with a warm, dark underpainting to quickly establish a middle tone that you can build upon. Use burnt sienna darkened with a bit of black. Pounce out the brushstrokes to even out the color without lifting it off your support, which will allow your drawing to show through the underpainting.

Build your underpainting by adding the dark shadows between the raised areas of bark. Create a thin mix of burnt sienna and black. Use a flat brush to apply the paint, holding the brush at the end of the handle to create loose, spontaneous marks.

Build up the thick parts of the bark using a small, triangular palette knife with a narrow but rounded tip. Add white to the previous mix for cooler browns and reddish grays, and carefully place thick color onto the raised areas of bark. Work from the edges toward the centers.

To add the final details to the edges of the bark, indicate the areas where the light is strongest. Mix more white into your previous mixtures and use a round brush to loosely add touches of color on the edges and tops of the raised sections.

240 | Pine Tree Needles

Aim to capture the general look of needles, saving the finest detail for the closest elements. An old, stiff brush with splayed bristles is a good choice. Create a soft background using a thin mix of sap green and a bit of burnt sienna. Use a flat brush and short strokes to suggest needles.

Before you paint the needles, build up shadow details. This will save time and keep your background from appearing complex, which will help it recede. Use the same stiff flat brush and sap green darkened with small amounts of black. Continue stroking in the direction of needle growth.

Once dry, build background details. For the dark, cool green of pine needles, mix sap green with bits of white and black. Use the corner of a flat brush to make rounded strokes that look like bundles of pine needles. For the brown branches, add yellow.

Create a light, cool green with sap green and small amounts of white and black. Using a flat brush, lighten some of the branches in the background to suggest more depth. Add more white to the mix and thin it down; then use a round brush to render individual needles on the foreground branches.

241 | Pine Cone

 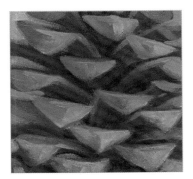 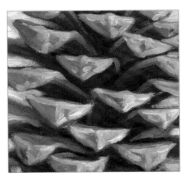

For the dark, semi-transparent neutral purple in the shadows, mix a semi-glaze of black, alizarin crimson, and a touch of white. Use a flat brush and work from the center of each section toward the triangular knob at the end, keeping your brushstrokes loose and soft. Let the paint dry between layers.

Add color to your shadows with a flat brush. Use purples mixed with ultramarine blue, alizarin crimson, and small amounts of white for the darkest areas along the stalks and under the knobs. Use raw sienna along lighter areas of the stalks and knobs.

Now add the lightest areas to the knobs. Mix equal parts white and yellow ochre plus a small amount of phthalo blue for a slightly green cast. Use a round brush to carefully add this color to the front right side of each knob.

To give your pine cone the depth that makes its shapes so interesting, use a round brush to add the final highlights on the fronts and edges of each knob and stalk. Keep your marks painterly to capture the variations in the surface texture.

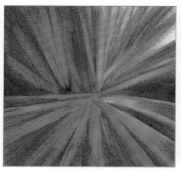 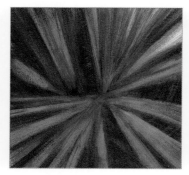 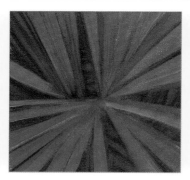 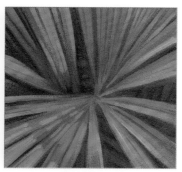

The most interesting aspects of palm fronds are the play of light on the individual leaves and negative spaces that occur between the leaves. It's important to emphasize both features in your work. Palm fronds have such a distinctive shape that you don't need to paint every single leaf to capture its character. Start with a thin underpainting of transparent green mixed with sap green and a touch of burnt sienna, which will establish the surrounding vegetation and a base color for brighter greens.

Finish painting your shadows and adding interest to the background with a darker, cooler layer of sap green mixed with small amounts of black. Use a ¼-inch flat brush as you stroke long lines and fill in larger areas. Retrace your marks to keep the edges flat and soft.

Now you are ready to paint the basic green values of the palm leaves. Add two parts cadmium yellow light to three parts sap green; then use the same ¼-inch flat brush to work in long, continuous strokes from the ends of the leaves toward the darker center. Decrease pressure and rotate your brush as you near the center to narrow your stroke and blend the color into the shadows.

Finally, it's time to add the bright yellow greens that give palm fronds their drama. Add more white and yellow to your mixture and thin it for flow. Then use a #2 round brush to add the highlights, working from the tips of the leaves toward the center.

243 | Thatched Roof

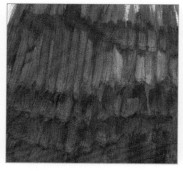 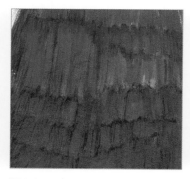 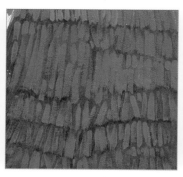 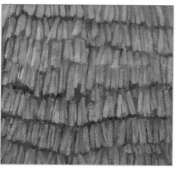

When creating the texture of a thatched roof, it is easiest to start with dark, blurred shadows and build on them with lighter values. Start by mixing burnt sienna with a small amount of sap green. Holding a ½-inch flat brush vertically, paint edgewise in loose, vertical strokes. After you have covered the surface, add more sap green to create a darker value and cut in short, vertical shadows that run horizontally across the roof.

With the warm, dark shadows in place, work on the straw itself. Begin in the shadows by adding cool, grayish golds with a mixture of equal parts yellow ochre, white, and black. Use the corner and width of a ¼-inch flat brush to paint in vertical sections with various widths, starting from the top and working down toward the end of each section.

Allow this darker, cooler layer of color to dry. Then switch to a #4 round brush and rotate your support so that you can stroke comfortably from the ends of the straw upward. Create a mixture of equal parts white and yellow ochre plus a small amount of burnt sienna; then thin the mixture to create smooth, clean vertical marks along the layers of thatch.

In this final step, enhance the light on the thatch that is closest to your light source—or simply add light to areas that need more dimension and variety. With a #2 round brush, add thinner lines along the edges these sections with a mix of equal parts white and yellow ochre. Do not overdo this stage, but rather use these highlights sparingly for a realistic look.

244 | Fern

 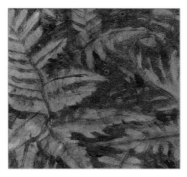 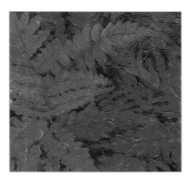 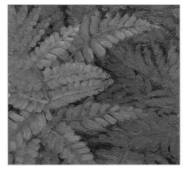

Ferns have busy leaves, so reserve your finest details for a few well-placed ferns in the foreground. Work from back to front so you don't have to paint around complex shapes. Load a flat brush with a dark, transparent mix of sap green and burnt sienna. Apply short strokes in various directions.

Once dry, switch to a smaller round brush and add dark greens to the shadows behind and between ferns, while building fernlike shapes in the negative spaces. Keep these areas simple so they don't compete with the more detailed foreground leaves.

Again, once dry, lighten sap green with cadmium yellow light, and apply small strokes that start at the tip of each leaf and end at the stem. Reload the brush frequently. For the foreground ferns, add more yellow and white.

In this final step, simply repeat step three using brighter greens mixed with more yellow and white. You might also switch to a #2 round brush for added control. Begin in the background and brighten your greens as you move forward, working on the closest branch last.

245 | Moss

Work on the moss and the surface beneath at the same time so they integrate well with each other. Paint the rock with a wash of black lightened with white. Use a flat brush to build texture with short strokes or loose stippling. For the warm shadows, dab on sap green and burnt sienna.

After your underpainting dries, build the shadow color of the moss using a mix of sap green and yellow ochre. Experiment with different brushes, but look for one that makes small, organic marks simulating moss texture as you stipple.

Allow your shadow layer to dry. Use the same brush to add lighter middle values of green to the higher parts of the moss with various mixtures of sap green brightened with small amounts of cadmium yellow light and white.

For the final layer, add the lightest sections of the moss where the growth is newer and closer to your light source. Continue to add more yellow and white to your mixture and, for more control, use a #2 round brush to carefully add tiny strokes where needed.

246 | Grass Field

When painting a grassy field, use color temperature and detail to create depth. Mix sap green with burnt sienna, and apply loose, horizontal washes of color. Use lighter, cooler colors and less detail in the distance, and use warmer, darker, and more textured strokes in the foreground.

Switch to an old, stiff brush to add darker details in the shadow areas with a dark, cool green, such as sap green. Apply short grasslike marks made using a light touch. Allow the paint to dry.

Add more specific grass details with a long striper brush. Use cadmium yellow light, white, and sap green for the middle green. Hold the brush at the end of the handle for loose, organic lines that start in the soil and move up and out. The blades of grass should be longest in the foreground.

To add the blades of grass that are hit by the most light, add more white and yellow to the mix and thin it down for better flow. Use the striper brush to paint long, curved blades in the lower half of the painting. Make sure the foreground holds the most detail and contrast for atmospheric perspective.

247 | Bubbles

 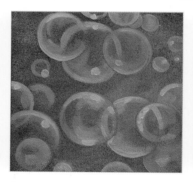 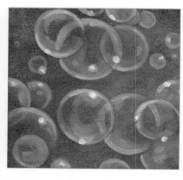

The key to painting bubbles is to create the illusion of transparency. Lay in your background colors and blend them so they are soft and nondescript—and you will have already done half the work! Use any color combinations, depending on where your bubbles are, and pounce to smooth out all the brushstrokes, leaving subtle gradations of color to build upon. For this background, apply a thin underpainting of sap green.

With the background in place, define some of the bubble edges with semi-transparent layers of the colors you wish to reflect. Begin with a blue-gray mix of ultramarine, white, and black. With a ¼-inch flat brush, start at the edges of your bubbles and, as the paint diminishes on your brush, blend the color toward the center of the bubble. Avoid covering the entire background to create a sense of transparency.

Once your previous colors dry, create a thin, semi-transparent mix of white and a small amount of phthalo blue. Use a #2 round brush to add the brighter lights circling each bubble. If the marks are too harsh, use your finger or a dry ¼-inch flat brush to blend the inner edge toward the centers of the bubbles. Add a few smaller solid circles; then gently press your finger into their centers to lift some color and make them appear transparent.

To finish, add bright colors along some of the edges of your bubbles, along with a few highlights with white to give them a more reflective appearance. Integrate the bubbles with the background by adding some bright green highlights using a #2 round brush.

Work from dark to light and keep your edges very soft to achieve the curving, intricate patterns made by smoke as it follows the air current. Start the dark background with a thinned mixture of equal parts Payne's gray, alizarin crimson, and ultramarine blue. Thin this mix and use a ½-inch flat brush to stroke in the curves and soft edges of the smoke, retracing your marks until they are blurred sufficiently.

Now focus on creating the more subtle gradations within the background by working wet-into-wet with a soft ½-inch flat brush. Variations of black, white, ultramarine blue, and alizarin crimson work well to create the dark purples of smoke as seen in the dark. Retrace your strokes as many times as needed to create very smooth gradations.

After your paint dries, add more white to your color and begin to build the lighter values of the smoke, adding interest and detail as the smoke twists and turns in the air. Keep your color semi-transparent by thinning it and then blending it with a soft, dry brush. This will soften your edges and eliminate brushmarks.

Once the previous layers dry completely, add the brightest whites to represent where the smoke is thickest and where the light hits it most directly. Use a #2 round brush to dab in the white, and then use a soft, dry blending brush to eliminate the brushstrokes.

249 | Flower Petals

Start with an underpainting of sap green warmed with a small amount of burnt sienna; this will serve as the base color for the entire flower and add the illusion of greenery in the background without the need for much time or detail.

Next build the middle values of each area. Use the corner of a ¼-inch flat brush and short, impressionistic strokes to paint the shadows in the flower centers using cadmium orange darkened with a touch of sap green. For the background, stroke in a loose mix of sap green and cadmium orange, lightened a bit with white. Then mix one part ultramarine blue with three parts white and, using your ¼-inch flat brush, apply one long stroke from the tip of each individual petal toward the center. As you stroke, slowly reduce the pressure on the brush.

Continue lightening the petals with soft lavenders and pinks. Mix these colors using white tinted with small amounts of alizarin crimson and ultramarine blue. Use a ¼-inch flat brush and, starting at the tip, pull one clean brushstroke along each petal, lifting it off the support about two-thirds of the way to the center.

Complete the flower by adding one final layer of thick, bright white on the petals where the light hits them most directly. Use a #2 round brush and focus on adding the striations that run the length of each petal. Start at the tip of the petal and let the white fade as you stroke toward the center. Then stipple a few cadmium yellow highlights over the flower centers to bring them to life.

250 | Fall Foliage

You can achieve the colorful texture of fall foliage, as seen from a distance, by applying multiple layers of color. You can use a number of tools for the layering process, but sponges are particularly useful. Begin by painting the background sky using equal parts white and ultramarine blue with a ½-inch flat brush. Let this dry before starting the next layer.

Before you begin isolating specific areas of foliage or individual leaves, first quickly allude to the more distant foliage that will peek through the detailed areas and add depth to your landscape. Wet a natural sea sponge and, after wringing out as much water as possible, dab it into a glaze mixed from Venetian red and ultramarine blue. Dab this onto your support, creating as much density as you desire. Remember to allow the blue of your sky to show through in areas.

Now that your darkest, coolest red foliage is done and dry, use the same sponge to add a warmer, lighter layer of leaves with a mixture of equal parts cadmium yellow and cadmium orange, darkened with small amounts of alizarin crimson. Avoid covering all of the previous layers, as they will add depth to your final painting.

To increase the depth of your foliage, continue using the same sponge to add a final layer of brighter leaves. The dryer the sponge and the more paint it holds, the more dramatic your additions will be. A mixture of equal parts yellow ochre and cadmium orange works well for the top layers, where the light is strongest and the leaves are brightest.

251 | Mountain Rock

When painting mountain rocks, remain loose and avoid over-working the details. Use a flat brush to apply an underpainting of burnt sienna darkened with a bit of black. This establishes the shadows with transparent color, which will recede against subsequent opaque layers.

Once dry, switch to a smaller flat brush to mass in the shadow sides of the rocks and add darker cracks. Use a mix of equal parts yellow ochre and Venetian red, darkened with black. Your marks should follow the grain of the rock surface, which will help describe the form with less detail.

Add contrast and texture on the top surfaces of the rocks in light. Use a flat brush or palette knife for impasto strokes. Mixtures of yellow ochre and Venetian red darkened with black work well for iron-rich rock. Keep your strokes short, following the grain of the rock.

To clean up edges, add more detail, and build a stronger sense of light, mix yellow ochre and burnt sienna with white. Using a round brush, add this light value where the light is strongest on the rocks. To add cracks, use a round brush and a glaze of burnt sienna darkened with black.

252 | Smooth Rock

 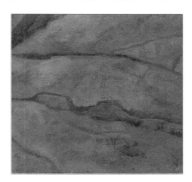 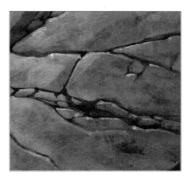

For realistic rock textures, build layers of blended colors followed by cracks and highlights. Paint the soft variations of color, starting with the darkest values. With a thin mix of black and small amounts of white and burnt sienna, use the tip of a flat brush to stipple a layer of mottled color.

For more subtle variations of color, use a smaller brush—such as a ¼-inch flat—and create less contrast between your color mixes. Work wet-into-wet as you stipple to achieve soft transitions.

Once dry, add more white and yellow ochre to the mix and build up light areas of stone. Now is a good time to clean up the edges along the cracks or simplify areas that have become too complex or confusing. Drybrush your color onto the surface, allowing the colors beneath to show through.

Finally, using a round brush loaded with a thinned mix of burnt sienna and a bit of black, refine the darks and details of the smaller rocks and cracks. Then switch to white paint and add thin highlights along the top edges of the rocks and cracks, focusing on those that capture the light most directly.

253 | River Pebbles

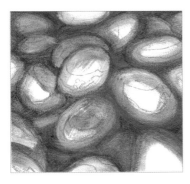 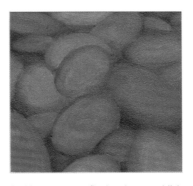 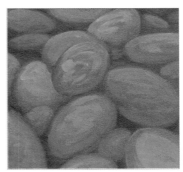 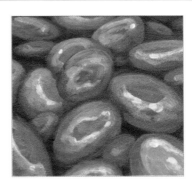

River pebbles have smooth, rounded edges and glossy, reflective surfaces when wet. Use a flat brush and a glaze of ultramarine neutralized with a bit of burnt sienna. Redraw the stones and fill in shadows, blending the color over the stones.

In this step, use a flat brush to establish the middle tones of the individual stones with yellow ochre, black, white, Venetian red, and ultramarine blue in various combinations. Work your brushmarks in circular movements that describe the roundness of the stones, and smooth out any rough strokes.

Add small amounts of white to your various colors and thin them down to semi-transparent glazes. Continue adding dimension to your stones with loose brushstrokes on the portions of the pebbles that peek above the water. Keep your marks organic so they look like wet reflections on smooth stones.

In this final step, add light reflections that encircle the tops of the stones as they peek above the water's surface. Use a #2 round brush and a semi-glaze of white paint to loosely suggest the shapes of surrounding objects, such as trees, on top of each stone.

254 | Sand

There are many ways to create the texture of sand, such as incorporating a textured medium or even using actual fine sand in your paint. However, you can create a convincing texture simply with paint. Start with a base of middle-value brown mixed with three parts ultramarine blue, two parts raw sienna, and one part white. Use a ½-inch flat brush in long, curving strokes to create the soft ridges of this sand dune. Keep everything loose and non-committal at this stage so the shadows recede.

Switching to a ¼-inch flat brush, build up the texture of the sand by using the corner of your brush to stipple in slightly lighter variations of your color mixture. Work along the ridges of the sand and gently blend into the shadows as the paint diminishes on your brush. Let this layer dry before you start another.

To build more texture and light in your image, mix white with small amounts of Venetian red and yellow ochre. Use your ¼-inch flat brush to brighten the dunes by stippling small dots of color along the ridges; as the paint diminishes on your brush, scumble thin color into the shadows.

To add the final highlights and add more specific texture to the peaks of the dunes, use an old, stiff #4 round brush. Consider cutting off the pointed tip of the hairs with a utility knife to give it a flat, circular end, which you can use to stipple thicker paint onto your painting. Add more white to your mixture from step three and dab it onto your painting wherever you'd like more light and texture.

255 | Seashell

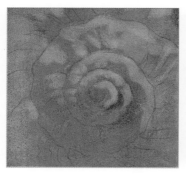 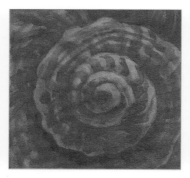 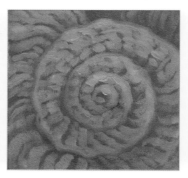 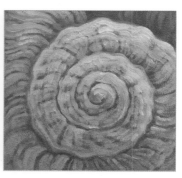

Seashells come in myriad colors, shapes, and patterns, so use this example as a guide for applying any color combination you wish. Begin the warm undertones of the shell with an underpainting of burnt sienna cooled down with a small amount of sap green. Use the pounce technique to eliminate any brushstrokes. Then pick out color from the lighter areas of the shell to indicate how the light falls across the form.

Next mix three parts Venetian red to one part ultramarine blue, lightened with a small amount of white. After studying the pattern of your shell carefully, establish the darkest parts first using a ¼-inch flat brush for the widest bands of color and a #4 round for more linear details, paying close attention to how the pattern follows the contours of the shell.

Now it is time to start building the lighter values of the seashell and adding detail to the pattern. With equal parts Venetian red, yellow ochre, and white, use your ¼-inch flat brush to paint single strokes that follow the contours of the shell, working between the darkest marks you added previously.

To finish, build up the detail and brighten the values where the light is strongest. Add more white and a touch of yellow ochre to your mixture and, using a #4 round brush, work along the length of the shell and across its width to render the raised pattern.

256 | Running River

The surface of water shows interesting patterns as it flows around and moves over rocks, branches, and other objects. To begin establishing these patterns, use a bluish gray mixed with two parts ultramarine blue to one part Payne's gray. Thin this with water (if using acrylics) or medium (if using oils), and use a ½-inch flat brush to loosely paint the shadows of the rocks and water.

To paint the middle values of the rocks and water, mix variations of ultramarine blue and white, darkening with black and warming with raw sienna. These neutral tones give the sense of vegetation and rocks under the surface of the running water. Use a ¼-inch flat brush to apply long strokes that follow the flow of the water.

Now begin building the bluish-white foam found around the rock, and continue weaving strokes through the water in the direction of flow. Use various mixtures of cobalt blue and white warmed with a touch of raw sienna. A small ⅛-inch flat brush or #2 round brush is a good choice for these long strokes.

Once your previous layers dry, use a #2 round brush to enhance the lights in the water patterns with pure white paint. Hold your brush at the end of the handle to help you create looser, more natural marks that suggest the foam and water.

257 | Ocean

 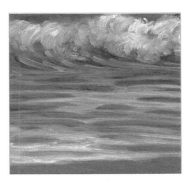 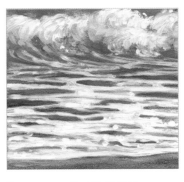

Ocean water features a variety of textures, from thick sea foam swirling along the surface to fine spray shooting off the tops of waves. With a little experimentation, you can learn to create realistic textures that do not appear too contrived. The more relaxed you are with the handling of your brush, the easier these textures will be to create. Build the transparent blues of the water using thinned manganese blue hue and ultramarine blue with a ½-inch flat brush. Apply the paint in loose, brushy strokes that follow the contours of the water.

To hint at the sand colors under the shallow layers of water, mix equal parts yellow ochre, Venetian red, and white cooled by a touch of ultramarine blue. Use the tip of a ½-inch flat brush to loosely paint bands of color along the shore. Next use the same method to add darker bands of blue glaze mixed from equal parts ultramarine blue and manganese blue hue. Work wet-into-wet, blending the areas of color together as you to create soft transitions within the water.

Having established the darker colors under the surface and in the shadows, it's time to add the lighter whites of the foam. For the waves, use a ¼-inch flat brush loaded with a mix of white and a touch of phthalo blue. Work from the back of the wave to the front and follow the flow of the water. Then thin the paint and switch to a #2 round brush to paint the soft pattern of foam as it rolls up onto the sand.

Once your previous layer dries, enhance the brightest whites of the foam in the foreground and within the waves. Load a #2 round brush with white paint thinned for flow, and hold your brush by the end of the handle to loosely add opaque white strokes that add dimension.

The most interesting aspects of a still lake are the reflections that fall on its surface. To create the reflections of the trees and foliage at the lake's edge, create a thin mix of three parts sap green to one part burnt sienna. Using a ½-inch or ¼-inch flat brush, work over the reflections from top to bottom and stroke in a subtle zigzag pattern to blur the details and create the illusion of water.

Next use a ½-inch flat brush to quickly paint the warm tones of the lake bottom with equal parts sap green, burnt sienna, and white. This will show through your subsequent layers and add depth to the water's surface.

Now that your underpainting is finished, create the whitish reflection of the top surface of the water. Mix a milky semi-glaze with three to four parts white and one part ultramarine blue and alizarin crimson. Use a soft ½-inch flat brush to apply a layer over the entire section of water to the right of the tree reflections. You can use a small amount of this color over the tree reflections to soften them if needed. Before the paint gets tacky, use a very soft, dry blending brush to remove all brushmarks.

Once your previous layers dry completely, create a strong sense of atmospheric perspective and enhance the glassy quality of the water. Use a ¼-inch flat brush to add a layer of white with horizontal strokes, making it thicker and lighter in the distance and thinner and more transparent in the near foreground.

259 | Rippled Lake

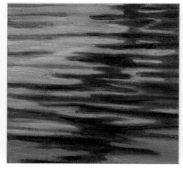
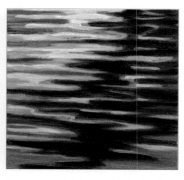

When painting rippled water, the reflections from the surrounding environment—such as boats, swimmers, or trees along the water's edge—merge with the cooler whites and blues of the water itself. It is important to study the curving weblike patterns created by rippling water. Start by laying in the transparent greens of the reflections using a thin mix of sap green warmed with a touch of burnt sienna. Using a ¼-inch flat brush, work from top to bottom to create a subtle zigzag pattern. Before this dries, knock down any hard edges by sweeping over your strokes with a soft, dry brush.

Once the underpainting is dry, paint your darkest blues using two parts white, one part ultramarine blue, and a small amount of sap green. Thin the paint so it flows smoothly. Use the same zigzag method to suggest horizontal ripples that are thinnest in the distance and fattest near the viewer.

To paint the lighter, bluish white reflections on the water's surface, mix white with small amounts of ultramarine blue. Use a #4 flat brush (or smaller round brush) to carefully paint horizontal bands that end gradually in the dark shadows of the water. Then apply more of the dark glaze over the shadows to blend and soften the edges of the lighter colors as you trace between them.

Once your paint dries, add the final white highlights on the highest ridges of the ripples. Use a #2 round brush and pure white to add soft, horizontal bands wherever needed.

260 | Clouds

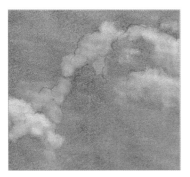 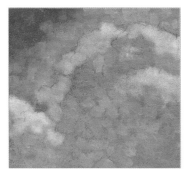

To create the fluffy white clouds you would find in a Maxfield Parrish painting, use a ½-inch flat brush to apply a warm gray underpainting with a mixture of three parts ultramarine blue, one part yellow ochre, and one part white. Use the pounce technique to remove the brushstrokes, and use a soft, clean cloth to pick out color where the light is strongest on the clouds. Keep your edges soft and blurred like clouds in nature.

Various shades of ultramarine blue mixed with white are perfect for the fluffy, cool cloud shadows and for the soft edges that blend into the sky. Use a ¼-inch flat brush and short, impressionistic strokes to start building texture in these areas. Avoid covering all of your underpainting, as its warmth will add depth and variation to your clouds.

After your paint dries, fill in the parts of the clouds that are receiving the most light. Use white warmed with a small amount of yellow ochre for the tops, and use white darkened with a bit of ultramarine blue to enhance the details in the shadows or in the distance.

Once your base dries, add a final layer of pure white on the areas where the light is strongest. Keep your transitions soft, but build up the thickness of your paint in your focal areas and where the light is brightest. Remember that thick paint tends to come forward, whereas thin, transparent color tends to recede.

261 | Frozen Pond

Usually shallow ponds start to freeze over in late fall, right after the leaves have fallen from the trees. Often you can see colorful foliage through the thin layers of ice. Therefore, before you start to paint the ice, first establish the colors of the water and foliage. Use a ½-inch flat brush to block in various mixtures of burnt sienna, yellow ochre, sap green, and ultramarine blue. Work from the warmer colors, seen through the smoothest, thinnest ice, toward the cooler, bluer areas where the ice is thicker and more opaque.

Continue building up the colors of the underpainting. Add more blue and white to your mixtures as you move forward in your picture plane (toward the viewer), where you see fewer reflections and more texture. Work wet-into-wet with your ½-inch flat brush to keep your edges blended.

With your underpainting complete, add the semi-transparent ice on top. Mix equal parts ultramarine blue and white, and thin it to create a semi-glaze. Using the tip of a ¼-inch flat brush, create the diagonal lines and striations that form when shallow water freezes over. Start with the primary lines and then fill in the secondary lines to form a complex series of sections that intersect each other, forming a rippled pattern.

The last five percent of work spent on a painting is what makes it come to life. A few well-placed highlights can make all the difference, giving it a sense of place and time through the quality of light. Light glimmers and glints off the surface of ice with diamondlike brilliance, but it is softer and subtler in other areas where it is absorbed by snow or seen through the atmosphere. Use white to apply these final highlights, and stroke in the direction the light falls on the ice—in this case, down and to the left.

262 | Raindrops on a Window

 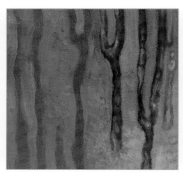 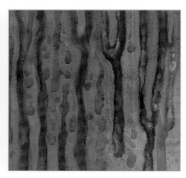

Before you can paint fog and raindrops on a window, begin with a background color you can build on. In this case, use a blue-gray mixed from manganese blue hue, ultramarine blue, and a small amount of white. Apply the paint using a ½-inch flat brush or larger, depending on your surface area. Pounce out all the brushmarks to leave a smooth gradation of color.

After the base colors dry, use a ¼-inch flat brush to scumble white thinly onto the surface of your board, simulating fog or steam on the window. Your base layer should show through but appear blurred. While the scumbling is wet, load a #4 round brush with a very thin version of your background color and press it at points along the top of your painting, letting the liquid drip down your surface. Some of the wet paint beneath should float up and gather in the drips. You can also gently drop bits of thinned color into these drips until you achieve the desired effect.

Continue building texture across the window by scumbling with a ¼-inch flat brush and a bluish white mix, working around the main streaks. A little stippling with the corner of your brush will look like condensation collecting on the glass.

Now add the final streaks of rain on the window. Hold your support vertically as the thin paint drips down your surface.

263 | Raindrops from the Sky

While painting raindrops, focus on building depth through the subtle contrasts between hard and soft edges. The first layer will be the softest (or blurriest), as if the rain is falling in the distance. To achieve this effect, create thin mixes with varying amounts of sap green and black, lightened with white. Using the edge of a ½-inch flat brush, turn your support so you can stroke from side to side in long stripes of various widths. Blur your brushmarks by tracing over them with repetitive strokes.

Once your previous layer dries, define the vertical lines created by falling rain. Turn your painting horizontally so you can more comfortably render straight lines. Use a #2 round brush loaded with a thin mix of white and a small amount of sap green.

To get the whites of the rain to glow, build up the thickness of the paint. Mix a very small amount of green gold with white and use the straight edge of a palette knife to place (or stamp) straight lines of color onto your image. If any line is too thick or messy, use a long striper brush to trace along the edge and pull paint upward, straightening and softening the mark as you move along its edge. Wipe your brush clean often so it readily picks up paint.

To create the impression of a sunny shower, make your whites very bright. Continue using your palette knife to build the thick white paint in areas where the light is strongest. After adding another series of vertical strips of color, refine them with a wet striper brush. (If using oils, wet the brush with medium; if using acrylics, wet the brush with water.) Continue to straighten your lines by pulling out color with the brush and wiping off the paint on a soft cloth.

264 | Snowflakes

To paint snow falling from the sky, first paint the background. In this case, create the illusion of snow at night as seen in the rays of a streetlight or perhaps in the headlights of a car. Start with a dark purple-gray by mixing equal parts black, ultramarine blue, and alizarin crimson, lightened with a touch of white where the sky is lighter between the trees. Use the tip of a ¼-inch flat brush to dab on small dots of color with very soft, blurred edges.

Using the corner of the same ¼-inch brush, continue to build up lighter and lighter layers of texture between the trees and in front of them using a various mixtures of white, Payne's gray, and alizarin crimson. Small, stippled marks work best for falling snow.

With the night scene background in place, you will now need to build a few layers of snowflakes. Add more white to your gray mixture and use a small #2 round brush to dab tiny spots randomly over the entire image. Use pure white for the larger, closer flakes.

For the final touches, use a fine #2 round brush to dab thick spots of pure white over the largest and closest snowflakes.

265 | Snow Powder

 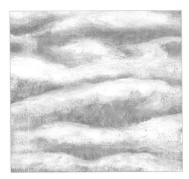 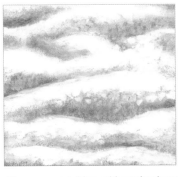

To establish the cool purple-grays of the shadows, mix various amounts of ultramarine blue with alizarin crimson, lightened with a small amount of white and thinned for flow. Quickly lay in an even layer of color, pounce out the brushstrokes, and pick out some color from the mounds of snow that will receive the strongest light.

To begin building the texture of the snow, work from the shadows toward the light, gradually shifting from darker, cooler variations of white to warmer, lighter tints. For the purple found in the shadows, mix small amounts of alizarin crimson and ultramarine blue with white. Use the corner of a ¼-inch flat brush to dab spots of color over the underpainting. Do not cover everything; the darker bits of underpainting serve as the shadows between clumps of snow.

After your paint dries, start building the lighter values of the snow using pure white. Start at the ridges of each section and, as the paint diminishes on your brush, scumble color into the shadows to add detail and brighten where needed.

After your paint dries, add another layer of pure white along the ridges and down the sides of the snow mounds using short, round strokes. Use thicker paint in the foreground, where the added texture will read as detail, and use softer strokes as you move to the more distant surfaces.

FOOD & BEVERAGE
266 | Citrus Fruit Rind

To begin building the dimpled texture of an orange rind, create a thin mixture of equal parts burnt sienna, cadmium red light, and cadmium yellow light. Dab in the color to create an irregular, dappled texture. Add a touch more burnt sienna for the darker areas.

Using various mixtures of cadmium red light and cadmium orange darkened with sap green, apply the basic middle and shadow values of the orange. Use the corner of a flat brush turned on its edge to create short, impressionistic strokes that resemble the mottled texture of an orange rind.

Once dry, switch to a round brush and develop the texture with small dabs of lighter colors, again working from dark to light. Use small amounts of thin cadmium orange and cadmium yellow light for highlights.

267 | Cut Citrus Fruit

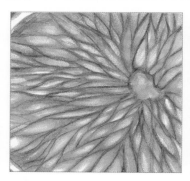 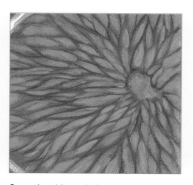 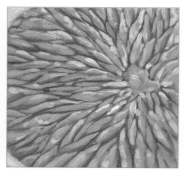

The most interesting parts of an orange slice are the shiny teardrop-shaped pieces that fan out from the center. "Draw" the pattern using a round brush loaded with a thin mix of cadmium orange, cadmium yellow light, and sap green, working from the center out.

Once dry, thin cadmium orange to create a transparent glaze. Layer it over the interior of the orange, blending to remove brushstrokes. Add equal cadmium yellow light and white to the glaze and paint lights over each section. Use thick brushstrokes to catch the light.

Now add the lightest values and highlights for a juicy appearance. Thin cadmium orange, white, and cadmium yellow light; then use a small round brush to stroke lengthwise over each section. Once dry, add cadmium yellow light to white and dab on highlights.

268 | Apple

To create this luscious red apple, start with an underpainting of the darkest shadow color. Using a ¾-inch flat brush, apply a solid layer of two parts alizarin crimson to one part black, thinned slightly for flow. Pull out some color in the highlight areas and background to establish the general form.

Next build the middle values with a mix of equal parts Venetian red and cadmium red light. Use a ¾-inch flat brush to make long strokes, curving downward from the top rim to the lower third of the apple. The curve of these brushstrokes will define the form.

To begin building the lighter red values on the top third of the apple, mix equal parts Venetian red with cadmium red light, adding a bit of white to lighten. Use a ¼-inch flat brush to work in short, impressionistic strokes from top to bottom, following the contour of the apple.

Apply the lightest colors around the apple's rim. Stroke down toward the center using short, impressionistic strokes, creating texture and variation without fully covering the base colors. Mix cadmium yellow light, sap green, and white to highlight the stem and add spots on the skin.

269 | Grapes

The most distinguishing characteristics of red grapes are the deep, reddish purples and chalky, bluish whites that cover the surface. To begin, establish the rich red undertones and shadows with a glaze made from a thin mix of equal parts alizarin crimson and dioxazine purple. Use a ½-inch flat brush to apply color loosely around the contour of the grapes and into the shadows. Add a little white to your mixture to increase its opacity and cool the purple, creating an effective transition between the deep reds and lighter blues.

After this initial layer dries, continue building the rich red purples of the grapes with a thin mixture of equal parts alizarin crimson and ultramarine blue darkened with small amounts of black. Use the corner of a 1-inch flat brush to stipple on the color and create a spotty texture. Work wet-into-wet for a softer effect.

Let the glazes dry completely. With the transparent layers of the grapes in place, it's time to start working on the bluer, more opaque areas. For this color, use a mixture of three parts white, one part alizarin crimson, and one part black or ultramarine blue. Load a ¼-inch flat brush and wipe off the excess paint from your brush, working from the lighter areas and moving toward the shadows as the amount of paint on your brush diminishes. Keep your marks loose and impressionistic rather than smooth and over-rendered, but avoid obvious brushmarks.

To create the bluish-white highlights on the grapes, mix small amounts of ultramarine blue and alizarin crimson with white. Load a ¼-inch flat brush and wipe off any excess paint, and then add short, impressionistic strokes along the tops and right sides of each grape. As the paint on your brush decreases, lightly work a little color onto the bottom and left shadow sides to create reflective light. This will make your grapes look more three-dimensional.

270 | Coconut

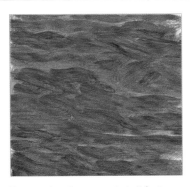 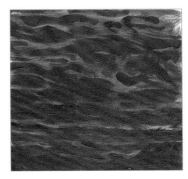 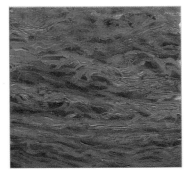 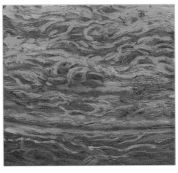

The exterior of a coconut shell features a variety of textures that you can achieve with a very loose approach. Start with a thin underpainting of equal parts burnt sienna and sap green. With a ½-inch flat brush, lay in a loose layer of color and let your brushstrokes show. Work from side to side along the natural curve of the coconut.

In the next layer, continue modeling the form of the coconut, making it darker at the bottom and lighter at the top. Use a #6 round brush loaded with equal amounts of burnt sienna and sap green, thinned a bit for flow. Following the contour of the coconut, use loose, squiggly strokes that serve as a great base for the hairy texture you will add in the following steps.

Now create the hairy fibers of the coconut shell. Work from dark to light and mix variations of sap green, cadmium orange, yellow ochre, and white. Use a #4 round brush to dab on thick spots of color in the lighter areas. Use a fine-pointed palette knife to scratch into the paint, spreading and dragging the paint to create hairlike fibers. For this technique, it's a good idea to experiment first on another painting surface.

After the previous layer dries, add more white and yellow ochre to your mixtures for the lightest details, and use a #4 round brush to loosely lay in the color. Then use your palette knife to scratch into the paint and create the fine strands of the coconut texture.

271 | Peanut Shell

To achieve the warm, golden brown found in the shadows of these peanut shells, create a thin mix of equal parts burnt sienna and green gold. Brushing lengthwise along the peanut forms, build up the shadow areas while keeping your brushmarks soft and noncommittal. This will help your edges recede and suggest more depth in your final image.

Mass in the middle values of the peanut shell using burnt sienna mixed with small amounts of black for darker areas and white for lighter areas. With a ¼-inch flat brush, paint short, impressionistic strokes lengthwise along the shell forms, following their natural curves. Allow some of your underpainting to show through.

To build the lighter areas and pattern of the shell, add yellow ochre and more white to your mix and carefully highlight the raised parts of the pattern that catch the light. The details do not need to be exact; simply study and capture the curves and character of the ridges. Wipe off the excess paint from your brush to keep the edges of your brushmarks soft, allowing them to blend with the darker values.

In this last stage, render the finest details and add the highlights. Mix one part yellow ochre to two parts white and load a ⅛-inch flat brush. Then use the drybrush technique to highlight the gridlike pattern of the shell. As the paint diminishes on your brush, add softer details to the shadows for interest.

272 | Walnut Shell

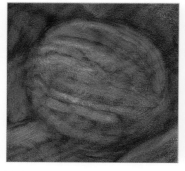

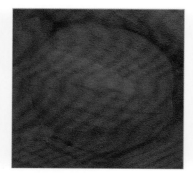

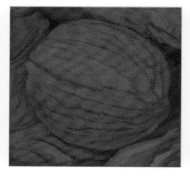

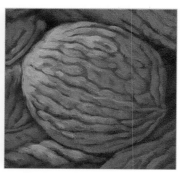

To begin building the texture of walnut shells, start with a warm, dark brown made up of one part burnt sienna to two parts sap green. These transparent paint colors are perfect for underpaintings because they allow your drawing to show through. Apply a flat layer of color with a ½-inch flat brush and pick out color on the lighter areas with a cotton swab or a soft cloth rolled into a point.

Using a ¼-inch flat brush, mass in the basic brown values for the walnut shells with a mixture of equal parts burnt sienna and black, adding small amounts of white or yellow ochre as you move onto the lighter areas. Work lengthwise along the shell pattern in short, impressionistic strokes.

After the middle values dry, lighten the mix from step two with a small amount of white. Load a ¼-inch flat brush or #6 round brush, wipe off the excess paint, and use the drybrush technique to define the lightest sections. The more texture you pick up from the painting surface, the more it will resemble an authentic walnut shell.

Now it's time to add highlights to capture the details of your shell. With a mixture of one part raw sienna to two parts white, use a ⅛- or ¼-inch flat brush to drybrush color onto the raised areas of the shell, carefully avoiding the veinlike lines between them. Study an actual walnut to understand how the various sections of the shell merge in and out of each other.

273 | Black Coffee

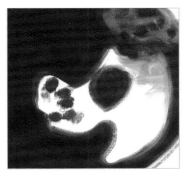 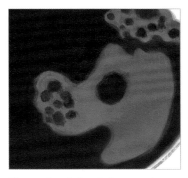 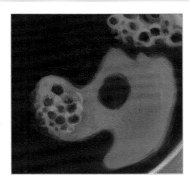 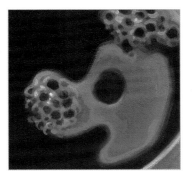

Begin building the smooth, dark color using a few layers of a rich, dark brown mixed from one part burnt sienna to three parts black. Use a ½-inch flat brush loaded with a generous amount of paint to cover the darkest areas. Blend the edges with a ¼-inch flat brush before they dry.

Mix equal parts burnt sienna and white, dulling the mixture down with a touch of black. This will create the reddish-gray middle value in the reflection of the black coffee. Paint a smooth layer of color using a ¼- or ½-inch flat brush.

Now add more white to the mixture from step two and apply another layer of opaque light brown to the reflection using your ¼-inch flat brush. Focus on building up the areas around the bubbles.

The bubbles are really what give the coffee interest and diversity. Mix white with a very small amount of burnt sienna, and use a #2 round brush to refine the white rings of the bubbles, tracing over your lines to soften their edges and blend them into the darker colors beneath.

274 | Dark Chocolate

The browns in a square of dark chocolate vary depending on the angle of the light. However, in general, dark chocolate reflects a cool, blue light that yields warm shadows. Start with a warm, medium-value brown mixed with equal parts of burnt sienna and black. With a ½-inch flat brush, cover the chocolate with an even layer of color; then quickly brush over the darker sections with another layer before the first layer gets sticky. Use a soft, dry fan brush to remove all the brushmarks.

Continue painting the middle values of the chocolate with equal parts burnt sienna and black, lightened with varying amounts of white. The different planes of the chocolate reflect the light differently, shifting the values from surface to surface. Depending on the width of the section, use a ½-inch or ¼-inch flat brush in long, smooth strokes. Remove any obvious brushmarks or sharp edges between sections by stroking over your canvas several times, softening the transition between planes.

The lightest areas of dark chocolate tend to be cool, bluish browns that stand in contrast to the dark, rich, warm browns of the shadows. Add more white and black to the mixtures to create cooler browns; use a ¼-inch flat brush to stroke this color where the light is strongest on the chocolate.

With the dark and middle values of the chocolate in place, paint the light, cool white reflected on the tops and light sides of the squares. Use a mixture of three parts white, one part black, and one part burnt sienna. Depending on the level of detail you want to achieve, alternate between a #4 round and a ¼-inch flat brush. Consider using a mahlstick (a long stick to steady your hand), or simply rest your forearm on your other hand as you paint.

275 | White Wine

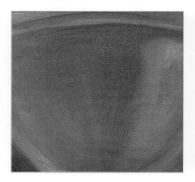 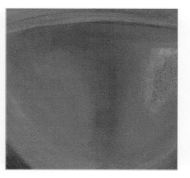 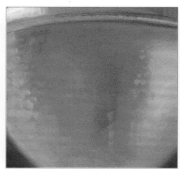 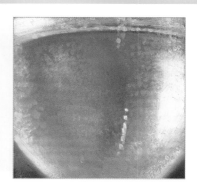

Although white wine is light gold in color, begin by establishing the cooler, neutral pink undertones by mixing equal parts burnt sienna and black with white to brighten. Thin this mixture and use a ½-inch flat brush to apply an even layer of color. Then use a soft cloth to pick out color on the glass along the rim (where the primary light hits) and bottom edge (where the reflected light hits).

While it may be a challenge to create the transparent look of liquid with oil or acrylic paint, you can create a convincing representation using glazes and careful transitions of color and temperature. In this step, create a base for applying brighter, more saturated colors later. Using a ½-inch flat brush, build on the central shadow with a thin mix of equal parts yellow ochre and raw sienna. Add a touch of white as you move to the lighter left side of the glass, and add ultramarine blue to create the cooler, bluer reflected light along the outer edges of the glass.

After the paint has dried, build up the lighter, warmer areas with a mix of one part raw sienna, one part yellow ochre, and two parts white. Wipe off excess paint from your ½-inch flat brush and then drybrush areas of the wine where the light is strongest. Use the corner of your brush to dab on spots of color to create the impression of reflections and condensation on the glass.

Allow the paint to dry and then brighten the light coming through the golden wine with a ¼-inch flat brush and a mixture of equal parts of white and yellow ochre. Apply small dabs of color between the lights and shadows to suggest more condensation.

276 | Red Wine

The secret to painting red wine—or any liquid—is to build up depth of color through glazes. Apply the glazes in several layers, allowing each to dry before adding the next. To create the base layer for red wine, mix alizarin crimson with small amounts of cadmium red light (for warmth) and black (to darken). Lay in a smooth layer of color and eliminate all brushmarks with a soft, dry brush. Clean your ½-inch flat brush and pat it dry on a cloth. Then use this brush to scumble over the lightest areas of your image, loosening up the glaze and removing it with the hairs of the brush. Wipe your brush and continue to pick out color as needed.

After your first layers dry completely, continue to build your dark, rich reds with another layer of glaze mixed from thinned alizarin crimson and a touch of black. Use a ¼-inch flat brush to trace over your brushmarks, blending and softening transitions. You can also use a separate soft, dry brush to sweep lightly over the glaze.

By adding alizarin crimson and cadmium red light to your mix in small amounts, you can build up the lighter values reflected in the wine and on the glass. Choose your brush size depending on the size of the details you are working on. Blur the transitions between the whites and reds by wiping off your round brush on a cloth and dragging the hairs along the edges of your colors. Repeat as necessary to achieve smooth blends.

In this final stage, brighten the white areas. Add a little cadmium red light to your white and apply the small details along the ridges of the wine. Using a flat brush, drybrush the soft transitions from white into the deeper red wine color at the center of the glass.

277 | French Baguette

The appetizing golden brown and contrasting textures of a baguette make it beautiful and interesting. Mix equal parts burnt sienna and sap green for the middle values, laying down a quick and loose layer with a ½-inch flat brush. Add more layers of this transparent mix over the darkest areas to begin modeling the form of the bread.

Mix two parts burnt sienna and one part yellow ochre with small amounts of black to darken or white to brighten. Use a ½- or ¼-inch flat brush to add the golden middle values on the sides and in the shadows of the crusty top. Quick, short, painterly brushstrokes will help you loosely suggest the cylindrical form of the baguette.

Continue to build up the middle values, especially on the top and along the main ridge of crust. Use the same colors from step two, but add yellow ochre and white to warm and brighten the mix. You can use the corners and flat edge of a ¼-inch flat brush to create small, impressionistic marks for the bumpy crust.

The final crust detail gives the baguette its distinctive appearance. With a light mix of white and yellow ochre, use a #4 round or ¼-inch flat brush to paint the ridges of crust where the bread splits and spreads using loose, organic brushstrokes. Hold your brush at the very end of the handle for more natural and varied gestures.

278 | Frosting

Capturing the look of creamy frosting is all about the curves and lusciousness of your paint. While the initial layers may be thin to establish the transparent shadows, you can build the subsequent layers with a palette knife and impasto strokes—just like frosting a real cake! Begin by laying in the shadows with a mixture of one part alizarin crimson to two parts white, warming up the mix with a touch of yellow ochre. Use a ½-inch flat brush to paint the darkest areas with long, curving strokes.

Switch to a ¼-inch flat brush and add warm purples to the shadows using equal parts alizarin crimson and cadmium red light brightened with a small amount of white. Apply these warmer colors on the shadowed sides of the frosting ridges. To create the cooler bluish purples in the shadows, add ultramarine blue and white and stroke along the ridges.

Continue to build up your values with lighter pinks and purples using your ¼-inch flat brush. Apply the paint on the sides and over the top plane of the cake using thick, swirling strokes. After these layers dry, use a small round-edged palette knife loaded with three parts white to one part cadmium red light to frost the top of your cake with impasto strokes.

ABOUT THE ARTISTS

STEVEN PEARCE got his start as an artist at a very early age. His mother was an accomplished oil painter, and his father was an oil painter, sculptor, and master jeweler. Their encouragement and valuable knowledge helped Steven grow as an artist. Creating art with a pencil has been and continues to be Steven's passion. He enjoys experimenting with other media, including colored pencil, oil, and acrylics. Steven loves drawing portraits, still life, wildlife, landscapes, and anything that represents well in graphite and charcoal. Learn more at www.srpearceart.com.

DENISE J. HOWARD has earned regional, national, and international awards for her colored pencil drawings. She has been featured in *Colored Pencil Magazine* and *Ann Kullberg's COLOR Magazine*, has work published in several books, and is a signature member of the Colored Pencil Society of America, the UK Colored Pencil Society, and the Pencil Art Society. Denise lives in Santa Clara, California, with her husband and a garden full of native plants and hummingbirds. To learn more, visit www.denisejhowardart.com.

MIA TAVONATTI is an artist with a variety of interests, including a strong passion for painting and drawing. She moved from Michigan to California to attend art school at California State University, Long Beach, where she earned her BFA and MFA in illustration. Mia has exhibited her work extensively, both in Europe and throughout the United States. She is the recipient of numerous scholarships and awards, and her work can be seen on more than 45 book covers and in several magazines. In addition to her illustrative work, she has created a number of murals and commissions for restaurants, private residences, and corporations. She teaches illustration and painting at the Art Institute of Southern California in Laguna Beach and currently resides in Costa Mesa, California.

Also available from Walter Foster Publishing

978-1-63322-104-8

978-1-63322-172-7

978-1-63322-795-8

Visit www.QuartoKnows.com